T5-BZT-759

Women Who Speak for Peace

Edited by
Colleen E. Kelley
and
Anna L. Eblen

ROWMAN & LITTLEFIELD PUBLISHERS, INC.
Lanham • Boulder • New York • Oxford

ROWMAN & LITTLEFIELD PUBLISHERS, INC.

Published in the United States of America
by Rowman & Littlefield Publishers, Inc.
4720 Boston Way, Lanham, Maryland 20706
www.rowmanlittlefield.com

12 Hid's Copse Road, Cumnor Hill, Oxford OX2 9JJ, England

British Library Cataloguing in Publication Information Available

Library of Congress Cataloging-in-Publication Data

Women who speak for peace / edited by Colleen E. Kelley and Anna L. Eblen.
 p. cm.
 Includes bibliographical references and index.
 ISBN 0-7425-0874-9 (cloth : alk. paper)—ISBN 0-7425-0875-7 (pbk. : alk. paper)
 1. Women and peace. 2. Women pacifists. I. Kelley, Colleen (Colleen E.) II. Eblen, Anna L., 1947–
 JZ5578 .W669 2002
 303.6'6—dc21 2001040423

Printed in the United States of America

♾ ™ The paper used in this publication meets the minimum requirements of American National Standard for Information Sciences—Permanence of Paper for Printed Library Materials, ANSI/NISO Z39.48-1992.

This book is dedicated to our families:

Arthur T. and Jacqueline G. Kelley
John-Daniel Kelley

Joe and Bobbie Eblen
Margie, Rock, and Jennie Eblen
Rick and Mario Popish, Mia and Laela Edidin

And in memory of George and Minnie Popish

Contents

Preface

Women Who Speak for Peace documents ten women peace activists through their public communication. The women appear in historical progression, from the earliest activists to those still raising their voices and peacemaking.

This collection of analyses grew from a series of papers presented at the 1997 and 1998 National Communication Association annual conferences. Several members of the Peace and Conflict Communication Commission created two competitively selected panels titled, "Talking in Harmony: Women Who Speak for Peace." Authors of these papers independently selected the peace activists and the texts that they examined. In several cases, they studied peacemakers they had met in the course of peace scholarship and activities. As the book project advanced, reviewers recommended chapters on certain additional peace activists, and we recruited other peace communication and peace history scholars. The advantages of this way of developing a book are that the authors have been strongly committed to the project and that many of the accounts include original, unpublished texts. On the other hand, the whole may not fully represent the range of international peacemaking. In order to address these concerns, we have provided an introduction that describes the context of U.S. peace activism and international trends. Individual authors give details on conflict and peace efforts in the regions they studied.

The initial peace communication panel papers focused on descriptive approaches to activists' public communication, also called discourse or symbolic behavior. During the growth of the book project, authors agreed upon a traditional method of speech communication inquiry, rhetorical analysis, which ultimately evolved into feminist rhetorical analysis. In the communication discipline, rhetorical schol-

ars choose a set of artifacts, typically discourse in the form of spoken or written texts, and analyze the elements that are persuasive or, as some feminist rhetoricians have suggested, "invitations to change" (Foss, Foss, and Griffin 1999). Rhetoricians examine the relationship of the text to the situation (context, occasion, audience, medium, speaker) and they evaluate effectiveness. The introduction explains the theoretical links of this book to peace communication, feminist analysis, and feminist peace history.

The editors and authors would like to acknowledge the following people and organizations that have assisted in the completion of this volume:

Some material for Margaret Cavin's "Helen Caldicott's Violent Rhetoric" previously appeared in an article by Margaret Cavin, Katherine Hale, and Barry Cavin (1997). Permission to use the material, under copyright of "Consortium on Peace Research, Education, and Development and the Peace History Society" was given by Matthew Derbyshire, Blackwell Publishers, who represents the journal *Peace & Change*. The editors gratefully acknowledge this permission.

Thanks to Western Washington University for professional leave granted to Anna Eblen while she edited this volume and to the Bureau for Faculty Research for a grant toward the work.

We appreciate comments from the anonymous reviewers of earlier versions of this book. We owe special gratitude to Frances Early for her comments on a draft of the introduction.

Two people offered backup and help throughout the process— Richard Popish provided computer consultation, as well as continuous encouragement. Ann Dwyer provided organizational help and administrative support.

Thanks to student readers and researchers Jessica McCarthy, Ann Germino, Janelle Ellingsworth, and Andrea Hautamaki.

The Communication Faculty at Western Washington University offered reflections and encouragement on the Eblen/Wisdom-Whitley article and the editing process.

We value the forum provided by the Peace and Conflict Communication Commission of the National Communication Association and Carolyn Dale for her responses to papers presented in one of the original "Women Who Speak for Peace" panels.

Our sincere appreciation goes to all the women peacemakers who made themselves and their voices available through interviews, correspondence, and contributing their papers and materials to library collections.

REFERENCES

Cavin, Margaret, Katherine Hale, and Barry Cavin. 1997. Metaphors of Control toward a Language of Peace: Recent Self-Defining Rhetorical Constructs of Helen Caldicott. *Peace & Change* 22, no. 3 (July): 243–63.

Foss, Karen A., Sonja K. Foss, and Cindy Griffin. 1999. *Feminist Rhetorical Theories.* Thousand Oaks, Calif.: Sage.

Introduction

Anna L. Eblen and Colleen E. Kelley

> The task of the twenty-first century is to strengthen the peace culture
> and to transform the warrior culture into a love of adventure and high-
> energy but nonviolent exploration of the unknown. . . . The ability to
> craft new social patterns and institutions and to create new ways of
> working together are also required. I have suggested that women's cul-
> tures have developed these strengths to an unusual degree, based on
> the richness of their knowledge and experience worlds.
>
> —E. Boulding, "Feminist Inventions in the Art of Peacemaking"

If people from the future look back at headlines from the twentieth
century, they might conclude that war was nearly constant, that peace
hardly ever prevailed. Yet, many have lived in relative peace day to
day or worked toward a just and peaceful world. Certainly, world
wars, civil disturbances, urban unrest, and domestic violence marred
the era. Future citizens reviewing old headlines and newscasts might
also mistakenly suppose that when peace did occur, men made the
peace just as they made the war. Regardless of popular media omis-
sions, women have created peace before and during the twentieth cen-
tury, and they will continue to do so. Women have raised their voices
during this formative epoch in ways they had not before. In order to
recognize these peace efforts and women peacemakers' impact upon
social processes, the following collection documents ten women's
peace communication. The purpose of the collection is twofold: (1) to
provide information and rhetorical analysis of women's communica-
tion about their work for peace, and (2) to discuss the effectiveness of
their efforts in light of feminist theory.

How did women talk about peace and violence? What brought
everyday women onto the public stage? This book moves through the

twentieth century by examining women who spoke for peace. Women
have accomplished extraordinary acts of peace. They have challenged
social institutions set upon a militaristic course. They have raised their
voices in response to violence, often in the face of intimidation,
imprisonment, and death. Those women who continuously spoke out
in the face of cultural and legal barriers came to the public platform
at varying times and places.

DEFINING PEACE

Kelley (1992) states that the most common definition of peace, the
absence of war, provides only a "negative" explanation of the term.
As such, the definition suggests lack of activity, which is quite differ-
ent from the activist's concept of peace. Smoke and Harman (1987) see
the negative definition as "an empty feeling, a sense that something is
lacking" (10). Thus, peace scholars have come to define peace in a way
that is simultaneously more concrete and more focused upon the com-
munication process itself.

Keltner (1987) highlights the idea that peace communication devel-
ops active processes that promote the lessening of war and violence
among individuals, groups, and nations. Nagler (1984) suggests that
people involved in peace communication advocate each other's wel-
fare. Cox (1986) notes that people engaged in peace communication
work to solve not only the original problems that brought them into
conflict, but also new ones that arise. Kelley (1992) synthesizes these
definitions: Rather than a state, peace is defined as an ongoing activity
of cultivating agreements. People participating in this reality of peace
act as cooperative participants seeking solutions rather than as com-
bative opponents seeking victory (2).

Kelley's (1992) article about peace communication education goes
on to generate a series of metaphors about peace, including peace as
healthy and robust (medical metaphor); peace growing, thriving (gar-
den metaphor); peace as wisdom and understanding (intelligence
metaphor); peace as an adventure (voyage metaphor). In all cases, she
demonstrates that peace metaphors can be powerful symbolic vehicles
for social change.

All of the women peacemakers in this collection engaged in activ-
ism for social change, although their approaches to peace differed.
Activism against violence and peace activism encompass related,
although not synonymous, symbol systems. Gradations of pacifism

occur within peace movement organizations. Absolute pacifists oppose violence and war under any circumstances and engage in social/political processes to promote cooperation and conflict resolution. In contrast, some peace activists also publicly oppose wars and conflicts and work toward collaborative solutions, but may subscribe to a "just war" discourse, believing that certain military interventions are necessary. Activists who resist violence may focus on one aspect of social violence, such as domestic violence, rather than on war, although many see relationships among all forms of violence. Even as the boundaries among these peacemaking concepts overlap, feminism also encompasses a variety of viewpoints.

DEFINING FEMINISM

Feminism, like peace, includes multiple definitions and discourses. Not all of the activists in this collection would have defined themselves as feminists. Nevertheless, researchers may examine their work using feminist rhetorical analysis. In this book, we have adopted a definition of feminism that is consistent with definitions of feminist rhetorical analysis. Wood (1999) states:

> I define feminism as an active commitment to equality and respect for life. For me, this includes respecting all people, as well as nonhuman forms of life and the earth itself. Simply put, my feminism means I am against oppression. . . . I don't accept oppression and domination as worthy human values. I believe there are better, more and enriching ways to live, and I am convinced we can be part of bringing these alternatives into existence. (6)

According to Foss (1989), feminist rhetorical criticism examines oppressive rhetorical methods and content, with focus on the status quo and changes. This form of rhetorical criticism often studies oppression based on gender, but may include analysis of race, ethnicity, disability, age, and socioeconomic status as well, particularly as these issues impact gender.

The definition of feminism adopted for this collection advocates the humanistic empowerment of individuals; it is concerned with human oppression in all of its incarnations. As characterized in this volume, feminism seeks to liberate through rhetorical transformation, and it may encompass individual, social, national, or international forums. According to this definition, feminism empowers the oppressed, be they women victimized by power-abusing patriarchies, persons of

color tyrannized by political systems, or men embroiled in incessant interethnic or international war. The goal of women's peace talk is, ultimately, the "making" of peace.

Carroll (1987) discusses the logical linkages between feminism and pacifism in her article about their historical and theoretical connections: "(1) first, and most widely recognized, is an argument based on the interconnections among *patriarchy*, domination, and war; (2) second, also fairly widespread, is an argument based on shared concern with the elimination of *violence* in both 'private' and 'public' spheres" (19).

As Forcey (1995) notes, women's issues and peace issues dovetail in shared assumptions about social change. She states, "Both, in sum, insist on the possibility of social transformation through political action" (9). In addition, this author observes that the educational process itself constitutes one aspect of social change and that peace studies and women's studies often use innovative pedagogy to facilitate student learning. It is our hope that this collection will provide a substantive tool to promote understanding of the peaceful changes that individuals and groups can undertake. The common thread binding these essays is that each chapter involves a woman whose talk was rhetorically structured to produce a transformation of an oppressive situation. Therefore, each woman in this collection centered her efforts on peace, which might mean a safe place to sleep, a transient cessation of war, or a nuclear-free world. To investigate peacemaking efforts, the authors of each chapter embrace a methodology that answers the following questions.

Methodology

1. What was the problem that the rhetoric's discourse had to manage? What was the discursive goal of her peacemaking effort?
2. What did she do and how did she do it? What is the discursive evidence (the texts) that supports the analysis and where did it originate?
3. What were the outcomes of her "peace talk"? Why did these results occur? What are the implications of the findings?

FEMINIST THEORY AND PEACE

Sylvester (1995) describes three story lines that she believes feminist literature tells about peace: the story of the "mother," the "warrior," and the mythic narrator. Sylvester states:

Story one goes like this: Women are more peaceable people than men, as a central tendency, because their lived experiences with mothering . . . impart concern to preserve rather than to ravish and destroy life. . . . Story two: Women might be more peaceable than men, but at times both must carry AK-47s in national liberation. . . . The third story line demolishes the story and the line: War and peace are of a piece, woven into a majestic narrative of myth and memories. (138)

Reardon's work (1996) represents Sylvester's first story line. Essentially, Reardon feels that the peace movement needs to work toward the transformation of social violence that underlies U.S. militarism by changing cultural symbols as well as behavior. In her view, women speak for peace through distinctively female symbolic choices. Some feminist rhetorical theorists, especially standpoint theorists, hypothesize that women's experiences of gender provide distinctive viewpoints about issues. Across different time and languages, women talk of mothering and peacemaking together. Reardon suggests that many problems stem from patriarchal systems, based on negative male discourses that value hierarchy, coercion, and fear. The remedy incorporates discourses that value cooperation and caring, along with new logics that include insights from personal experience, reference to relationships and significant human life events.

Other feminist theorists (Campbell 1983; Gilligan 1982; Ruddick 1989; Stearney 1994; Tonn 1996) have explored the relationship of feminine images in peace movements and other social movement organizations. The evolution of metaphorical images, such as "the mother," in feminist thinking has redefined the image away from a patriarchal emphasis on motherhood as a reproductive capacity. Feminist theory provides for mothering within the framework of alternative family structures, as well as having been mothered, and looks to women's experience rather than the patriarchal motherhood image (Stearney 1994, 149–50). Hallstein's (1999) ethic of care evokes an even more diverse image useful to peacemakers and to those who study them.

Some feminist theorists make the point that caring, an ethic including but not limited to mothering, can be separated from the image of motherhood (Stearney 1994; Tonn 1996; Hallstein 1999). They describe the potential for caring to create independence (Campbell 1983; Tonn 1996). According to Tonn, caring allows women to sharpen their own skills and mentor those who have had less practice in social/political action. Social movement organizations and individuals within movements may use these powerful images in unreflective or counterpro-

ductive ways, or, conversely, they can evoke the images to their advantage (Stearney 1994).

Hallstein (1999), in her article on the image of "caring," states, "I suggest that a fully elaborated view of feminist standpoint theories provides a basis for a feminist ethics that both respects diversity and values care . . . that offers some possibility for diverse people, who have interpretive capabilities and intentionality, to deliberate together across their differences, make choices, and be held accountable for those choices" (32). Early (1995) states that the study of women and peace incorporates the history of gender meanings. She says that feminist historians, rather than attributing oppression to linguistic determinism, "remain committed to the assumption that individuals and groups can actively resist oppressive forces and shape their worlds in creative ways" (24). Both Hallstein's and Early's work support the idea that people can transcend limiting symbolic (language and behavior) environments that attempt to circumscribe gender or gender-appropriate behavior, especially concerning social change.

Feminist peace theory, then, exposes the workings of gender in patriarchy, militarism, and violence, as well as in the processes of peacemaking. Analysis of symbolic behavior deals not only with the rhetorical choices that characterize the systems of oppression and the activist voice, but also with the effects that these choices produce. Foss (1989) describes the rationale and procedures for feminist rhetorical criticism. Foss helps rhetorical critics judge the effectiveness of women peacemakers' performances. Adopting Foss's feminist perspective, women's peacemaking efforts are effective to the extent that the audience understands more about gender and its place in the peace and conflict discourse. Further, the efforts are effective to the degree that the peacemaking activities improve women's lives.

As this book demonstrates, women came to peace issues in various ways, depending upon their lived experiences. Particular peacemaking approaches and effects varied, not only because of the socioeconomic, racial, and gender norms each faced, but also depending upon the violent forces that each of them confronted. For example, African American antiviolence activist Ida B. Wells protested lynching in the southern United States, middle-class white activist Jeanette Rankin spoke out for suffrage and used her U.S. congressional vote against both world wars, and Jane Addams struggled at Hull House for social justice and spoke out for world peace. Maria Pearson (Running Moccasin) spoke to achieve reconciliation between Native Americans and whites and to stop desecration of burial sites during the same years

that Mary Lou Kownacki led Pax Christi and sought inner-city peace by establishing shelters and care facilities. Australian Helen Caldicott and Betty Bumpers of the United States, both middle-class, white, well-educated women, took very different approaches to try to end nuclear proliferation in the 1980s. During the same time period, Sis Levin mediated in the Mideast toward the release of her husband, taken hostage in Lebanon. In the 1990s Ruth Perry served war-torn Liberia as an interim leader in order to allow time for interethnic factions to negotiate, while on the other side of the world, Aung San Suu Kyi used nonviolent speech and writing to advocate democracy in long-troubled Burma (Myanmar).

HISTORICAL BACKGROUND
OF WOMEN AND PEACE

1890s to 1918: Women Organize Before and During World War I

During the twentieth century, women have maintained strong voices about nonviolence both in peace movement organizations and as activist individuals. Early (1986) states that North American peace organizations had existed throughout the nineteenth century, primarily among religious organizations, with women as members, although men dominated the organizations. Ongoing reform work brought women into separatist associations, providing new platforms for women's writing and speaking (43). By the turn of the century, despite controversies stirred by the notion of "separate spheres," women participated more actively than ever before in public policy debate. Women worked toward universal suffrage, social justice, and peace. "In a little over a decade, between 1901 and 1914, forty-five associations devoted to the cause of peace were founded in North America" (Early 1986, 44). By 1915, women began several separatist peace organizations that would continue to play significant roles in peacemaking.

U.S. activist women's opposition to international war led to the formation of the American Union Against Militarism (later to become the American Civil Liberties Union) and the Women's Peace Party (WPP). Early (1986) states that the 1915 preamble to the WPP constitution, by Anna Garlin Spencer, established the connections between women's rights and peace, as well as set the tone for later peace communication.

Early (1986) quotes Spencer, *"Therefore, as human beings and the mother half of humanity, we demand that . . . women be given a share in deciding between war and peace"* (45).

Internationally, women from twelve countries met at The Hague in 1915 to try to end the world conflict and later established themselves as the Women's International League for Peace and Freedom (WILPF). Women's activist groups often worked with multiple purposes, and this occasionally led to divisions within and between groups, although many women easily tolerated the varying viewpoints represented in mixes of peace concerns with other social reform. Reformers often found it unrealistic to separate seeking peace from suffrage, basic women's rights, and other social justice issues such as poverty, violence, and militarism.

Internal divisions were not the only problems that peace activists faced. External critics, especially during official wartimes, accused peacemakers of disloyalty. Peace communication and movement activity during World War I diminished, but did not disappear. Kennedy (1999) states that in the United States those who continued their activities were likely to incur severe governmental sanctions based on their activities, and women peace activists faced charges of "unnatural" womanly behavior.

1919–1945: Peace Women in the Interwar Years and World War II

Between the wars, peace organizations evidenced several themes concerned with making connections among peace-related issues and among various peacemaking individuals and groups. A few women's peace organizations attempted to reach across racial, religious, and class lines, especially in the 1920s. Even well-meaning predominantly white feminist peace organizations had difficulty overcoming racial barriers. According to Blackwell-Johnson (1998), in the U.S. WILPF, African American women persevered and brought about a more diverse and important discussion of peace and freedom. Early (1986) describes the interwar (during the years 1919 to 1935) activities of the WILPF, which showed "an increasing concern with the connections between peace, fundamental human rights, and economic development" (47).

In the 1920s "Red Scare," officials reacted to women's reform efforts. These taunts toward pacifists continued in one form or another for the rest of the century. Alonso (1993) describes the years leading

up to World War II this way: "As the 1930s faded, it became painfully clear that neither the vote nor all their lobbying efforts had resulted in a permanent peace. The ten years from 1935 through 1945 proved to be so difficult for the movement that by the end of it, only one of the four original suffrage peace organizations, WILPF, would still be intact" (125).

Adams (1991) depicts the WILPF during World War II; with half the U.S. membership lost, the remainder supported conscientious objectors and tried to relieve war effects. In Europe, various WILPF branches performed courageous nonviolent acts, including Resistance activity, Jewish refugee assistance, and peace education. WILPF President Balch asserted that all peace groups, as well as the international community, shared moral responsibility for failing to provide a viable alternative to war (215–16).

1946–1965: Antinuclear and Nonviolent National Liberation

After World War II, international peace efforts slowly began to form around nuclear issues and peace/social justice movements in colonial countries. Following the development and use of the atom bomb in World War II and continued weapons testing, peace organizations began to advocate armament limitations. In Japan, for example, "Hibakusha," Hiroshima and Nagasaki's atomic warfare victims turned peace activists, inspired a renewed nonviolent tradition. Another stream of nonviolent activism, encouraged by Gandhi's example in India, sought peaceful means for national liberation and social justice in Asia, Africa, South America, and the Pacific (Young 1986, 199–201). Socialist thought often influenced quests for peace and social justice.

Perhaps because of historic ties with international groups, U.S. peace activists faced a major threat—McCarthyism—during the years following World War II. As the nuclear age and Cold War nuclear arms race gathered momentum, Joseph McCarthy's Red Scare targeted dissenters of all types. The paranoia grew into the House Committee on Un-American Activities (HUAC) hearings, with investigations of "disloyal" individuals and organizations. Guilt by association and harassment of peace activists caused even more problems and discouragement.

Reemergence of widespread women's activism of the late twentieth century was heralded both internationally and in North America by

women in the "ban the bomb" protests. Swerdlow (1993) estimates
that fifty thousand women joined the U.S. Women's Strike for Peace.
Extended international actions led to the elimination of atmospheric
nuclear tests through the 1963 Partial Test-Ban Treaty. Swerdlow
(1991) asserts that the 1962 confrontation between Women's Strike for
Peace (WSP) and the House Committee on Un-American Activities
over supposed Communist infiltration of the peace movement
resulted in a fatal blow to HUAC. She reports, "Women led the way
by taking a more courageous and principled stand in opposition to
Cold War ideology and political repression than that of their male
counterparts" (464).

In Europe and Asia, nuclear concerns continued to create a new
type of peace organization, altered by the global threat of nuclear
weapons (Young 1986, 200–201). International coalitions also began to
form in protest of U.S. Southeast Asia policy. In the United States both
WSP and the WILPF soon moved from dealing with HUAC and the
Test-Ban Treaty success to a prolonged effort to end U.S. Vietnam
involvement.

1966–2000: Citizens Influence Nation States and Disarmament

Alonso (1993) and Young (1986) describe this reemergence of wide-
spread political activism as the 1960s moved along. They believe that
the quest for racial and international justice, building sentiment
against the nuclear arms race, and efforts to end the Vietnam War
involved more international and transnational activism, women, and
people of color in social change endeavors. Among people of color,
change energy often centered upon nonviolent approaches to race
relations and civil rights within and across racial identification. For
example, in the United States the civil rights movement that began to
protest African American/white segregation also manifested itself in
the American Indian Movement (AIM), as well as civil rights activism
in the Hispanic community. During this same time, women's issues
again came to attention, in part because of activists' experiences
within the civil rights and peace organizations (Alonso 1993, 193).

Alonso (1993) finds historical precedent for the evolution of "sec-
ond wave" feminism in the Vietnam era peace movement. She asserts
that, although the suffragists' feminism-pacifism link remained clear
in the early part of the century, the sheer magnitude of violence in the
World War II era displaced expressions of the feminist connection to

peace work. During Vietnam, the links again became evident, both to peace movement participants themselves and to the public through women peacemakers' rhetorical choices. The reawakening of feminist consciousness during the civil rights and antiwar movements took place when women felt that male leaders consistently overlooked women's concerns and viewpoints.

Swerdlow (1993) explains the appeal and the transformation of the "protective mother" image in WSP during the emergence of "women's liberation." Their work through the 1960s and early 1970s within the peace movement had expanded women's self-definitions and competencies. Swerdlow (1993) puts it this way, "The image of the good mother [changed] from passive to militant, from silent to eloquent, from private to public" (242).

Women around the world experienced similar transitions in their work with peace movement organizations. Theorists state that development of strategies that empowered women stood as one hallmark of women's participation. Another commonality of women's participation was the development of new forms and models of peacemaking. For example, peace camps (Greenham Common), peace education, citizen diplomacy, and transnational marches arose as innovative solutions (Boulding 1995; Sheridan 1988; and Young 1986).

When the U.S. troops finally withdrew from Vietnam in 1973, women continued to organize around a number of global issues, making links between oppression of all sorts and violence. As Alonso (1993) suggests, the United Nations Decade for Women (1975–1985) provided opportunities for women throughout the world to come together to discuss and act. These interactions expanded U.S. women peace activists' acknowledgment of issues beyond a white, middle-class, first world viewpoint and simultaneously reworked definitions of peace and feminism (227–28). Feminists did not universally embrace a "natural" connection between women and peace. Carroll (1987) says that some felt that feminists, especially women living under violent and oppressive regimes, should join in revolutionary military endeavors (14). Others simply disclaimed peace work as a diversion that took women's energy away from feminist efforts (Carroll 1987, 5).

Nonetheless, women's continued peace efforts during the Decade for Women "concentrated on the global implications of the nuclear arms race" (Alonso 1993, 229). The theme, taken up by a variety of peace movement organizations, demonstrated how money spent on nuclear arsenals could be better spent. As the Cold War arms race

heated up during the 1980s, women's peace groups once again led, as people from all walks of life focused their efforts on a "nuclear freeze." Lofland (1993) calls the nuclear peace movement surge the fourth mobilization of the century (the first was pre–World War I, the second during the interwar years, and the third, the Vietnam protests; 10). Lofland (1993) estimates that U.S. peace movement organizations numbered around ten thousand at the high point of the Nuclear Freeze surge and that the number fell to around seven thousand by the end of the decade (136). He estimates that around ten million people in the mid-1980s attended events or financially supported peace organizations (139).

The pervasiveness of such activism around the globe suggests that the effects on governments may have been more direct than officials might admit. Even as the superpowers rattled missiles, the Cold War was drawing to a close. Among the complex internal and external changes that led to transformation in the Soviet sphere of influence and Russia–U.S. relationships, certainly citizen activism played a part. The peace movement both abroad and within the United States brought an era of domestic political pressure to bear on the arms-race-as-usual. Peacemakers persisted in communicating the dangers and economic costs of old policy. During the last years of the waning century, U.S. women's peace movement organizations and individuals often redirected their efforts to urban violence or international peace efforts.

WOMEN WHO SPEAK FOR PEACE
AND PEACE SCHOLARSHIP

This book makes a unique contribution to scholarship in that it documents the voices of ten influential women and uses rhetorical analysis to uncover their impact. Although a number of fine books have chronicled history of women in the peace movement, this book stands alone in focusing on in-depth examination of women peacemakers' public discourse. We present well-known and less well-known twentieth century women of peace. As an added asset, articles include materials never reported before, for example, interview and first-person accounts (Pearson and Levin) or examination of artifacts from recent collections (University of Arkansas Peace Links Collection).

The final chapters in this volume are still being lived. Peace workers stay focused on long-term peace efforts as well as local conflicts, work-

ing to bring international negotiation pressure and to alleviate suffering during crises. Feminists have kept public scrutiny on war's effects for women and families, for example, during "ethnic cleansing" in the Balkans and Africa. The variety of women peacemakers in *Women Who Speak for Peace* brings different voices to the scholarly realm. We have attempted to keep the accounts of their deeds. If not recorded and analyzed now, they might be lost. This book has provided a singular opportunity to give women peacemakers voice in the scholarly tradition. We have been honored to study their peace communication.

REFERENCES

Adams, Judith Porter. 1991. *Peacework: Oral Histories of Women Peace Activists*. Boston: Twayne Publishers.

Alonso, Harriet Hyman. 1993. *Peace as a Women's Issue: A History of the U.S. Movement for World Peace and Women's Rights*. Syracuse, N.Y.: Syracuse University Press.

Blackwell-Johnson, Joyce. 1998. African American Activists in the Women's International League for Peace and Freedom, 1920s–1950s. *Peace & Change* 23, no. 4 (October): 466–82.

Boulding, Elise. 1995. Feminist Inventions in the Art of Peacemaking. *Peace & Change* 20, no. 4 (October): 408–38.

Campbell, Karlyn Kohrs. 1983. Femininity and Feminism: To Be or Not to Be a Woman. *Communication Quarterly* 31: 101–8.

Carroll, Bernice A. 1987. Feminism and Pacifism: Historical and Theoretical Connections. In *Women and Peace: Theoretical, Historical and Practical Perspectives*, edited by Ruth R. Pierson, 2–24. Beckenham, Kent, England: Croom Helm.

Chatfield, Charles. 1993. *The American Peace Movement: Ideals and Activism*. New York: Twayne Publishers.

Cook, B. W. 1991. Female Support Networks and Political Activism. In *Women's America: Refocusing the Past*. 3d ed., edited by Linda K. Kerber and Jane Sherron DeHart, 306–25. New York: Oxford University Press.

Cortwright, David. 1993. *Peace Works: The Citizen's Role in Ending the Cold War*. Boulder, Colo.: Westview.

Cox, G. 1986. *The Ways of Peace: A Philosophy of Peace as Action*. Mahwah, N.J.: Paulist.

Early, Frances H. 1986. The Historic Roots of the Women's Peace Movement in North America. *Canadian Women's Studies* 7, no. 4 (winter): 43–48.

———. 1995. New Historical Perspectives on Gendered Peace Studies. *Women's Studies Quarterly* 23, no. 3 & 4 (fall): 23–31.

———. 1997. *World Without War: U.S. Feminists and Pacifists Resisted World War I*. Syracuse, N.Y.: Syracuse University Press.

Forcey, Linda Rennie. 1995. Women's Studies, Peace Studies, and the Difference Debate. *Women's Studies Quarterly* 23, no. 3 & 4 (fall): 9–14.

Foss, Karen A., Sonja K. Foss, and Cindy Griffin. 1999. *Feminist Rhetorical Theories*. Thousand Oaks, Calif.: Sage.

Foss, Sonja K. 1989. Feminist Criticism. In *Rhetorical Criticism—Exploration and Practice*, edited by Joseph A. Devito and Robert E. Denton, Jr., 151–60. Prospect Heights, Ill.: Waveland.

Gilligan, Carol. 1982. *In a Different Voice: Psychological Theory and Women's Development*. Cambridge, Mass.: Harvard University Press.

Hallstein, D. Lynn O'Brien. 1999. A Postmodern Caring: Feminist Standpoint Theories, Revisioned Caring, and Communication Ethics. *Western Journal of Communication* 63, no.1: 32–56.

Harris, Adrienne, and Ynestra King, eds. 1989. *Rocking the Ship of State: Toward Feminist Peace Politics*. Boulder, Colo.: Westview.

Hogan, Michael J., ed. 1992. *The End of the Cold War: Its Meaning and Implications*. New York: Cambridge University Press.

Hurwitz, E. F. 1977. The International Sisterhood. In *Becoming Visible*, edited by Renate Bridenthal and Claudia Koonz, 325–45. Boston: Houghton Mifflin.

Kelley, Colleen. 1992. Beyond Peace as "Not War": The Search for a Transcendent Metaphor. *Journal for Peace and Justice Studies* 4: 54–69.

Keltner, Sam. 1987. Peace Communication: Scope and Dimensions. Paper presented at the annual meeting of the Speech Communication Association, November, Boston.

Kennedy, Kathleen. 1999. *Disloyal Mothers and Scurrilous Citizens: Women and Subversion during World War I*. Bloomington: Indiana University Press.

Lofland, John. 1993. *Polite Protestors: The American Peace Movement of the 1980s*. Syracuse, N.Y.: Syracuse University Press.

Mechling, E. W., and G. Auletta. 1986. Beyond War: A Socio-Rhetorical Analysis of a New Class Revitalization Movement. *Western Journal of Speech Communication* 50: 388–404.

Nagler, M. 1984. Redefining Peace. *Bulletin of Atomic Scientists* (November): 36–38.

Pierson, Ruth Roach, ed. 1987. *Women and Peace: Theoretical, Historical and Practical Perspectives*. New York: Croom Helm.

Reardon, Betty A. 1996. *Sexism and the War System*. Syracuse, N.Y.: Syracuse University Press.

Ruddick, Sara. 1989. *Maternal Thinking*. Boston: Beacon.

Salomon, Kim. 1986. The Peace Movement—An Anti-Establishment Movement. *Journal of Peace Research* 2: 115–27.

Schott, L. 1997. *Reconstructing Women's Thoughts: The Women's International League for Peace and Freedom Before World War II*. Stanford, Calif.: Stanford University Press.

Sheridan, Diana. 1988. Empowering a Minority Voice: Strategies of Norwegian Peacemaking Women. Paper presented at the annual meeting of the Western States Communication Association, February, San Diego, Calif.

Small, M., and W. D. Hoover, eds. 1992. *Give Peace a Chance: Exploring the Vietnam Antiwar Movement*. Syracuse, N.Y.: Syracuse University Press.

Smoke, R., and W. Harman. 1987. *Paths to Peace: Exploring the Feasibility of Sustainable Peace*. Boulder, Colo.: Westview.

Stearney, Lynn M. 1994. Feminism, Ecofeminism, and the Maternal Archetype: Motherhood as a Feminine Universal. *Communication Quarterly* 42, no. 2: 145–59.

Stewart, C. J., C. A. Smith, and R. E. Denton, Jr. 1989. *Persuasion and Social Movements*. 2d ed. Prospect Heights, Ill.: Waveland.

Swerdlow, Amy. 1991. Ladies' Day at the Capitol: Women Strike for Peace Versus HUAC. In *Women's America: Refocusing the Past*. 3d ed., edited by Linda K. Kerber and Jane Sherron DeHart, 463–79. New York: Oxford University Press.

———. 1993. *Women Strike for Peace: Traditional Motherhood and Radical Politics in the 1960s*. Chicago: University of Chicago Press.

Sylvester, Christine. 1995. Riding the Hyphens of Feminism, Peace, and Place in Four- (or More) Part Cacophony. *Women's Studies Quarterly* 3 & 4: 136–46.

Tonn, Mari B. 1996. Militant Motherhood: Labor's Mary Harris "Mother" Jones. *The Quarterly Journal of Speech* 82, no.1: 1–21.

Warren Karen J., and Duane L. Cady, eds. 1996. *Bringing Peace Home: Feminism, Violence, and Nature*. Indianapolis: Indiana University Press.

Wehr, P. 1986. Nuclear Pacifism as Collective Action. *Journal of Peace Research* 2: 103–13.

Wood, Julia. 1999. *Gendered Lives: Communication, Gender, and Culture*. 3d ed. Belmont, Calif.: Wadsworth.

Young, Nigel. 1986. The Peace Movement: A Comparative and Analytic Survey. *Alternative* IX: 185–217.

Chapter 1

Ida B. Wells's Campaign for Peace and Freedom

Kathleen Kennedy

That chivalry which is "most sensitive concerning the honor of women" can hope for little respect from the civilized world, when it confines itself entirely to the women who happen to be white. Virtue knows no color line, and the chivalry which depends upon complexion of skin and texture of hair can command no honest respect.

—Ida B. Wells, *A Red Record*

In March 1892, Thomas Moss and two other men were lynched in Memphis, Tennessee. The events that led to their lynching are not exactly clear. Moss was on the board of directors of the People's Grocery, a community-owned grocery store that competed with a white-owned business. Apparently, after a series of fights between blacks and whites that began over a child's game of marbles, the owner of the white store convinced nervous Memphis officials that the People's Grocery was the locus of an African American conspiracy. When law enforcement agents entered the store to arrest its founders, guards in the back fired their weapons, unaware that the plain-clothed men were police. Unsure of who had fired the shots, law enforcement officials arrested Moss and other leaders of the People's Grocery. A few days later, a white mob broke into the jail, drove Moss and his friends to the edge of town, and shot them.[1]

On the surface, this lynching was like the hundreds of lynchings of African American people that occurred in the 1880s and 1890s. Yet this particular lynching galvanized antilynching forces and propelled Ida B. Wells to national leadership. Wells, the owner and editor of Memphis's African American newspaper, *The Free Speech*, and a close friend of Moss, was outraged by the lynching. When city officials refused to

condemn or investigate Moss's lynching, Wells told Memphis's African American community to take matters into their own hands. "There is therefore only one thing left that we can do; save our money and leave a town which will neither protect our lives and property, nor give us a fair trial in the courts, but takes us out and murders us in cold blood when accused by white persons"(Wells 1970). Wells's angry call for African American people to leave the city of Memphis struck at the heart of the conflict that had led to Thomas Moss's lynching—the continuing property interest that whites claimed in African American people.

Wells's own exile from Memphis was less voluntary. For months after Moss's lynching, Wells used her newspaper to criticize lynchings. In May, a white mob struck the final blow against Wells by destroying her press after she published what is her most famous editorial. In that unsigned editorial, Wells challenged the underlying myth that legitimized lynchings—that African American men raped white women. "Nobody in this section of the country believes that old threadbare lie that Negro men rape white women," Wells wrote, "if Southern men are not careful, they will overreach themselves and public sentiment will have a reaction; a conclusion will then be reached which will be very damaging to the moral reputation of their women" (Wells 1991b, 14). Few words could have been more explosive as witnessed by the response of the white Memphis press. "The fact that a black scoundrel is allowed to live and utter such loathsome and repulsive calumnies is a volume of evidence as to the wonderful patience of Southern whites," wrote one editor. A second editor exclaimed that "if the Negroes themselves do not apply the remedy without delay it will be the duty of those whom he has attacked to tie the wretch who utters these calamities to a stake . . . brand him in the forehead with a hot iron and perform upon him a surgical operation with a pair of tailor shears" (Wells 1991b, 17).

Wells's editorial and the response it engendered exposed the underlying ideologies behind lynchings. On the one hand, they demonstrate the extremes to which white southerners would go to protect their property interests in both African American people and in their own racialized gender identities. Their responses to Wells's editorial claimed the right to literally strip African American men of their manhood should they transgress race and gender boundaries. They underscore the invisibility of African American women in the lynching equation, as they assume that the author of the antilynching editorial in question was male.[2] Yet African American women provided crucial

voices to the debate over lynchings because their writings exposed the relationships between racial violence and constructions of gender in American society. This exposure challenged the gender and racial boundaries that were critical to white southerners' constructions of themselves and their moral order. Specifically, by implicating white women's complicity in sexual liaisons with African American men, Wells struck at the heart of this racialized gender system that attributed to white women an essential moral purity and to white men the right to violently defend that purity. Wells's contribution to peace history is both her exposure of the political and economic motives behind lynchings and her dissection of how middle-class gender conventions reinforced racialized violence.

Wells's actions in the months following Moss's lynching were the beginning of an antilynching crusade that would ultimately mark her as the premier race woman of her era. Wells's campaign was part of and helped define the first African American civil rights movement in U.S. history. After the Civil War, African Americans reconstructed communities and families devastated by slavery. For a brief period, the federal government actively guaranteed African Americans equal citizenship for the first time in U.S. history. The Reconstruction Amendments made citizenship rights the purview of the federal government and federal agencies, such as the Freedman's Bureau, and aided former slaves by providing them education and implementing policies designed to protect African American men's patriarchal role in the family.[3] But the gains of Reconstruction were short lived. When the federal government withdrew its support for Reconstruction and its troops from the South, Democratic redeemers reimposed white supremacy in the South. African American people resisted redemption through political and economic means; the central role women played in this resistance is just now being studied by historians.[4]

Although lynchings had a long history in the United States, lynchers did not specifically target African American men until after the Civil War. Most historians agree that the causes of lynching were rooted in the racial politics of the post-Reconstruction South and were part of a program to disenfranchise African American men.[5] As Wells demonstrated, the number of African American people lynched increased as federal protection of African American men's political and economic rights waned. Yet, the numbers alone do not tell the full story of lynchings. These lynchings were violent rituals designed to mark the limits of gender sameness among men and to restore to white men and women property in African American people's labor

and bodies. It was within their violent and often pornographic rituals that lynchings conveyed specifically racialized and gendered messages (Harris 1984; Wiegman 1995).

Even before her antilynching campaign, Wells's life reflected this ongoing struggle between African American people and southern redeemers. Wells was born in Holly Springs, Mississippi, a few months before the Emancipation Proclamation was issued. In 1878, after her parents died in a yellow fever epidemic, Wells left Rust College to begin a teaching career. Two years later she accepted her aunt's invitation to move to Memphis. There, she acquired a better teaching position and became involved in the social and political life of the African American community. In 1884, Wells gained national attention when she sued the Chesapeake, Ohio, and Southwestern Railroad for forcing her to move from the first-class car to a "colored" car. Wells initially won her suit, but the Tennessee Supreme Court overturned the decision. Disillusioned with the American legal system's ability to redress racism, Wells began her career in journalism. In 1889, she became the co-owner of the *Free Speech* and *Headlight*. Two years later, Wells was fired from her teaching job after writing an editorial criticizing the school board for its lack of support of African American schools. Over the next twenty years, Wells dissected the causes of racial violence by exposing the political and economic causes of lynching.[6]

Today, Ida B. Wells-Barnett is one of the few turn-of-the-century African American women that historians and literary critics have studied extensively. Her writings are now assigned reading for undergraduates, and feminist theorists credit her as one of the originators of African American feminist thought. Yet, to include Wells within a tradition of women peacemakers requires a rethinking of what has been customarily understood as feminist peace history and theory. As applied to this particular period in American history, feminist peace history has focused on the development of the women's peace movement and its primarily white middle-class leadership. Coming from an intellectual tradition grounded in both progressive social values and late nineteenth century gender roles, most of these activists argued that women's roles as mothers or potential mothers gave them insights into politics that men lacked. Motherhood, peace activists contended, required women to develop particular social skills such as empathy, relational thinking, and negotiation that could counter the adversarial power politics that characterized international relations.[7] Even today, this argument remains at the root of much of feminist the-

orizing that critiques war as an extension of patriarchal relationships that reinforce a construction of citizenship based on manly sacrifice in war.[8]

It is not clear that this particular feminist peace theory is relevant to or accounts for the conditions of women of color. For example, the maternalism that has formed the foundation for much feminist peace theorizing and activity is constructed primary through the experiences of white middle-class heterosexual women. How might that peace theorizing account for the violence that permeated the lives of slave women such as Margaret Garner (Weisenburger 1998) or the poor working-class women in Dorothy Allison's (1988) stories? Race and class violence saturates the lives of many poor mothers and mothers of color whose mothering does not escape but rather works in a dialectic relationship with that violence.

Women peacemakers' feminist critiques of war have exposed the intimate relationship between war making and conservative gender roles. Although the process of war making may increase some public opportunities for women, that same process ultimately reconfirms definitions of citizenship that marginalize women.[9] But as we begin to consider the role of race in this process, the temptation has been to simply add African American women's experiences to the equation; that is, to suggest that while the gains of war were harder for women of color to achieve, like white women, they gained more public roles because of the war. There is much less discussion on the complex relationships between race, gender, and American war making, in particular, and violence, in general.[10] Wells's work sought to begin this discussion.

To find the peace work of women of color and working-class women, we must expand our subject beyond traditional peace organizations and maternalist assumptions. That is not to say that women of color did not join traditional peace organizations. But as Joyce Blackwell-Johnson (1998) has argued, when African American women, for example, joined white-dominated peace organizations, they often pursued different agendas than did white women. Taking the Women's International League for Peace and Freedom (WILPF) as her example, Blackwell-Johnson examines the reasons why African American women joined the organization and their reception by the white majority. Blackwell-Johnson argues that African American women such as Mary Terrell saw the WILPF as a potential antilynching organization because of its commitment to nonviolence. She concludes that while African American women played an important role in such

peace organizations, their presence as well as their efforts to get peace organizations to expand their definitions of war and peace sparked controversy and division. For this reason, most of African American women's work for peace and freedom took place outside the women's peace movement.

As Evelyn Higginbotham (1989) argued in her call for more historical work on African American women, the inclusion of black women enables a theorizing that recognizes the interrelationships between race, gender, and sexuality. When seen in this light, studying African American peacemakers is not additive but can fundamentally change how peace and violence are understood. Contained within African American women's work for peace and freedom are sophisticated theories about race, gender, oppression, and power because they exposed the intimate connections between violence, race, gender, and sexuality. If we, as peace theorists and activists, listen to their words, we will uncover a rich narrative that can facilitate contemporary theorizing about the roots of violence. Wells's work is central to the history of women's peacemaking in the twentieth century because it exposes how organized political violence was rooted in the nexus between race, gender, and sexuality.

Wells began her antilynching campaign in the pages of *The Free Press* under a pseudonym. It was not until she began writing for the *New York Age* that she identified herself as the author of the controversial editorial that had exiled her from the South. She continued to use the press to relentlessly attack lynching, in general, and Memphis, in particular. Instead of tempering her charges, as some African American leaders suggested, Wells accelerated and added specificity to her charges. In October 1892, Wells began a career as a public speaker, addressing club women in New York and Boston. Later that year, she published *Southern Horrors: Lynch Law in All Its Phases* with five hundred dollars raised by African American women. The next year she published a chapter on lynching in *The Reason Why the Colored American Is Not in the World's Colombian Exposition*. Two years later, she published her most explosive work, *A Red Record*, which more carefully examines interracial relationships. In 1900, she published her third pamphlet, *Mob Rule in New Orleans*. Her autobiography, *A Crusade for Justice: The Autobiography of Ida B. Wells* (1970), was published posthumously by her daughter, Alfreda M. Duster. Taken together, these works outline a woman who evaluated her own life and those of others—white or African American—by their status as race women or

men; that is, people devoted to securing peace and justice for African American people.

Wells understood that her opponents would scrutinize her arguments to capitalize on any misstatement she might make. She wanted her conclusions to be supported by unimpeachable facts and careful logical argumentation. To this end, she used progressive techniques of investigative journalism. She relied on statistics gathered by the *Chicago Tribune* and her own research into press accounts of lynchings to record the number of lynchings and the crimes allegedly committed by those lynched. Her findings did not support the contention that African American men raped white women or that lynchings targeted rapists. The accusation of rape, Wells noted, was only made in about one-third of lynchings. Instead, Wells demonstrated that the common element in most lynchings was that the person lynched (she noted that African American women and children were also lynched) was in economic competition with whites (Wells 1991a, 150–57; Wells 1991b, 28–30). Her statistics underscored the fact that the property interests whites had in African American labor was at stake in lynchings, not the virtue of white womanhood.

For nineteenth century southern white men, lynching provided an extralegal method of protecting the racial and gender identities that they believed the North's project of Reconstruction had recklessly threatened. To such men, African American men's political, economic, and patriarchal rights were an affront to their own manhood. Lynching protected white men's property rights by punishing African American people who claimed property rights in themselves or their own labor. It also reinforced white men's property rights over white women. By participating in lynchings, white women turned their bodies over to white men, who secured their rights to manhood by protecting those bodies' racial purity (and by extension the purity of women's husbands' and fathers' lineages).

Wells understood that the true stories of the lynching narratives were told not only in statistics but also in the pornographic rituals that accompanied lynchings. These rituals marked African American bodies in specifically gendered terms. Castration and other forms of mutilation were designed to reinforce the idea that African American men were not truly men. Such rituals reassured the white community of both its property rights in African American bodies and in its own whiteness. To demonstrate this point, Wells deconstructed lynching rituals as presented in the white press. Her analysis of the gender and racial politics of lynchings detailed the ritualistic violence of lynchings

to demonstrate that their calculated brutality was designed to strip African American people of their property and citizenship rights.[11] But before she could undertake this project, race and gender conventions required that she explain her authorship.

In part because Wells did not shy away from the grisly and sexual component of the lynching narrative, her work engendered a strong response. Wells hoped that her methods would lend credibility to her study, but they did not shield her from attacks on either her message or her person. Both white and African American critics were dismayed by her caustic and unrelenting critiques. In their attempts to discredit her, they charged that personal glory rather than concern for the race motivated her (McMurry 1998). Partly due to these criticisms, Wells took pains to explain her actions in the preface to *Southern Horrors*. She asserted that her reason for publishing her tract was not self-aggrandizement but rather to prove that the "Afro-American race is not a bestial race. . . . It is with no pleasure that I dipped my hands in the corruption here exposed," Wells explained, but "somebody has to show that the Afro-American race is more sinned against than sinning" (Wells 1991b, 14–15).

On its surface, Wells's explanation was similar to others given by female moral reformers in the nineteenth and early twentieth centuries. It was not unusual for nineteenth century women writers to apologize for writing; their modesty confirmed that their words stemmed from the moral authority they acquired from true womanhood. But Wells's words were not modest. Nor did Wells draw upon true womanhood to justify her writings. Unlike middle-class white women, Wells could not use her womanhood as a shield. Because of her race and her message, she lacked access to the modesty and maternalism that protected white women when they critiqued violence and social ills. By "dipping [her] hands into the corruption here exposed," Wells risked staining herself with that corruption. No woman could discuss matters of sexuality without her own sexuality and sexual practices being questioned. For African American women, this dilemma was even more pronounced due to racialist constructions of womanhood.

Racialist constructions of womanhood defined African Americans "as having bestial sexual natures" (Wiegman 1995, 56). Biological racism ascribed this difference between white women and African American women to the unusually large buttocks and genitalia of African women. As Robyn Wiegman (1995) argues, African American women became "the material ground for defining and ascertaining other social positions." In the African American woman, European Ameri-

cans found evidence of African American men's inferiority and white women's "gendered priority" (77). Scientific racism reinforced hierarchies between women, giving white women unique access to the civilizing discourses of morality and maternalism while denying African American women such access by defining them as oversexed and behind white women in their evolutionary development. While middle-class African American women claimed a moral code—propriety—to justify their interventions in politics, unlike white women, they were not automatically granted true womanhood (Higginbotham 1989; Miller 1999, 11). Both racialized discourses of womanhood and the experiences of African American women with violence did not allow the same sexual naïveté for African American women. They had to speak directly about sexuality, violence, and sexual choices in order to protect African American women and to obtain racial equality. But once they spoke about such violence, they conveyed a knowledge about sexuality that implied sexual experience.

One way that African American women accommodated to sexual violence was to develop a "code of silence around intimate matters as a response to discursive and literal attacks on black sexuality" (Mitchell 1999, 436). This "culture of dissemblance" enabled African American women to gain some control over that violence by "protecting their 'inner lives and self' through a selective revelation of the persona that 'created the appearance of disclosure' " (Mitchell 1999, 436).[12] But as Wells and other leaders of the African American women's movement noted, this silence came at a price. In explaining the formation of the African American women's club movement, Josephine St. Pierre Ruffin explained, "Year after year, southern women have protested against the admission of colored women into any organization on the ground of the immorality of our women and because our reputations have only been tried by individual work, the charge has never been crushed"(Jones 1985, 112).

Wells believed that she had to end the silence about sexualized and racialized violence and risk her reputation because this silence served to justify violence against African American people. In lieu of silence or true womanhood, Wells chose truth as her shield. Take, for example, Wells's preface to *Southern Horrors*: "It is a contribution to truth, an array of facts, the perusal of which it is hoped will stimulate this great American Republic to demand that justice be done though the heavens fall" (14). As historian Nell Painter (1996) argues in her biography of Sojourner Truth, the discourse of truth served as a way in which African American women could reconstruct themselves from

the soul-murdering violence of slavery (and Reconstruction). When Isabelle took on the identity of Sojourner Truth, she reconstructed herself from a sexually abused slave woman into an itinerant preacher who reclaimed property in herself and her people's history. While Isabelle found her truth in the word of God, Wells found her truth in more secular methods, but, nonetheless, truth served for Wells as it did for Truth. For Wells, the murder of Thomas Moss and her reading of accounts of lynchings were potentially soul-murdering experiences. While she did not literally embody truth as did Truth, she used truth as both a method and a shield. Wells found legitimacy and self-actualization in a long historic tradition of African American women who authenticated themselves through a pedagogical tradition in which they helped others see their own realities and by articulating fears that kept others silent. By telling the truth directly and simply, Wells hoped to push her audience toward social change (Royster 1995, 172–73).

Wells attacked violence with truth. She believed that violence against African American people continued because the true reasons why African American men (and women and children) were lynched and why African American women were raped were kept hidden through intimidation. According to Wells, the biggest lie told by the lynching narrative was that white women did not seek sexual relationships with African American men. Southerners considered all sexual relationships between African American men and white women to be rape. "The southern white man says that it is impossible for a voluntary alliance to exist between a white woman and a colored man," Wells wrote, "therefore the fact of an alliance is proof of force" (Wells 1991b, 145). On the contrary, Wells asserted that some white women did desire and actively seek out sexual relationships with African American men. "This statement is not a shield for the despoiler of virtue," Wells (1991b) wrote in *Southern Horrors*, "nor altogether a defense of the poor blind Afro-American Sampsons who suffer themselves betrayed by white Delilahs" (14).

By describing African American men as Sampsons and white women as Delilahs, Wells shifted the responsibility for interracial relationships to white women. Her biblical analogy also revealed her outrage over white women's complicity in the lynching scenario. Wells argued that all the evidence she needed to prove that white women willingly entered into sexual relationships with African American men and then lied about those relationship was in the stories told by the white press. Those stories told of some women who acknowledged such relationships and took steps to shield their partners, and

Wells used these stories to demonstrate the possibility of love beyond the color line. But more commonly, Wells asserted, those stories told of white women who accused African American men of rape after their relationships had been discovered, usually because of the birth of a mulatto child. The most damaging of these stories was that of Mrs. Underwood, a prestigious member of the town of Elyria, Ohio, who admitted to lying about her relationship with William Offett because, in her words, "I hoped to save my reputation by telling you a deliberate lie" (Wells 1991b, 21). Wells used this sentence to emphasize two important points: White women lied about their relationships with African American men, and white women's reputations, that is, their claim to true womanhood, were a product of racialized discourse rather than the actions women took.

Wells coupled her critique of the power that white women received from their race with a discussion on how lynching narratives disempowered them vis-à-vis white men. Within lynching narratives, white women traded their property in themselves for protection. While white women lacked property in themselves, ironically they held property in African American people and in their racial identities (Miller 1999, 20). Wells then faced the difficult task of both investing white women in rejecting chivalry and its denial of women's ability to protect themselves and in divesting them of the property they held in white womanhood. It was not white women's virtue that prevented society from spiraling into savagery but rather democratic process, rule of law, and individuals' ownership of self.

Wells's argument that white women sometimes sought relationships with African American men brought her into conflict with Frances Willard, the leader of the Women's Christian Temperance Union. On her trip to England, Wells criticized Willard for comments Willard had made that appeared to support lynchings. Willard responded by defending the reputations of white women who she believed Wells had slandered. At the heart of their disagreement was the fact that Willard held fundamentally different views of womanhood than Wells (Bederman 1995, 66–67). Willard held fast to the belief that white women were incapable of lust and seduction. To Willard, Wells's suggestions amounted to an "imputation upon half the white race in this country that is unjust, and, save in the rarest exceptional instances, wholly without foundation" (Willard, quoted in Wells 1991a, 227). Wells responded by explaining that while she believed that individual white women seduced African American men, she had never suggested that white women as a group desired

or seduced African American men. She did not impugn the reputation of white women, Wells claimed, but merely spoke the truth when "the facts were plain that the relationship between the victim lynched and the alleged victim of his assault was voluntary, clandestine and illicit" (Wells 1991a, 227). Wells acknowledged what Willard could not—that white women were capable of sexual passion and held power in their relationships with African American men.

Underscoring Wells and Willard's dialogue was a fundamental issue of power and privilege. Willard's goal was to protect the reputations and moral purity of white women. This goal was absurd to Wells. "With me," Wells wrote, "it is not myself or my reputation, but the life of my people that is at stake" (Wells 1991a, 222–23). For Wells the issue was responsibility. Part of Willard's race privilege was the fact that all that was at stake in her debate with Wells was her own reputation. It was Willard's ability to turn the issue of lynchings—the murder of African American men and women—into a discussion of the reputations of white women that most enraged Wells. It reinforced her conviction that white women were more interested in protecting the privileges they received from white womanhood than in examining how those constructions of white womanhood might support violence.[13]

As Erica Miller (1999) argues, Wells exposed the contradictions inherent in the lynching narrative to demonstrate that lynchings and miscegenation laws protect property rather than morality. The property protected were the privileges associated with both white womanhood and white manhood. As white southerners used lynching and other means to deny the African American man his political and economic rights, they stripped him of the cultural significance of manhood. For this reason, Wells argued, African American men fought so hard to protect their right to vote: He clung to his right of franchise with a heroism that would have wrung admiration from the hearts of savages. He believed that in that small white ballot here was a subtle something that stood for manhood as well as citizenship, and thousands of brave black men went to their graves, exemplifying the one by dying for the other (Wells 1991a, 143).

Wells sought to reconstruct African American manhood by re-remembering the history that had led to lynchings. She wanted to present a heroic history to counter the narratives of lynching that sought to feminize African American men. Lynching threatened the manhood of African American men not only through a ritual that symbolically and literally castrated them but also by denying them

the tangible rights of manhood. As a mechanism of social control, lynchings prevented African American men from voting and from gaining economic success. Guaranteeing freedmen the vote was an important part of the radical Republicans' agenda because it offered political access to African American men, but it also symbolically conferred upon them the status of manhood. By disenfranchising African American men in the 1890s, white southerners understood that they denied African American men property in their manhood.

Wells recognized that lynching narratives coupled images of African American men with those of African American women. Her writings attacked the "dialectics of the lynch mentality that linked the propriety of black womanhood to that of black manhood" (Logan 1991, 7). Racialist discourses defined African American women as either mammies or as Jezebels. Originally constructed during slavery, these images defined African American women as uniquely suited for domestic work or as nonwomen—women who fell outside of womanhood and who consequently could be exploited by any man. This ideology essentially denied African American women property of self and African American men property in their wives' labor, as white families continued to require African American women's domestic labor and white men demanded African American women's sexual services (Jones 1985; White 1985, 27–61). Under this racialist dialectic, lynchings maintained white men's property in African American men, while rape preserved their property in African American women's bodies.

Wells pointed to the rape of African American women by white men as further evidence that lynching was an expression of white men's power. Wells wrote:

> It is not the purpose of this defense to say one word against the white women of the South. . . . Such need not be said, but it is their misfortune that the chivalrous white man of that section, in order to escape the deserved execration of the civilized world, should shield themselves by their cowardly and infamously false excuse, and call into question that very honor about which their distinguished priestly apologist claims they are most sensitive. To justify their own barbarism they assume a chivalry which they do not possess. True chivalry respects all womanhood, and no one who reads the record, as it is written in the faces of millions of mulattoes in the South, will for a minute conceive that the southern white man had a very chivalrous regard for the honor due the women of his own race or respect for the womanhood of which circumstances placed in his power. That chivalry which is "most sensitive concerning the honor of womanhood" can hope for but little

respect from the civilized world, when it confines itself entirely to the women who happen to be white. Virtue knows no color line, and the chivalry which depends on the complexion of skin and texture of hair can command no honest respect. (Wells 1991a, 147)

Wells used irony to disassemble lynching narratives to reveal the hidden race and gender codes that underlay them (Logan 1991, 6). One of those silent codes enabled white men to rape African American women without sanction. Wells critiques that code by granting white women the virtue that her critics charged her with slighting, but, Wells notes, virtue "knows no color line" (Logan 1991, 6). Wells claims for African American women the virtue that the dialectic of the lynching narrative denied; by doing so, she reverses the racialist discourse of manliness. White men were savages, Wells contends, because they raped African American women.

What Wells granted with one hand she took away with the other. While she begins the passage by claiming no disrespect to white women of the South, the women she grants virtue to were northern white women teachers who went south after the Civil War and African American women—two groups that southern white men denied had virtue. In the case of northern white women, they gained virtue through their service to the race. Likewise, Wells believed that African American women acquired virtue through such service. Again, Wells reinforced the idea that it was through their actions not their race that women acquired propriety (Schecter 1990, 301).[14]

Wells did not argue, as did some leaders of the African American civil rights movement, that the solution to lynchings was the restoration of patriarchal rights for African American men. But Wells did understand the context in which she wrote, and she accepted middle-class values of propriety. She wrote within a culture that did not separate manhood from men's participation in politics and their ability to support and protect their families (Baker 1990, 66–91). Wells expected that African American men would show the virtues of middle-class manhood. These expectations were most apparent when Wells came under attack for her most controversial statements. When attacked, she demanded that African American male editors come to her defense, and when they failed, she questioned their manhood and commitment to the African American community. For example, when African American editors were slow to defend attacks on Wells's reputation, she used her column in the *New York Age* to criticize their behavior. "It would seem," Wells wrote, "that if they cared nothing

for my painful position and feelings, truth, honor and a true regard for race welfare would cause [them] to make a public statement" (Wells, quoted in McMurry 1998, 218). She was even harsher with African American men who contradicted her antilynching statements:

> These Negroes who run when white men tell them to do so, and stand up and let the white man knock them down or kill them if it suits his pleasure are the ones who see no good in "fire-eating" speeches. Such Negroes do nothing to stop lynchings, are too cowardly to do so, and too anxious to preserve a whole skin if they could, but never fail to raise their voices in deprecation of others who are trying to do whatever can be done to stop the infamy of killing Negroes at the rate of one per day. (Wells, quoted in Mc-Murry 1998, 218)

Wells did not take criticism well and often responded to her critics viciously. And Wells's caustic personality and her militancy brought calls from moderate African American leaders for her to temper her remarks. But Wells's comments reveal more than her undying faith in the righteousness of her cause, they also demonstrate her expectations for race men. She expected that race men would act with honor and protect the reputations of African American women. To Wells, manliness was intimately connected to African American men's service to the African American community.

CONCLUSION

This chapter has argued that the significance of Wells's work is how its exposure of the interrelationships between race, gender, and sexuality in the lynching narrative complicates our understanding of feminist peace history and theory. The very constructions of womanhood that white middle-class women claimed gave them a unique stake in peacemaking, Wells argued, buttressed violence against African American people. Like other African American women, Wells looked to white women to rethink their stake in those constructions of womanhood to change the discourse that gave white women access to moral purity at the expense of the bodies of women of color. This dichotomy, Wells argued, enabled violence against men and women of color and prohibited "respectable" women from challenging that violence.

The metaphors that Wells chose to represent her life were not drawn from images of peace but rather from those of war. She depicted her

life as a crusade and placed herself within a tradition forged by Joan of Arc, a Christian soldier who led her people against an invading force—for Wells, one that included an army of redeemer historians determined to destroy African Americans' legacy of democratic self-government.[15] Her crusade fused black nationalism and feminism into a sophisticated critique of how race and gender underpinned a violent political system that denied African American people property in themselves. In doing so, she participated in the creation of a race-centered self-conscious womanhood that gained moral authority through action rather than inherent racial virtues (Braxton 1989, 103–12). This development and African Americans' struggle against racialized violence, Wells argued, were the central redeeming moments in an otherwise violent and undemocratic chapter in the nation's history.

NOTES

1. For descriptions of the events leading to Moss's lynching, see Linda McMurry (1998) and Ida B. Wells (1970).

2. For information on African American women and lynching, see Bettina Aptheker (1982).

3. The best study of Reconstruction is Eric Foner (1988).

4. See, for example, Elsa Barkley Brown (1994); Hazel Carby (1984); Paula Giddings (1984); Glenda Gilmore (1996); and Evelyn Brooks Higginbotham (1992) and (1993).

5. The literature on lynching is extensive. See, for example, W. Fitzhugh Brundage (1993) and (1990); Jacquelyn Dowd Hall (1979); Stewart E. Tolnay and E. M. Beck (1992); Christopher Waldrep (1999); and Robyn Wiegman (1995).

6. In addition to her antilynching campaign, Wells helped found some of the most important civil rights organizations in American history. Attacks against her were instrumental in the formation of the National Association of Colored Women. Wells was also present at the organizing meeting of the National Association of Colored People. McMurry (1998); Jacqueline Jones Royster (1997, 1–41, 209–12); and Wells (1970).

7. See for example, Mary Louise Degen (1972 [1942]); Kathleen Kennedy (1995); and Barbara Steinson (1981). For a review of the literature on this subject, see Frances Early (1995).

8. See for example, Jean Bethke Elshtain (1987) and Sara Ruddick (1999). For a critical engagement of maternal peace politics, see Micaela Di Leonardo (1985).

9. See for example, Miriam Cooke and Angela Woollacott (1993); Helen M. Cooper (1989); and Margaret Randolph Higonnet (1985).

10. Cook's anthology does discuss race in the context of the American wars with developing nations and the American policy in the Middle East. For other

anthologies that integrate race into gendered studies of war, see Amy Kaplan and Donald Pease (1993); Billie Melman (1998); and T. Enean Sharpley-Whiting (1997).

11. For examinations of Wells's gendered critique, see Carby (1984); Simone W. Davis (1995); McMurry (1998); Miller (1999, xi–45); Royster (1995, 167–84); and Patricia A. Schechter (1990).

12. The idea of the "culture of dissemblance" was introduced in Darlene Clark Hine (1989).

13. During the Progressive era, white women did participate in antilynching work. As Frances Early argues, Tracy Mygatt wrote the first antilynching play by a white woman, and some women's groups took antilynching stands. See Early's upcoming work in *Women's History Review*.

14. Schechter argues that Wells's work bridged the public-private divide that connected rape to lynchings. Schechter compares Wells's work to that of Anna Julia Cooper. Schechter contends that, like Wells, Cooper identified the continued sexual exploitation and rape of African American women as obstacles to black progress. But Cooper's solution emphasized greater family intervention and the extension of community protection to fallen women. Unlike Wells, Cooper did not use the word *rape*. As Schechter notes, Cooper's solution emphasized the family and kept the crime of rape in the private domain: "The dominant culture understood lynching as something men did to other men in public—it was publicized aggressively and its victims made a spectacle. Rape, by contrast, was coded 'private'—it happened to women often in private or domestic spaces." Wells's work bridged this divide as she "connected the 'private' crime of rape to the 'public' crime of lynching." This refusal by Wells to recognize Victorian divisions between the public and the private spaces showed intricate connections between constructions of sexuality and gender and racialized political power.

15. For a discussion of these metaphors, see Braxton (1989, 93–98) and Akiko Ochiai (1992).

REFERENCES

Allison, Dorothy. 1988. *Trash*. Boston: Alyson Press.

Aptheker, Bettina. 1982. *Woman's Legacy: Essays on Race, Sex, and Class in American History*. Amherst: University of Massachusetts Press.

Baker, Paula. 1990. The Domestication of Politics: Women and American Political Society, 1780–1920. In *Unequal Sisters: A Multicultural Reader in U.S. Women's History*, edited by Ellen Carol Dubois and Vicki Ruiz, 66–91. New York: Routledge.

Bederman, Gail. 1995. *Manliness and Civilization: A Cultural History of Gender and Race in the United States, 1880–1917*. Chicago: University of Chicago Press.

Blackwell-Johnson, Joyce. 1998. "Now We Got Another Chance to Do Something for 'Em": African American Activists in the Women's International League for Peace and Freedom, 1920s–1950s. *Peace and Change* 23 (September): 466–82.

Braxton, Joanne M. 1989. *Black Women Writing Autobiography: A Tradition within a Tradition*. Philadelphia: Temple University Press.

Brown, Elsa Barkley. 1994. Negotiating and Transforming the Public Sphere: African American Political Life in the Transition from Slavery to Freedom. *Public Culture* 7 (fall): 1–40.

Brundage, W. Fitzhugh. 1993. *Lynching in the New South: Georgia and Virginia, 1880–1930.* Urbana: University of Illinois Press.

———, ed. 1990. *Under the Sentence of Death: Lynching in the South.* Chapel Hill: University of North Carolina Press.

Carby, Hazel. 1984. *Reconstructing Womanhood: The Emergence of the Afro-American Woman Novelist.* New York: Oxford University Press.

Cooke, Miriam, and Angela Woollacott, eds. 1993. *Gendering War Talk.* Princeton, N.J.: Princeton University Press.

Cooper, Helen M., ed. 1989. *Arms and the Woman: War, Gender, and Literary Representation.* Chapel Hill: University of North Carolina Press.

Davis, Simone W. 1995. The "Weak Race" and the Winchester Political Voices in the Pamphlets of Ida B. Wells-Barnett. *Legacy* 12, no. 2: 77–97.

Degen, Mary Louise. 1972 [1942]. *The History of the Women's Peace Movement.* New York: Garland.

Di Leonardo, Micaela. 1985. Morals, Mothers, and Militarism: Antimilitarism and Feminist Theory. *Feminist Studies* 11 (fall): 598–617.

Early, Frances. 1995. New Historical Perspectives on Gendered Peace Studies. *Women's Studies Quarterly* 23, nos. 3 and 4 (fall–winter): 95–115.

Elshtain, Jean Bethke. 1987. *Women and War.* Chicago: University of Chicago Press.

Foner, Eric. 1988. *Reconstruction: America's Unfinished Revolution, 1863–1877.* New York: Harper and Row.

Giddings, Paula. 1984. *When and Where I Enter: The Impact of Black Women on Race and Sex in America.* New York: Bantam.

Gilmore, Glenda. 1996. *Gender and Jim Crow: Women and the Politics of White Supremacy in North Carolina, 1896–1920.* Chapel Hill: University of North Carolina Press.

Hall, Jacquelyn Dowd. 1979. *Revolt against Chivalry: Jessie Daniel Amers and the Women's Campaign against Lynching.* New York: Columbia University Press.

Harris, Trudier. 1984. *Exorcizing Blackness: Historical and Literary Lynching and Burning Rituals.* Bloomington: University of Indiana Press.

Higginbotham, Evelyn Brooks. 1989. Beyond the Sound of Silence: Afro-American Women in History. *Gender and History* 1: 50–67.

———. 1992. African-American Women's History and the Metalanguage of Race. *Signs* 17: 251–74.

———. 1993. *Righteous Discontent: The Women's Movement in the Black Baptist Church, 1880–1920.* Cambridge, Mass.: Harvard University Press.

Higonnet, Margaret Randolph, ed. 1985. *Behind the Lines: Gender and the Two World Wars.* New Haven, Conn.: Yale University Press.

Hine, Darlene Clark. 1989. Rape and the Inner Lives of Black Women in the Middle West: Preliminary Thoughts on the Culture of Dissemblance. *Signs* 14: 912–20.

Jones, Jacqueline. 1985. *Labor of Love, Labor of Sorrow: Black Women, Work, and the Family from Slavery to the Present.* New York: Basic.

Kaplan, Amy, and Donald Pease, eds. 1993. *Cultures of United Imperialism.* Durham, N.C.: Duke University Press.

Kennedy, Kathleen. 1995. Declaring War on War: Gender and American Socialist Attack on Militarism, 1914–1918. *Journal of Women's History* 7, no. 2 (summer): 27–51;

Logan, Shirley W. 1991. Rhetorical Strategies in Ida B. Wells's "Southern Horrors": Lynch Law in All Its Phases. *Sage* VIII, no. 1 (summer): 7.

McMurry, Linda. 1998. *To Keep the Waters Troubled: The Life of Ida B. Wells.* New York: Oxford University Press.

Melman, Billie, ed. 1998. *Borderlines: Genders and Identities in War and Peace, 1870–1930.* New York: Routledge.

Miller, Erica M. 1999. *The Other Reconstruction: Where Violence and Womanhood Meet in the Writings of Ida B. Wells, Angelina Weld Crimke, and Nella Larsen.* New York: Garland.

Mitchell, Michele. 1999. Silences Broken, Silences Kept: Gender and Sexuality in African-American History. *Gender and History* 11, no. 3 (November): 436.

Ochiai, Akiko. 1992. Ida B. Wells and Her Crusade for Justice: An African American Woman's Testimonial Autobiography. *Soundings* 74, no. 2 and 3 (summer/fall): 365–81.

Painter, Nell Irvin. 1996. *Sojourner Truth: A Life, A Symbol.* New York: Norton.

Royster, Jacqueline Jones. 1995. To Call a Thing by Its True Name: The Rhetoric of Ida B. Wells. In *Reclaiming Rhetoric: Women in the Rhetorical Tradition,* edited by Andrea A. Lunsford, 167–84. Pittsburgh: University of Pittsburgh Press.

———, ed. 1997. *Southern Horrors and Other Writings: The Anti-Lynching Campaign of Ida B. Wells, 1892–1900.* Boston: Bedford Books.

Ruddick, Sara. 1999. *Maternal Thinking: Toward a Politics of Peace.* New York: Ballantine.

Schechter, Patricia A. 1990. Unsettled Business: Ida B. Wells against Lynching, or How Antilynching Got Its Gender. In *Under the Sentence of Death: Lynching in the South,* edited by W. Fitzhugh Brundage, 292–317. Chapel Hill: University of North Carolina Press.

Sharpley-Whiting, T. Enean, ed. 1997. *Spoils of War: Women of Color, Cultures, and Revolutions.* Lanham, Md.: Rowman & Littlefield.

Steinson, Barbara. 1981. *American Women's Activism in World War I.* New York: Garland.

Tolnay, Stewart E., and E. M. Beck. 1992. *A Festival of Violence: An Analysis of Southern Lynchings, 1882–1930.* Urbana: University of Illinois Press.

Waldrep, Christopher. 1999. Word and Deed: The Language of Lynching, 1820–1953. In *Lethal Imagination: Violence and Brutality in American History,* edited by Michael A. Bellesiles. New York: New York University Press.

Wells, Ida B. 1970. *A Crusade for Justice: The Autobiography of Ida B. Wells,* edited by Alfreda M. Duster. Chicago: University of Chicago Press.

———. 1991a. A Red Record. In *Selected Works of Ida B. Wells-Barnett,* edited by Trudier Harris, 150–57. New York: Oxford University Press.

———. 1991b. Southern Horrors: Lynch Law in All Its Phases. In *Selected Writings of Ida B. Wells-Barnett,* edited by Trudier Harris, 14–45. New York: Oxford University Press.

Weisenburger, Steven. 1998. *Modern Medea: A Family Story of Slavery and Child-Murder from the Old South*. New York: Hill and Wang.

Wiegman, Robyn. 1995. *American Anatomies: Theorizing Race and Gender*. Durham, N.C.: Duke University Press.

White, Deborah Grey. 1985. *Ar'n't I a Woman? Female Slaves in the Plantation South*. New York: Norton.

Chapter 2

Jane Addams: Peace Activist, Intellectual, and Nobel Prize Winner

Edith E. LeFebvre

> We heard everywhere that this war was an old man's war that the young men who were dying, the young men who were doing the fighting, were not the men who wanted the war, and were not the men who believed in the war. . . . Somewhere in the high places of society, the elderly people, the middle-aged people, had established themselves and had convinced themselves that this was a righteous war.
>
> —Jane Addams, 1915

Historically, those controlling the public agenda and information availability have supported the patriarchal status quo. Feminist theorists have facilitated our appreciation of past events by recognizing and legitimizing perspectives initially lost as the patriarchal lens dominated our understanding of history (Harding 1991; O'Brien Hallstein 1999; Shepler and Mattina 1999; Woods 1992).

O'Brien Hallstein (1999) describes a distinct standpoint from which social subordinates relate to all experiences, often at odds with a patriarchal perspective. She supports this standpoint through a revisioned ethic of care described as a moderate postmodern critical perspective: "caring originated and emerges from power relationships that position those with less power to care for or be attentive to those with higher status and power" (39). Subordinate attentiveness generates a unique and valid perspective of events by recognizing knowledge from the whole of human experience, broadening the base of epistemology (O'Brien Hallstein 1999).

The influence of extraordinary women on society has often been ignored. As women expressed different ways of knowing, social constraints limited their voices. This chapter describes the experience of

37

Jane Addams, the first American woman to receive the Nobel Prize for Peace. The treatment of Addams exemplifies the experience of women of her day. We consider the effects of constraints on Addams as she reframed social reality by deconstructing powerful cultural myths at the core of the American patriarchal system. Addams was a phenomenal woman who worked tirelessly as a pacifist and social justice advocate to better American society. There are several fine treatises that cover the professional and personal life of Jane Addams.[1] This chapter offers a brief synopsis of Addams before an analysis of her pivotal public act, the Carnegie Hall speech, the media and public response, and, finally, Addams's response.

JANE ADDAMS

Jane Addams, born in 1860 in Illinois, experienced the effects of the industrial revolution on women's opportunities (Opfell 1986). Addams graduated from Rockford Women's Seminary in 1881. In her private and academic writings, Addams revealed herself to be an idealist (Addams Notebooks). Once graduated, Addams spent time traveling abroad. Addams visited the Toynbee Hall experiment in London, where university men resided, socialized, and recreated along with the poor. Addams appreciated their pragmatic and involved approach to social reform. Upon return from England, Addams, with her friend Ellen Starr, took over a large run-down residence in a West Side Chicago neighborhood in 1889. The women refurbished the dwelling, took residence, and christened it Hull House, the first settlement house opened to assist the poor in America. The concept was contemporary, particularly because it was taken on by two independent women. However, Addams and Starr were not a threat to patriarchal social order as caring, feeding, and educating the poor were noble pursuits for affluent single college-educated women. As a social experiment, Hull House was a success and emulated by others (Addams 1910).

American papers referred to Addams as "The Genius of Hull House," "The Only Saint America has produced," and "Chicago's First Citizen." Addams was often the focus of pulp popularity contests such as "Who is the best woman in Chicago?" In 1908 the *Ladies Home Journal* embraced Addams as the "First American Woman." Her popularity grew as a lecturer and writer, and organizations sought her participation. By the early 1900s, Jane Addams was one of the

most famous and respected women in America. She published eleven books and 150 essays and reports between 1907 and 1916. Her practical approach to philanthropy, business, and reform worked well within the American free enterprise system. She epitomized women's role outside the home as her political involvement was directed toward social reform for the poor (Davis 1973, 199–200).

Between 1904 and 1935, Addams received honorary degrees from fifteen universities. Addams held an array of leadership positions in various political and social organizations. However, Addams's public persona was irrevocably altered following her Carnegie Hall speech (Davis 1973). In that speech, Addams did something unthinkable, and without intentional malice: she questioned sacred American myths— the myth of the soldier, the myth of nationalism, and the myth of patriarchy (Shepler and Mattina 1999).

This analysis of Addams's fall from grace starts with an examination of her Carnegie Hall speech. The Carnegie Hall speech is important as Addams publicly articulated her perspective of the causes and effects of war. Through a content analysis of the speech and examination of topic frequency, we gain further understanding about what Addams perceived as important. The distinct points Addams made can be grouped into nine topic categories (see table 2.1).

CARNEGIE HALL SPEECH

Addams's Carnegie Hall speech delivered July 15, 1915, summarized her Women's International League for Peace and Freedom (WILPF) Netherlands conference experience. She chaired this international

Table 2.1 Carnegie Hall: Topic Categories of Main Points

Topic Categories	Frequency
The Hague conference and delegation	9
Commonalties between warring nations	8
Young adults' response	4
Alternative approaches	4
Pacifists' response	3
Postwar effects	3
War experiences	3
Support for war	2
Women's response	2

conference of women from the warring countries interested in ending World War I. In July 1915, the United States was not yet involved in fighting the war. The WILPF conference received little attention in the U.S. press. Conference attendees delineated a list of resolutions to secure peace. Two delegate groups were formed. Addams led one WILPF delegate group to deliver the conference resolutions to leaders of both the warring and neutral countries of Europe (Kittredge 1988). The resolutions called for the establishment of a permanent international court and conference, the inclusion of women on an international and national level, and an agreement that no territory would be transferred without the consent of the indigenous people involved.

Addams described her delegate experience.[2] She had no intention to incite her audience, as she clearly stipulated in the opening of her speech:

> It is difficult to formulate your experience when brought face to face with so much genuine emotion and high patriotism. . . . And you do not come back—at least I do not—from these various warring countries with any desire to let loose any more emotion upon the world . . . you do not know where words may lead the people to whom you are speaking. They seem to have acquired such a fearful significance and seem to have power over the very issues of life and death itself.

Her opening remarks were, unfortunately, prophetic.

In category one, conference and delegates, statements described the activities of the WILPF conference. Addams stated, "On the last day of that conference it was suggested that the resolutions be carried by committees to the various governments of Europe, and to the President of the United States." Addams's group was received by the ministers of foreign affairs, chancellors, prime ministers, and members of Parliament. Over a five-week period, the delegates met with nine governments.

Addams did not exaggerate the delegates' effect: "Please do not think we are overestimating a very slight achievement or taking too seriously the kindness with which we were received abroad." Her motivation was to have people recognize the horror of combat and to generate support for alternatives. Addams described the officials' interaction with the delegates as courteous. She noted officials may have agreed they preferred to substitute negotiations for "sacrificing the young men" of their countries because of the direct approach taken by the delegates' discussions. The delegates were pragmatic. The official responses received defined the dominant social reality,

which associated cooperation with weakness, a perceived feminine attribute unacceptable under the circumstances.

Category two, commonalities between warring nations, identified perceptions she found the warring nations shared. For example, "the same causes and reasons for the war were heard everywhere. Each warring nation solemnly assured you it is fighting under the impulse of self-defense"; and

> The men said—again in very similar phrases—that a nation at war cannot make negotiations . . . cannot even express willingness to receive negotiations, for if it does either, the enemy will at once construe it as a symptom of weakness. However, each warring nation assured the delegates that if a neutral nation interceded to mediate, "there is none of the warring nations that would not be glad to receive such service." Now that came to us unequivocally.

Addams found each country united in war; however, the populace was divided into "two general lines of approach. One finds expression in the military . . . the other, a civil party, which very much deprecates this exaltation of militarism." She found citizens from each side who felt "that the longer the war goes on the more the military power is breaking down all the safeguards of civil life and of civil government." People voiced concern over military control and how that military power would be contained after the war.

A poignant statement summarizing Addams's findings was included in commonalities between warring nations, as she explained: "We didn't talk peace as we went about . . . isn't it hideous that whole nations find the word peace intolerable?" Paradoxically, the delegates found that "the people say they do not want this war, they say that the governments are making the war. And the governments say they do not want this war." Addams attempted to report the perplexity she found inherent in war. However, she failed to recognize that powerful Americans would also find the word *peace* intolerable.

Category three, young adults' response, greatly affected the media response to Addams's speech:

> We heard everywhere that this war was an old man's war that the young men who were dying, the young men who were doing the fighting, were not the men who wanted the war, and were not the men who believed in the war. . . . Somewhere in the high places of society, the elderly people, the middle-aged people, had established themselves and had convinced themselves that this was a righteous war.

Addams quoted an article written by a young man in *Cambridge Magazine*: "The greatest trial that this war has brought is that it has released the old men from all restraining influences, and let them loose upon the world." Addams found a generation gap for the support of war. She referred to a conversation she had with "one of the leading men of Europe," who argued that war would have been impossible if postponed ten or twenty years "because of the tremendous revolt against it in the schools and the universities."

Within category four, alternative approaches, Addams advocated an international tribunal of "men who would not placate the claims of one government and set them over against the claims of another. . . . Now that does not seem an impossible thing." The proposed tribunal would regulate international disagreements and oversee an international legal system, the purpose of which would be to negotiate disputes and supplant combat. Addams identified international bodies currently operating for science, the postal system, commerce, and finance as support that international collaboration was possible. Her approach was pragmatic; however, her ideas were lost.

The pacifists' response and postwar effects categories addressed the delegates' acknowledgment of a limited view of the war's effect. The nature of their mission naturally brought them into contact with pacifists in each nation. Addams stated that many supported a resolution beyond military means and felt frustrated and disenfranchised by their governments. Dissenters recognized press censorship: "in the warring countries nothing goes into the press except those things which the military censors deem fit and proper. As a result, those not supporting a military solution were not able to express their opinions publicly, so that like minded individuals . . . would not become aware that they did not stand alone."

Addams described the inevitability of war's ending, "the fanatical feeling which is so high in every country . . . can-not last." She noted that at war's ended, after the dead were counted and the horrors of war were realized, the warring nations may inquire of the neutral nations, "What was the matter with the rest of the world that you kept quiet while this horrible thing was happening, and our men for a moment had lost their senses in this fanaticism . . . you wavered until we lost the flower of the youth of all Europe." Addams implied an image of warring nations as spinning out of control, "and what it needs, it seems to me, and to many of us, is a certain touch of human nature." *Human nature* referred to the power of human reasoning and forgiveness. A tribunal would serve to apply a "touch of human

nature," which was later described by the media as an idealistic, pacifist, and woman's approach. Addams's subordinate gender position negated the merit of her proposal, negated her standpoint. Addams described the effects of war as blurring the line between humane and inhumane action. Addams was relating her unique standpoint as a woman to a society based on a patriarchal view and unwilling to entertain her insight as valid. Addams's comments inherently challenged the myth of nationalism and patriarchy, which became the underlying issues of media and public contention.

While describing the war experience, Addams relayed firsthand experiences of young people fighting the war: "We learned that there are surprising numbers of young men and old men who will not do any shooting because they think that no one has the right to command them to do that thing." She stated that there "are thousands in the trenches" that felt strongly about their national position and fought with valor. Addams had no idea that her public image would be affected gravely as she shared the reality she had witnessed:

> We heard in all countries similar statements in regard to the necessity for the use of stimulants before men would engage in bayonet charges—that they have a regular formula in Germany, that they give them rum in England and absinthe in France, that they all have to give them the "dope" before the bayonet charge is possible.

Addams attempted to describe the terror of the battlefield. She claimed society ignored the horrors of war as many civilians perceived battlefield action as glorious and heroic. Unfortunately, the comment on the soldiers' use of stimulants was sensationalized by the press, and the summer following her speech brought a torrent of media attacks (Kittredge 1988). The effects made Addams lose her privileged spot in the hearts of Americans. Linn (1935) reported that Addams later stated, "It did not occur to me that the information was either new or startling"(314). Kittredge (1988) described Addams as having "the deepest respect and sympathy for the young soldiers who were fighting and dying in Europe. But what she said was true; many armies distributed wine or whiskey to soldiers to raise their spirits before battle"(86). Addams's decline in popularity carried a momentum lasting fifteen years (Linn 1935).

Shepler and Mattina (1999) describe the myth of the soldier: "Soldiers are noble, honorable, self-sacrificing, courageous, disciplined, and obedient" (159). Collectively, soldiers represent all men. The myth of the soldier is extended to society's patriarchal order and

nationalism at its best. Addams contradicted those powerful cultural myths.

Category eight, support for war, included another comment that may have contributed significantly to the media's attack of Addams: "The most shocking impression" of her experience was that "in the various countries the temper necessary for continuing the war is worked up and fed largely by the things which have occurred in the war itself." She compared the war to a boys' club fight perpetuated by revenge:

> Let us say that there are two groups of boys in a boys' club. . . . If one says, "We did this because the other fellows did" you will simply have to say, "I won't go into the rights and wrongs of this, but this thing must stop, because it leads nowhere and gets nowhere." . . . I submit that something of the same sort is happening in Europe now.

Addams deviated from an implicit rule—the need to characterize men in war as mature, rational, and courageous; soldiers are surrogates for a nation. Addams articulated her witnessed reality from her standpoint.

Addams described feelings of women she interviewed whose loved ones fought and women active in nursing and support services, categorized here as women's response. Women expressed hopelessness and despair over their inability to affect the destructive forces overtaking Europe. Addams shared the women's standpoint and felt strongly that resolution would be forthcoming if men from neutral countries experienced in international concerns took the lead to negotiate between disputing nations.

MEDIA AND PUBLIC RESPONSE

Accusations directed at Addams included both questioning her facts as presented and, more distressing to her, attacks on the quality of her character and intentions. According to Ryan (1982), the rhetorical acts of accusation and apology are to be considered as a speech set for critical analysis. Rhetorical examples from media accusation and Addams's apologia are included in the following sections.

Following the Carnegie Hall speech, the headlines in the *New York Times* read, "Troops Drink-Crazed, says Miss Addams" (Davis 1973, 226). Richard Harding Davis (1915), a respected writer and war correspondent, harshly criticized Addams:

In this war the French or English soldier who has been killed in a bayonet charge gave his life to protect his home and country. . . . Through winters in the trenches he has endured shells, disease, snow and ice . . . separated from his wife, children, friends. . . . When the order to charge came it was for them he gave his life. . . . Miss Addams denies him the credit of his sacrifice. She strips him of honor and courage. She tells his children, "Your father did not die for France, or for England, or for you; he died because he was drunk."

Davis's (1915) comments were clearly related to the romantic view Americans shared about war. Davis also failed to recognize the common experiences and sacrifices shared by soldiers on both sides. Retired from the military, Davis responded defensively. Davis resented her allegation that the war "released the old men from all restraining influences, and has let them loose upon the world." Addams's comparison of war to a fight in a boys' club was an unfortunate metaphor implying war was linked to male immaturity. Davis's response may have been affected by what was implied about men in general and patriarchal wisdom (Davis 1915). Many critics framed Addams's perspective as inherently inferior based on her subordinate gender position.

Addams was not prepared for the extent of the fallout. Her critics came from all walks of life. The personally resentful and mean-spirited letters continued into the 1920s. Kittredge (1988) listed several examples of such attacks. "One newspaper called Addams 'a silly, vain, impertinent old maid, who may have done good charity work at Hull House, Chicago, but is now meddling in affairs far beyond her capacity.'. . . The *Louisville Courier* called her 'a foolish, garrulous [overtalkative] woman'" (86–87). These attacks usually centered on unflattering gender portrayals. Newspaper articles, editorials, and speeches vilified her involvement working for peace, women's suffrage, and other political issues. Davis reported that in Detroit, Michigan, Addams's speech was delayed forty-five minutes by hecklers. These outbursts became typical of her speaking experience throughout the country. The attacks on Addams were personal and gender-based because her statements gave rise to individual and national indignation that defended the patriarchal cultural myths necessary to support war.

Once America entered World War I, the attacks on Addams intensified. The images of war Addams had presented had to be rejected by the American public. Cognitive dissonance dictates the perception of those fighting a war, and those whose loved ones are in the fight. In those cases, even though people may recognize and acknowledge the

futility of war, their behavior, beliefs, and values are necessarily tied to supporting war because personal sacrifice and patriotic, bellicose rhetoric govern their perceptions (LeFebvre 1995). Dissonance theory argues that once people support a cause that brings about personal pain and loss, they must justify their support by continuing to believe their actions are righteous. The momentum of war fever is not confinable by a divergent individual's pleas for sanity or a "touch of human nature," as Addams soon discovered.

According to Davis (1973), Addams symbolized those disloyal to America. However, Addams felt a strong need to be useful; her personality was such that being idle was not a possibility. Shunning ridicule and bad press in 1918, she worked for Hoover's Department of Food Administration lecturing to women on domestic efforts needed during the war. She redirected her activities, and public opinion seemed to soften, as long as she engaged in work deemed appropriate for a woman and unthreatening to patriarchal order.

Although her North American support diminished, she was elected international president of the WILPF at Zurich in 1919 and served until she retired in 1929. The Zurich meeting was set to correspond with the Paris peace talks. The membership included prominent women from Europe and America. The WILPF sent resolutions to Paris to influence the terms of the peace treaty. The WILPF delineated specific peace terms but they were ignored. The WILPF expressed regret for the misguided Peace Treaty of Versailles. The treaty created a sense of animosity throughout Europe and eventually contributed to World War II (Opfell 1986). Unfortunately, a standpoint of forgiveness and reconciliation did not direct the treaty (Linn 1935).

In the 1920s, Addams received negative press again. America became obsessed with a Communist conspiracy. Addams had championed the importance of freedom of speech and worked in the United States and internationally for peace and human rights. Some argued that pacifism was linked to Communism and a threat to American democracy. Politicians looking to make a name for themselves boarded the loyalist bandwagon. Senator Clayton Lusk from New York encouraged the state legislature to conduct an investigation of suspicious groups. The result came to be known as the Lusk Report. According to Davis (1973),

The Lusk Report became the Bible of the super-patriots . . . and provided massive documentation for the alleged connections between peace organizations, women's groups, and all those who advocated social welfare, with

socialism, Communism, and Bolshevism. . . . Jane Addams' name occurred frequently in the four volumes. (354)

Anyone listed was suspected of national disloyalty. Hull House and those affiliated received denouncement by "super-patriotic" groups. Overwhelmingly, "the veterans organizations, retired Army officers and military societies of all kinds found Addams a convenient symbol to attack" (Davis 1973, 266). Opfell (1986) found Addams described as a dangerous woman with connections to groups such as the American Legion, the Daughters of the American Revolution, and the Ku Klux Klan. Military intelligence had Addams listed as a questionable American.

In the early 1930s, Addams's later years, public mood changed and Addams regained celebrity status (Ryan 1982). Her roller-coaster popularity ride undoubtedly took its toll on her spirit, but not on her determination. Personal attacks left her undaunted.

ADDAMS'S RESPONSE

Apologia is an attempt by an individual to repair his or her reputation through public discourse (Ryan 1982). Addams's apologia occupied the space of years. She revisited the Carnegie Hall speech in her lectures, writings, and personal correspondence, trying to clarify the points she felt were missed or misunderstood. Initially, she was defensive. Her standpoint was publicly suspect, configured as gender hysteria and naïveté. Addams felt an exigency to prove her statements were fact rather than mere opinion. She accepted responsibility for failing to recognize the delicate nature of her statements. In a letter dated July 27, 1915, to Paul Kellogg, editor of the *Survey*, Addams offered the following:

> I have a letter from Alice Hamilton dated July 20th in which she says "We certainly were told that regular rations of rum are served on the English side, and that before a bayonet charge the Germans give a mixture containing sulphuric ether, and the French, absinthe." This was not in reply to a letter from me but in response to Richard Harding Davis, et al. I have been told by a Chicago doctor of the use of this sulphuric ether in coffee, etc. when the soldiers were to be specially stimulated. In time I believe we will get some straight information on the subject.

Hamilton was a WILPF delegate. Addams's efforts were of little damage control value once the press sensationalized select comments.

Addams's three-pronged attack on the military—that it was an old man's war; the immaturity of men (boys' club metaphor); and a questioning of the soldiers' valor (the need for stimulants)—was not made with malicious intent. In a letter to Mr. Sedgwick, editor of *Atlantic Monthly*, Addams wrote:

> Enclosed please find a copy of my Carnegie Hall address. It is full of blunders in phrasing. . . . I quite agree with you that my expression was unfortunate. My protest, however, is that Miss Replied, writing for a responsible magazine, exaggerated even the most yellow of the newspaper reports of a statement used to illustrate the distaste men feel for the more primitive kind of warfare.

Davis (1973) described Agnes Replied as making a career out of writing disparaging articles about Addams.

President Theodore Roosevelt referred to Addams as "poor bleeding Jane" and "one of the shrieking sisterhood," and he dismissed the demands of the WILPF conference because of the participants' "naïveté." Again the attacks focused upon gender stereotypes and reinforced patriarchal dominance. Her differing standpoint was soundly dismissed. Addams was particularly taken aback by Roosevelt's attitude toward her considering her previous support for him during the Progressive Party's run for the presidency. *Harper's Weekly* on July 31, 1915, published, "Women, War and Babies," in which Addams clearly directed her remarks at women: "I head a movement planned to unite womanhood, in all parts of the world, in a great protest against Europe's war." She felt strongly that "women be given a share in deciding between war and peace" and that if women were given voice, war would cease. She also made a case for the WILPF by delineating the international initiatives developed to secure peace and ensure international participation in dispute resolution. Her *Harper* article was void of emotionally laden anecdotes.

In October 1915, in "Peace and the Press," published in *The Independent*, Addams addressed the problems a public figure experiences with the press: "Public opinion must of course depend upon the data which are provided . . . and the power of the press to determine these data gives it ultimate control over the minds of the multitude who read but one type of journal." Addams articulated a defense against the press noting that the news was slanted to support the war effort: "A good patriot of differing opinion finds it almost impossible to reach his fellow countrymen . . . if he succeeds in getting a hearing for his views, exposes himself to the most violent abuse." Her interesting

choice of male-gendered pronouns in self-referential statements probably reflected common usage and status concerns.

In December 1915, *The Independent* published "The Food of War," another Addams apologia artifact, in which the boys' club metaphor was defended through anecdote. Addams explained that while she was a delegate a man in France told her:

> "We hope to be able to squirt petroleum into the German trenches so that everything will easily catch fire." I replied, "That seems very terrible." "Yes," he said, "but think of the poisonous gas and the horrible death of our men who were asphyxiated." Constantly one hears that Germany has done this; the Allies have done that; some tried to do this and we foiled them by doing that.

Addams wrote, "One of the hideous results of war is the inveterate tendency of the 'average' man to fall into the spirit of hot retaliation" (1915e, 430). She was addressing the Carnegie Hall boys' club metaphor by offering testimony to rebut the media claim that it was merely her opinion.

On May 15, 1917, Addams spoke at the City Club of Chicago; the *Club Bulletin* later published her "Patriotism and Pacifists in War Time." She specifically differentiated pacifists from passivism by explaining and justifying the actions of American pacifists during war. This speech, an artifact of apologia and given two years following the Carnegie Hall speech, defended her position in a conciliatory and explanatory tone. Pacifists were characterized as active in securing nonviolent dispute resolution. Standpoint feminist theory would find that pacifism fits within an ethic of care.

During the 1920s' Communist scare, Addams gave a speech in Chicago following mass arrests of aliens. Addams stated, "The cure for the spirit of unrest in this country is conciliation and education—not hysteria. Free speech is the greatest safety valve of our United. States. . . . Let us end this suppression and spirit of intolerance which is making America another autocracy" (Davis 1973, 261). The next day, *Chicago Tribune* headlines stated: "Reds Upheld by Jane Addams as Good Americans" and "Jane Addams Favors Reds." Addams struggled to alter her message to avoid the press distorting it. Regardless of how she tried to express her patriotism by calling for civilized approaches to problems, she felt her message was misinterpreted. The media attributed an image to Addams that she could not relate to. In a letter to the *Tribune*, she attempted to rectify the inaccurate slant placed on her Chicago speech (Davis 1973). The public response over-

whelmingly denounced her as a communist sympathizer and disloyal American. Responses were not just negative, they were mean.

Although Addams was relentlessly assaulted for over a decade, she remained true to her beliefs. She found it difficult to comprehend how hatred, bigotry, and violence could supersede acts of charity, understanding, and kindness. Standpoint theorists would reference her concerns as advocating an ethic of care. Disheartened but not beat, wounded but not defeated, she consistently maintained her integrity.

CONCLUSION

The fortitude of Jane Addams is commendable. Her critics continued a barrage of attacks, denying her standpoint legitimacy due to her gender. Addams advocated support of international dispute resolution that showcased humanity's more rational qualities. Although her critics were often hateful and unforgiving, she manifested her beliefs by advocating civility.

Addams suffered because she voiced a standpoint divergent from the myth of patriarchy. The relentless drive to deny her standpoint failed to silence her. Her apologia did not halt the torrent of character indictments; however, her persistent advocacy for the "human touch" was acknowledged in 1931 when she became the first American woman to be awarded the Nobel Peace Prize. At last, officials recognized her efforts to share a standpoint other than the patriarchal view.

Addams died in Chicago on May 21, 1935, at the age of seventy-five. During her life she exemplified the meaning of pacifism to promote nonviolent solutions to problem situations.

During times of national stress, those advocating alternatives to war, divergent from the majority overwhelmed by propaganda, are targets for professional and personal, often gender-based, character assassination. Socially sanctioned insanity has a prerequisite: All must believe, and those who don't support war must be chastised severely for questioning the insanity of war. This was Addams's crime. What troubled Addams was how emotionality was favored over rationality (LeFebvre 1995). The public was intolerant of Addams's perspective of war. As is most often the case, war was not seen as the emotionally charged and violent response to conflict that it is. Addams urged the government and the public to support rational approaches to problem resolution. However, the press negated her testimony and framed her perspective as an emotional response by virtue of her gender.

Addams's information was rejected as it directly contradicted the government's systematically developed propaganda, which feeds on emotionality. By refusing to legitimize a perspective that refuted the patriarchal view, officials and media denied divergent ways of knowing.

From a moderate feminist standpoint perspective, Addams's rhetorical acts manifested an ethic of care that her unique experience afforded. Foremost, Addams advocated recognizing the futility of war and the cost incurred by the individual, the country, and the world. Addams's challenges of the myth of the soldier, the myth of nationalism, and the myth of patriarchy derived from her alternative standpoint. Addams opposed the dominant patriarchal perspective of her time. Her response provided a model for peace activists and others whose experience of reality opposes the mainstream perspective. Rather than retreat, Addams, true to her nature, took on a decidedly problem orientation and continued to share her opinions through her writings and activities within the United States and abroad. Although it took over two decades before her efforts were recognized as valorous, she demonstrated what she advocated; dissenting views require the messenger to be persistent, maintain rationality, and respond nonviolently.

In concluding this examination of Jane Addams's peace activist efforts, it seems befitting to share what she penned as a young woman filled with idealism and benevolence, about to step into her life: "Nothing is more certain than that improvement in human affairs is wholly the work of uncontented characters."

NOTES

1. See, for example, Allen F. Davis (1973); James Weber Linn (1935); and J. Conway (1969).

2. Jane Addams's quotes in this section are taken from Jane Addams's Carnegie Hall speech and can be found in Jane Addams (1915a).

REFERENCES

Addams, Jane. Notebooks. Box 42, Swarthmore College Peace Collection, Swarthmore, Pa.

———. 1910. *Twenty Years at Hull House.* New York: Macmillan.

————. 1915a. Address delivered at Carnegie Hall, July 9. Stenographic transcription carbon, 1–30.

————. 1915b. Address of Miss Jane Addams, Delivered at Carnegie Hall. *The Christian Work* 9 (July supplement): 145–48.

————. 1915c. Letter to Mr. Sedgwick. *Atlantic Monthly*, November 13.

————. 1915d. Letter to Paul U. Kellogg, July 27. Lillian D. Wald Papers, New York Public Library, New York.

————. 1915e. Peace and the Press. *The Independent*, October, 430–31.

————. 1915f. The Revolt against War. *The Survey*, July 17, 355–59.

————. 1915g. Women, War, and Babies. *Harper's Weekly*, July 31, 101.

————. 1915h. Women, War and Suffrage. *The Survey*, November 6.

————. 1917. Patriotism and Pacifists in War Time. *City Club* [of Chicago] *Bulletin*, June 16, 184–90.

Conway, J. 1969. Jane Addams: An American Heroine. Ph.D. diss., Harvard University.

Davis, Allen F. 1973. *American Heroine*. New York: Oxford University Press.

Davis, Richard. H. 1915. Letter to *New York Times*, July 13.

Harding, S. 1991. *Whose Science? Whose Knowledge? Thinking from Women's Lives*. New York: Cornell University Press.

Kittredge, Mary. 1988. *American Women of Achievement: Jane Addams*. New York: Chelsea House.

LeFebvre, Edith E. 1995. Bellicose Rhetoric: A Model of the Rhetorical Process in Support of War. Paper presented at the 22d Annual Conference of the International Peace Science Society, October, University of Illinois, Champaign.

Linn, James Weber. 1935. *Jane Addams: A Biography*. New York: D. Appleton-Century.

O'Brien Hallstein, D. Lynn. 1999. A Postmodern Caring: Feminist Standpoint Theories, Revisioned Caring, and Communication Ethics. *Western Journal of Communication* 1 (winter): 32–56.

Opfell, Olga S. 1986. *The Lady Laureates: Women Who Have Won the Nobel Prize*. 2d ed. Metuchen, N.J.: Scarecrow.

Ryan, Halford Ross. 1982. Kategoria and Apologia: On Their Rhetorical Criticism as a Speech Set. *Quarterly Journal of Speech* 68, no. 3, 254–61.

Shepler, Sherry R., and Anne F. Mattina. 1999. ''The Revolt against War'': Jane Addams' Rhetorical Challenge to the Patriarchy. *Communication Quarterly* 2 (spring): 151–65.

Woods, Julia. 1992. Gender and Moral Voice: Moving from Women's Nature to Standpoint Epistemology. *Women's Studies in Communication* 15: 1–24.

Chapter 3

Jeanette Rankin: Peace at Any Cost
Victoria Christie

I want to stand by my country, but I cannot vote for war. I vote no.

—Jeanette Rankin, congresswoman from Montana, April 6, 1917

As a woman I cannot go to war, and I refuse to send anyone else.

—Jeanette Rankin, December 8, 1941

The State of Montana has had a crowning disgrace that you have brot 'n us.

—L. Chatterton, "Letters to Jeanette Rankin," December 1941

I gave you my vote in the election that sent you to Washington—but I'm sorry I did so. I understood your vote in 1917 as that would mean an expeditionary force—but now! We must unite and fight the enemy, who is strong and prepared. Please, Miss Rankin, change your policy and do your utmost to give the people of the state of Montana some faith in your judgment. We need you! It may mean the end of our beloved United States if we cannot cope with this powerful enemy.

—Julia A. Gumprecht, "Letters to Jeanette Rankin," December 9, 1941

WHO WAS JEANETTE RANKIN
AND WHAT DID SHE DO?

Jeanette Rankin (1880–1973) secured a place in political history in the fall of 1916 when she became the first woman to serve in the U.S. Congress. She was a native of Montana, a state that granted women the right to vote, or suffrage, in 1914. When Rankin began serving in the 65th Congress, the 19th Amendment, the Anthony Amendment for

national women's suffrage, was still two years from passage. During the 65th Congress, 218 women from 26 states were sent to jail for terms of up to six months for picketing peacefully for woman suffrage (Flexner 1975, 277). Some seventy-two years lapsed between the Seneca Falls Convention, the first women's rights conference that called for voting rights for women, and its passage.

On April 6, 1917, a year in which most women could not vote in the United States, Jeanette Rankin, along with forty-nine other congressmen, voted against the declaration of war with Germany requested by then-President Woodrow Wilson. At the end of that term, she waged an unsuccessful bid for a Senate seat, then worked for world peace and other causes for the next twenty years. Fate granted Rankin her second chance to vote for a momentous, world-changing war. In 1940, as a sixty-year-old woman, she again returned to Congress. On December 8, 1941, President Roosevelt called for a declaration of war against Japan after the Pearl Harbor attack. She was the lone dissenter, this time voting no while 388 congressmen voted yes. "As a woman I cannot go to war, and I refuse to send anybody else," she declared (McGinty 1988, 32).

As she was the first woman to sit in Congress, the popular press celebrated Rankin as a kind of prophetic culmination of what women in public life might accomplish. She experienced international celebrity upon election and, later, humiliation and ignominy when her constituents, goaded by Montana legislators who were bitter over her support of Butte mining strike leaders, barred her entry to a hall for one of her own scheduled speeches (*Wibaux Pioneer* 1918). After registering the sole dissenting vote for entering World War II, she never again ran for public office. Throughout her life, she vacillated between barely sufficient financial resources and poverty and was given to experimental—some would say whimsical—projects with what monies she did have. Her resources went to travel and peace activism.

Some twenty-six years after her 1941 congressional vote, in January 1968, she led a group of hippies, students, and professors, in the Jeanette Rankin Brigade, in a peace march in Washington, D.C., against U.S. involvement in Vietnam (Alonso 1993, 222; Josephson 1974, 182). The Jeanette Rankin Brigade included broad-based support from a wide array of people, including Mrs. Martin Luther King, and while conservative reports estimated that only five thousand people marched, others stated that the number of marchers was closer to ten thousand. At the culmination of the march, Ms. Rankin confronted both the Speaker of the House and Montana's Senator Mike Mans-

field, then the Senate majority leader. When Miss Rankin reached Senator Mansfield's office, he offered her tea. With characteristic gumption, she refused, and the eighty-eight-year-old woman insisted that they talk about peace in Asia and an end to the Vietnam War. She had come to represent what was to her a third-generation speaking for peace, not to have refreshment.

How can one speak for peace when the pressures to go to war are so very great and the rewards, for some, so seductive? Perhaps in peacetime one can carefully consider and weigh one's options. But in the event of an aggressive attack such as that at Pearl Harbor, can one legitimately refuse to defend one's country? This chapter explains that because of her suffrage roots, her aversion to using war to settle differences, and her sensitivity to issues of economic class, Rankin's conscience left her only one choice, to vote no. Her no votes were part of a lifelong and evolving consciousness of how war devastated the home and drained national resources that would be better spent for the benefit of all citizens. The effects of war, she felt, fell more heavily on some citizens than others. In the end, she knew that war leaves no other alternative for the future than building more effective war machines and ever better methods of killing.

SUFFRAGE: AN AWAKENING

Jeanette Rankin's life reflects a specific time, a social group, and a place—all of which were unique. Born in Missoula, Montana, Rankin matured in the atmosphere of women fighting for the right to vote, a movement whose beginnings were inextricably tied to issues of peace (Alonso 1993, 52). She participated in suffrage campaigns in Washington, California, and New York under the auspices of the National Women's Association, undertaking assignments of increasing responsibility.

In 1910, while visiting her home state of Montana for a Christmas holiday break from suffrage work in Washington, she read that legislators were treating suffrage as a farce, a source of comic relief from the serious business facing the state. She requested that the legislature hear her as a representative of the Equal Franchise Society, a group she had hastily formed upon realizing that no organization existed to promote suffrage in Montana. The evening of her speech turned into a kind of minor celebration on the occasion of the first woman to address the Montana legislature, which presented Rankin with a bou-

quet of violets in the spirit of the occasion (*Helena Independent* 1911; Josephson 1974, 29). Rankin led the Montana campaign for suffrage while remaining committed to the national campaign as well.

She participated in the 1913 Washington, D.C., suffrage parade by leading the Montana delegation along with her sister, whom she had persuaded to dress in a Sacagawea costume. When the time came for the national conference of the National Women's Association in Nashville, Tennessee, she sent word that only if suffrage passed in Montana could she attend. On November 3, 1914, the news of the Montana suffrage victory, in a state that was politically unimportant but which gave much needed hope to the suffrage cause, preceded Jeanette Rankin to the convention. She received a tumultuous welcome, standing on the national conference platform as the person who did the most to deliver Montana as the twelfth state for suffrage. With her were peace activist luminaries Jane Addams and Rosika Schwimmer, a Hungarian feminist noted for advocating what were considered daring antiwar tactics (Josephson 1974, 45).

Within three years of this moment, Rankin would be a representative in the U.S. Congress for the first of her two nonconsecutive terms. Within three days of stepping in as the first woman elected to national office of the U.S. Congress, she would be in the minority in voting against entering World War I. She ran for office as a Republican, although political parties never mattered very much to her. Her own platform centered on causes ranging from protecting the health and welfare of children and mothers to labor issues. She was decidedly and vocally antiwar, and she was a staunch feminist.

Suffrage, peace activism, and feminism intertwine. Feminism grew out of suffragism (Donovan 1998, 1–30; Alonso 1989, 5). How might Rankin's suffrage roots have influenced her votes against war? When we ask what connects suffrage and peace activism, we must first examine briefly how the idea that women could vote evolved, and what the social conditions were in which suffrage leaders first called for votes for women. Then we can understand the connections between suffrage and antiwar attitudes and comprehend the challenges Rankin posed to America.

The ideological connection between woman suffrage and war was made early, as woman suffrage first grew out of the movement to abolish slavery. The bondage of human beings necessitates violence, and the treatment of women slaves in particular stirred women. At the time when women began thinking of the plight of all women, there was a firm separation between what was known as the "public"

sphere and the "private," or the "home," sphere. Women, with their destinies tied by social custom to marriage, by biology to child bearing, by religion to silence, and by law to inclusion in a family unit, were not seen as people with natural rights specific to themselves as individuals. Society demanded that they stay within the private, or domestic, sphere (Flexner 1975, 1–77). Women had no civil liberties in that they did not exist as legal entities under what were known as laws of coverture; they could not own property; they did not own their own wages; and they had no rights to their children in a divorce.

We can think of a sphere as a three-dimensional place, a kind of oval bubble, that is constraining and restraining but that also offers protection against the rough elements of the world. The public and private spheres were separate, unbridgeable, and women belonged to the latter, not always by choice, but certainly by social dictate. The public sphere, within which policy decisions were made by powerful rhetors, belonged to men, not to women (Griffin 1996, 211–39). Most women did not expect to escape or to leave behind the private sphere, nor did they want to. In fact, they thought it their particular duty to protect the boundaries within which children were sheltered and to promote the values of the home—peace, tranquility, fairness, justice, and the humane treatment of people. Suffragists sought, instead, an enlarged responsibility wherein their abilities could be applied usefully to citizenship as would be appropriate to the public sphere. As DuBois (1998) writes, "Although suffragists accepted the peculiarly feminine character of the private sphere, their demand for the vote challenged the male monopoly of the public arena" (34). The radical nature of women voting stems from just this point.

In Rankin's first major speech, given to the Montana legislature on the need for suffrage for women, she prompted women to take full responsibility. She said, "The American woman must be bound to American obligations not through her husband's citizenship, but through her own, directly. And her dignity will not be revealed until she is freed to serve humanity as a separate and distinct individuality" (*Helena Independent* 1911). Rankin ardently believed that the public sphere needed the presence of women and that if women ignored their citizenship duties the democracy might fail. When she first campaigned for office, she learned that $300,000 had been appropriated to study fodder for hogs and only $30,000 set aside to study the needs of children. "If the hogs of the nation are 10 times more important than the children," she claimed, "it is high time that women should make their influence felt" (Rankin Collection).

In the early suffrage years, speaking publicly also belonged to the public sphere, and female abolitionist speakers were soundly rebuffed many times, not because their detractors marshaled a good argument against what they said but because they were speaking publicly at all (Flexner 1975, 314–30; Zaeske 1995, 191–207). Even talking about many of the conditions that accompany war and the general human condition, such as sex, disease, and death, threatened not only to defeminize women but also to cast doubt upon their morality and their Christianity. Suffrage rhetors were challenged in that piety and morality that were tied in a complex knot representing Christian and feminine virtue, and "few women dared to risk appearing un-Christian" (Zaeske 1995, 197) by speaking to mixed assemblies, or assemblies containing men. Not only were women who spoke forcefully not virtuous, they represented nonrational points of view. Zaeske (1995) states, "In the early republic, when democracy justified more men participating in politics, it was women who were painted as irrational, as swayed by the passions, and as the source of 'promiscuous intermingling' that would disrupt decision making" (198). If women argued they should take their position in the public sphere to speak against war, then they must endure criticism from the clergy and from society about the unnaturalness of their presence. All-important decision-making bodies contained mostly men (Zaeske 1995, 197–98).

RANKIN ENACTS SUFFRAGE IDEALS

One essential tension that the suffrage movement faced had to do with the perception of the femininity of women and the nature of men and women. Excited emotions surface when change threatens long-stable roles between the sexes. One of the most powerful arguments against suffrage was that securing the vote would cause women to take on negative male qualities—become bullying and violent—and men to become womanlike, sissified and passive. For women to vote, an act requiring them to enter the rough public sphere, would make women like men as well as threaten male dominance. Paradoxically, antisuffrage forces argued that women were too weak, soft, emotional, and nonrational to comprehend the contentious issues of the day, especially war. The voting booth was a small step on the way to women gaining some influence upon public issues. Whatever their real reservations, antisuffrage forces worried publicly that women's nature was

not suitable to the requirements of the public sphere, even in so small a step as voting. The larger implication was that women would not only speak publicly but forcibly about such issues as labor legislation and about the nation's direction, including its decisions to go to war.

Rankin, like a multitude of others, had to create a vision of women beyond the home. There were no models of how a woman might run for public office, go to Congress, and publicly object to poor policies. Rankin was among the first, most prominent public symbolic figures to fuse the home and the public spheres, to present openly the idea that what happened in the public reverberated exponentially in the home. By preference a soft-spoken, shy woman, Rankin overcame her timidity while working on suffrage campaigns and forged an identity in the political arenas of Montana pioneer towns. She believed ardently in the power of reason and expected that her audience would listen courteously to her unless intimidated beforehand by their bosses or political thugs. She went to Butte and Anaconda, both mining towns where fierce labor struggles took place, and listened to miners and their wives. Late in his life, her brother Wellington, who had been a great supporter of Jeanette in big and small ways, said of her in an interview, "Jeanette was a great campaigner. Very few people can go into the kitchens of women and be wanted and comfortable" (Rankin Collection).

Regarding her sense of justice, Wellington remembered that as a child Jeanette cried out about the unfairness that the family cow was used for her products—her calves and her milk—and then sold for meat (Rankin Collection). Rankin's labor loyalties were very clear. In her speech before the Montana legislature supporting suffrage she said, "It is not for myself that I am making this appeal, but for the six million women who are suffering for better conditions, women who should be working amid more sanitary conditions, under better moral conditions, at equal wages with men for equal work performed. For those women and their children I ask that you support this measure" (*Helena Independent* 1911).

One of the ways that suffrage averted the voting-will-make-men-into-women argument was to raise expectations about women as virtuous voters who would work for social good (Sheppard 1994, 7, 135). The virtuous voters argument raised expectations that could not possibly be met. For example, cartoonists tried to redefine the roles of women by portraying images of female suffrage that would be acceptable to the larger public. The themes of domesticity, femininity, and motherhood were preponderant. Cleanliness, the cartoonists implied,

in government and in the home, would improve if women got the vote.

A cartoon that portrayed Jeanette Rankin in her role as potential congresswoman captured the hopeful spirit of her election bid. Rankin, as a thirtyish, upscale woman with her bags packed to go to Congress, is standing with her arms outstretched to embrace a girl running toward her, the "Suffrage Amendment." Sheppard (1994) states that the cartoon lessens "the contradiction between politics and women, but its effect is double-edged: celebrating the congresswoman's public role at the expense of reminding the viewer that as a woman she is intrinsically different" (188).

During and after election, Rankin's projected image often violated expectations regarding ideal femininity—emotional, passionate, and nonrational; these worked very much against Rankin. When the papers were not ignoring her campaigns as if they did not exist, they reported upon her style of hair and dress. As she entered the public sphere she was met with a fanfare that she found both unwelcome and perplexing. The press virtually ignored her during her first congressional campaign. Early returns indicated she had been defeated, but when it was announced that she had won, the media scrutiny over the oddity of a woman holding national office intensified to the point that she refused to come out of her house unless the media personnel removed themselves from the premises. World spotlights were turned on her, and if the press ignored her implacable, steady, clearly articulated stand on war, it was not her fault. She made clear in both of her campaigns for Congress that she would vote to keep "American boys out of Europe" (Montana Historical Society Archives n.d.).

Most damaging, the press commented upon what it termed her emotion when voting on war and other issues. During the vote against entering World War I, Rankin waited until the second roll call to cast her vote, saying afterward that she had promised to keep an open mind as long as possible and to wait until the last. The House custom allows for members of Congress to be polled on votes a second time, so she did nothing extraordinary in waiting. When polled, she said, "I want to stand by my country, but I cannot vote for war." It was reported that she supported herself with her desk, then "sank down sobbing" (*Helena Independent* 1917, 1). Interpreting the drama very differently, she said that the House grew noisy when she said "nay" because some members feared she would give a speech, which is against the rules when polling.

On more than one occasion when Rankin tackled an important issue

she was accused of displaying feminine weakness. The *Butte Miner* took her as typifying the ability of all women. "Few women, and particularly those in whom womanly instincts predominate, are given a temperament that even by the greatest stretch of the imagination can be called judicial, and Montana's congresswoman is no exception to this general rule" (*Butte Miner* 1917). When Rankin voted against entering World War I, newspapers across the country called her "failure" an argument against the further extension of suffrage (*Butte Miner* n.d.).

Rankin worked throughout her life to bring the public and private together as one. Part of the public reaction to her surely stemmed from seeing a woman do the unthinkable—use her position of power to promote women's concerns. Rankin enacted suffrage ideals of the strong feminine woman, and she did not flinch at the consequences of her actions.

VOTE THE "MAN'S VOTE" OR THE WOMAN'S HEART?

A second essential tension that suffrage supporters faced concerned, at its core, the differences between the perceptions of women and men. The suffrage foes claimed that the family unit, headed by a man, needed one vote and that the man's vote would reflect the interests of his wife and daughters, as well as any other females living in the house. The women, whose primary role was defined within the family unit, did not need a separate voice. DuBois (1998) states, "Citizenship represented a relationship to the larger society that was entirely and explicitly outside the boundaries of women's familial society as individuals, not indirectly through their subordinate positions as wives and mothers" (34). At its core, suffrage gave a woman a voice outside of the family, a separate identity, and in that it made her like a man—a truly radical idea.

The issue has greater implications than what might be readily apparent. The core issue is, do men and women see the world in sufficiently similar ways and have the same interests at heart such that one vote can represent both? If suffrage rhetors answered, "We are different," they potentially reversed some classical arguments about being the same—in the sense of women being as strong as, as capable as men. If women are different than men, is the source of difference a weakness or a strength? Are they less capable, or could they offer

something more to public discourse, something that men, due to their biological destinies, could not perceive?

Women voters, it was argued, would bring public dialogue to a higher, more moral sphere than men could. Stanton argued that "one of the greatest needs of the republic is high-toned, manly men"(Stanton, [1867] 1989; DuBois 1998, 95). She called the unequal position of the sexes a male aristocracy, and an unchecked male element in government "a destructive force, stern, selfish, aggrandizing, loving war, violence and conquest" (Stanton [1869] 1978). Issues such as child labor and appropriate working hours could not be captured by one vote, and in any case, the man who made it might not prioritize in the way the women would. The woman's vote, they argued, would highlight feminine values. Should women vote the same as their men, the franchise might well be a redundancy. The threat to family unity posed by a woman voting differently than her husband must be endured for the greater good that women voting would bring to society (Shaw [1915] 1989, 458–59).

Early evidence for the manner in which women's votes changed politics comes from a conversation that Dr. Anna Howard Shaw, a powerful suffrage rhetor and major leader of the movement, had with Senator Carey of Wyoming, a state that franchised women in 1876. When she queried him about the effect of women voters, he said that even though women were in a distinct minority in Wyoming, they were a source of uncertainty for parties when they chose candidates. Any potential candidate with a sullied record would be deserted by women voters, who could not easily be stereotyped by profession—such as the miners' vote—or by their interests—such as the saloon vote. When choosing party candidates, Carey reported, "Now we ask 'Can he hold the women's vote?' Instead of bidding down to the saloon, we bid up to the home" (Shaw [1915] 1994, 272).

No topic might divide men and women more distinctly than that of war. Certainly the effects of war fall very differently upon men than they do upon women. Dr. Anna Howard Shaw was asked by a male detractor during a suffrage speech, "What does a woman know about war, anyway?" She had commented that "it is remarkable that even at this age men cannot discuss international problems and discuss them in peace." She then asked another man in the crowd to hold up a paper whose headline read "250,000 Men Killed Since the War Began." She explicated what women know about war, that due to high maternal death rates at the time in childbirth, women's lives were at stake when they bore children. Through their male children espe-

cially, women most keenly feel the effects of war. Shaw's argument presaged what Rankin would later say. According to Shaw:

> No woman knows the significance of 250,000 dead men, but you tell me that one man lay dead and I might be able to tell you something of its awful meaning to one woman. . . . She gave her life for him, and in an hour this country calls him out and in an hour he lays dead. . . . When her son died her life's hope died with him. In the face of that wretched motherhood, what man dare ask what a woman knows of war. Read your papers, you cannot read it because it is not printable . . . the horrible crimes perpetrated against women by the blood drunken men of the war. (Shaw [1915] 1989, 458–59)

Later Shaw would say, "A woman who does not want to have anything to say in regard to her nation going to war, has no right to have anything to say in regard to her nation coming out of war. If we cannot have the power to speak before war is declared, we ought not cry out for power to speak after the fighting has begun" (Alonso 1993, 63).

War was the ultimate manly activity, and the willingness to go to war defined manhood. Killing, even institutionalized killing such as that done during a war, reflects ideals of manliness. If women spoke out against war, they proved themselves unable to make "the man's decision." Suffragists had long thought that male willingness to war upon one another was a throwback to a prehistoric need for physical strength in men. Those who objected to suffrage did so for a host of reasons, one of which was that if women did not fight in wars, then they should have no voice in whether one was waged.

Jeanette Rankin was closest in her adult life to her beloved brother, Wellington, who had urged her to translate her yearning to do important life work into running for political office. He had been her political advisor and her mentor; he had given her stipends between jobs and bankrolled the new clothes she needed when she first became a congresswoman. He was her most trusted advisor. When it came time for her vote against entering the war, Wellington urged her—some might say pressured her—to do the politically expedient thing. She needed to show the world that women were capable of handling the hard, tough issues, that they would not flinch at taking measures to protect their civilization. Wellington urged her to "make the man's vote," which meant to vote for the war. Possibly one of the most difficult personal conflicts she encountered was the disappointment that her no votes gave to Wellington.

Rankin asserted her authority as a woman in her public response to war. Rankin voted, it could be said, "the mother's heart." She stated

unequivocally with her antiwar votes that women's job is to protect the lives of men. Women like Rankin who had worked for peace realized that militarism was something largely created by men. The Women's Peace Union, the longest lasting group promoting peace activism, and a group for whom Rankin worked for a short stint, thought that women were "dupes" of men for endorsing wars. They also recognized that "a militaristic society often envisioned pacifism as being feminine" (Alonso 1989, 167). The women wanted a feminization of the world to take place, to the extent that feminine values would stop the destruction caused by war.

Rankin was exceedingly clear through both campaigns what her posture was in regard to war. In the campaign for her second term her slogan was "Prepare to the limit for defense; keep our men out of Europe" (*Butte Daily Post* 1940). The *Butte Daily Post* reported a speech given in nearby Anaconda during which Miss Rankin said, "If we are ready to protect our shores, we can say to the whole world, you cannot get in, and we are not coming over to give the lives of our young men to settle problems in Europe that you have been unable to settle for 2,000 years" (*Butte Daily Post* 1940). On another occasion she stated flatly what Anna Howard Shaw had foreshadowed nearly fifteen years earlier: "As women we will join together and say, 'we are going to protect our product, our young manhood" (*Montana Standard* 1941).[1] Shaw and Rankin had worked together on the Montana campaign and undoubtedly had influenced each other.

In voting no, Rankin carried forward suffrage themes of leaders such as Lucretia Mott, Elizabeth Cady Stanton, and Anna Howard Shaw. While she was the most visible public symbol of those themes, her votes were hardly surprising. She asserted the authority of womanhood and laid out its challenge. Late in her life she said that her vote against World War I was the most important act of her career. War, she thought, would only stop when people said no.

DIVIDED LOYALTIES

From suffrage to pacifism was one step that Jeanette Rankin, as well as national women's organizations, made with a sense of divided loyalty and of political uncertainty. The nettlesome questions they needed to answer individually and collectively were the following: Does being against war mean one is for women's suffrage? How assertive could women be against the war? Once a war effort or mobi-

lization begins, is it unpatriotic to not do everything one can to support the war?

The first of these potential conflicts regarded the nature of supporting suffrage and one's stance on war. The Women's Peace Union is a good example of the philosophical problems women faced. It is the longest surviving organization to support peace; the union's organizers sought to actually outlaw war. Its platform planks reflected approval of popular ideas such as the creation of international laws to prevent war. One proposed plank that caused debate was the call for the vote for women; antisuffragists worried that the inclusion of support for women's suffrage would limit the appeal of the organization. If individuals were adamantly against war, it did not mean they were for suffrage (Alonso 1993, 63).

Despite the increasing awareness of the fact that women needed the power of the vote to stop war, suffrage leaders had to negotiate a space between two competing and compelling arguments. If suffrage were to succeed, what form would women's participation take? Would women take the helpmate position or enter the fray with assertive promotion of their agendas? If the latter was the case, then the cause of suffrage might be harmed. The frequent charge that public life "unsexed" women, making them manly and unfeminine, was countered as untrue by suffrage leaders, including cartoonists. Suffrage leaders appealed to current tastes in femininity, claiming that "women, once enfranchised, would still play the decorative, nurturing, and moral roles society expected of them" (Sheppard 1994, 9). The notion that women with votes would work to serve causes while men held the reigns of political power was largely accepted. Images of strong, courageous, contentious women were rare.

Women themselves thought that to enter the public sphere too forcefully would be the undoing of the one thing that women offered, their idealism. Sheppard (1994) states, "Suffrage rhetoric and the cartoons that encapsulated that rhetoric reinforced the very prejudices that kept some old attitudes in place. Their 'strong women' were, for the most part, if not in allegorical form then shown working for nonpartisan, idealistic causes" (10). Women still had internalized the stereotype that they advance a cause for only the cause, not to buttress their own esteem or to gain a portion of the political pie—to do that was to compromise one's own ideals. "Women shrank from direct contests with men in the political arena" (11).

Long-entrenched sexual attitudes toward the relative places of men and women in society were not fundamentally changed when women

won the vote. The idealism with which women approached suffrage and antiwar work, as well as the disappointments they encountered in pursuit of peace, would take many years to understand. Over a long period of time, women became politicized, universalizing their experiences. During that time, women vacillated between always taking a strong stand against war, for example, only to grapple with whether one could always be against war under any circumstances, even the circumstances of sending one's own husband or son off to war. Also, it is a mistake to think that all women are pacifistic and all men are not—nothing could be less accurate. By 1917, it "had become painfully clear that women were not inevitably pacifistic, as American women not only went along with intervention but also mobilized their civic organizations in support of national mobilization" (Van Wienen 1992, 707).

Carrie Chapman Catt, the leader of the National Women's Suffrage Association in charge when the final suffrage victory came, did not think that suffragists "should be in the forefront of any peace organization, demonstration, or conference for fear that such a presence might harm the unity of the suffrage campaign" (Alonso 1993, 62). In 1917, Catt pledged the National Women's Suffrage Association support for World War I, although she did so in as neutral as terms as possible. Although Catt's support was mixed, she could not have it said that to support suffrage was to lack patriotism—the backlash against suffrage would be too great (75). Suffrage agitation created the circumstances for the first woman to be elected to Congress, but Catt understood that radical antiwar rhetoric on the part of suffrage supporters would undermine the cause (76). Imagine the public relations challenge that Rankin posed to Catt!

Problematically, people who were for suffrage were for it in part because women as "natural pacifists" would promote and work for peace and actively work against war. Rankin, the first woman to gain the power to make a difference politically, votes no. She again votes no, as the sole dissenter some twenty-four years later. The press excoriated Rankin. "Montana's Shame," she was called, a liar and, later, a "Commie" (Campbell 1917). In part, the reason for the name calling may have had something to do with her bold, unapologetic claims regarding war.

Rankin dedicated her life to winning suffrage and promoting peace, and yet her election to national office appeared, at the time, to undermine the suffrage cause. While Catt negotiated a space for suffrage

rights to succeed, Rankin's votes seemed to validate some negative stereotypes used against women's suffrage.

Continuing ethical decisions confronted Rankin throughout her career. For example, she once worked for the Women's Peace Union, but did not come out as strongly as it demanded against any support of a war (Alonso 1989, 104–9). Rankin was harassed unmercifully by the American Legion and called a Commie (Josephson 1974, 137). Government harassment of peace activists and suffragists was common, and to be called unpatriotic in times of war is dangerous (Alonso 1993, 83). Rankin held firm throughout her lifetime in support of peace, regardless of the personal or political deprivations her stance caused her.

CONCLUSION

The goals of the peace and suffrage movements intertwined in that suffrage would improve the lives of women and children, as well as allow women access to important power to promote peace. What early suffragists could not imagine was that Jeanette Rankin, a symbol of what suffrage could accomplish, would stir controversy that threatened to undermine the very arguments advanced for suffrage. While the movement's potential for education and labor reform may have won the vote for American women, Rankin's vote against both wars must have cast doubt in the public consciousness of entitlement to the public sphere.

Jeanette Rankin lived within the constraints reflected in her time, the need to be feminine, to please people who had helped her to succeed in her bid for a congressional seat, and to try to respond to the needs of the suffrage and peace movements. As a powerful suffrage and antiwar symbol of her time, Rankin faced nearly impossible challenges: to prove that women were capable of making the hard choices that public life implied and had the ability to move from the protective sphere of the home to the public sphere. Rankin's peace activism grew out of her suffrage roots, and throughout her lifetime she faced many conflicts. Her election to Congress represented hope for suffrage supporters; Rankin herself an exemplar of all that woman could be. Her vote against entering World War I and her subsequent vote against entering World War II after lives were lost in an attack on American soil gave detractors evidence that women were not capable of understanding the conditions that necessitated war.

Rankin joined a long list of women who stood firmly against war. One important early suffrage leader, Lucretia Mott, a Quaker rooted in antiwar sentiment, hoped that someday arbitration would take the place of warfare. Elizabeth Cady Stanton understood the parallels between all subjugation: women, slaves, and men who kill in service to their country. She took it as an article of faith that women had a special mission, to bring peace, and that women would someday do it. In 1872, Stanton said, "The true woman is as yet a dream of the future" (Alonso 1993, 44).

To be involved with women is to dream about what they can become someday. At the end of her life, Rankin said that she was disappointed in the little change that had occurred during her lifetime. Rankin believed that women had not taken full advantage of their new rights. She had such great hope for what women would do after they secured the vote: "Thirty years ago looking forward to that much time, it seemed much could be accomplished for women. Looking backward, it seems that very little has been done, although compared with the length of time women had no legal rights at all, the advancement has been great" (*Helena Independent Record* 1947).

She wanted women to become politically active and unapologetic about their claim to the public sphere. Most of all she wanted them to understand that they have the power to act, to influence people if they would just be willing to ignore inevitable pressures. She echoed what the American philosopher Henry David Thoreau said when he claimed that if ten honest men who ceased to hold slaves were to be locked up in the county jail for their convictions, "it would be the abolition of slavery in America" (Thoreau [1849] 1993, 289). Rankin, as an eighty-seven-year-old woman arguing for an end to the Vietnam War said, "It is unconscionable that 10,000 boys have died in Vietnam, and I predict that if 10,000 American women had mind enough they could end the war, if they were committed to the task, even if it meant going to jail" (Josephson 1974, 182; Alonso 1993, 222). Certainly she would say that imprisonment is a small price to pay to save the lives of young men. She was a woman of high principle willing to act upon her mission—political equality for women, and peace and justice for all people.

NOTE

1. The Associate Press Biographical Service No. 2884, Biographical Editor, The Associated Press, 50 Rockefeller Plaza, New York City. April 1, 1941. Published in the *Montana Standard*, April 4, 1941.

REFERENCES

Alonso, Harriet Hyman. 1989. *The Women's Peace Union and the Outlawry of War, 1921–1941*. Knoxville: University of Tennessee Press.

———. 1993. *Peace as a Women's Issue: A History of the U.S. Movement for World Peace and Women's Rights*. Syracuse, N.Y.: Syracuse University Press.

Buhle, Mari Jo, and Paul Buhle, eds. 1978. *The Concise History of Woman Suffrage*. Urbana: University of Illinois Press.

Butte Daily Post. 1940. October 30.

Butte Miner. n.d. On When to Pause.

Butte Miner. 1917. Miss Rankin's Speech to Recalcitrant Miners, August 19.

Campbell, Karlyn Kohrs, ed. 1989. *Man Cannot Speak for Her*. New York: Praeger.

Campbell, Will A. 1917. Who Is Telling the Truth? Jeanette's Varied Interviews. *Helena Independent*, August 16.

Donovan, Josephine. 1998. *Feminist Theory: The Intellectual Traditions of American Feminism*. New York: Continuum.

DuBois, Ellen Carol. 1998. *Woman Suffrage and Women's Rights*. New York: New York University Press.

Flexner, Eleanor. 1975. *Century of Struggle: The Woman's Rights Movement in the United States*. Cambridge, Mass.: Belknap Press of Harvard University Press.

Great Falls Daily Tribune. 1917. April 8, 1.

Griffin, Cindy L. 1996. The Essentialist Roots of the Public Sphere: A Feminist Critique. *Western Journal of Communication* 60: 211–39.

Helena Independent. 1911. Suffrage Bill Gains Support, August 9.

Helena Independent. 1917. On Kaiser Congress Declares War, April 6, 1.

Helena Independent Record. 1947. March 2.

Josephson, Hannah. 1974. *First Lady in Congress Jeanette Rankin: A Biography*. Indianapolis: Bobbs-Merrill.

McGinty, Brian. 1988. Jeanette Rankin: First Woman in Congress. *American History Illustrated*, May, 32.

Montana Historical Society Archives. n.d. Quotes by and about Jeanette Rankin. Helena, Mont.

Montana Standard. 1941. April 4.

Rankin, Jeanette. Quotes by and about Jeanette Rankin. Jeanette Rankin Collection. Montana Historical Society Archives, Helena, Mont.

Rankin, Wellington. Audio interview. Jeanette Rankin Collection. Montana Historical Society Archives, Helena, Mont.

Shaw, Anna Howard. [1915] 1989. The Fundamental Principles of a Republic. In *Man Cannot Speak for Her*, edited by Karlyn Kohrs Campbell. New York: Praeger.

———. [1915] 1994. *Anna Howard Shaw: The Story of a Pioneer*. Cleveland, Ohio: Pilgrim Press.

Sheppard, Alice. 1994. *Cartooning for Suffrage*. Albuquerque: University of New Mexico Press.

Stanton, Elizabeth Cady. [1867] 1989. Kansas State Referendum Campaign Speech at Lawrence, Kansas. In *Man Cannot Speak for Her*, edited by Karlyn Kohrs Campbell, 259–77. New York: Praeger.

———. [1869] 1978. Address to the National Woman Suffrage Convention, Washington, D.C., January 19, 1869. In *The Concise History of Woman Suffrage*, edited by Mari Jo Buhle and Paul Buhle, 249–56. Urbana: University of Illinois Press.

Thoreau, Henry David. [1849] 1993. Civil Disobedience. In *Walden and Other Writings* by Henry David Thoreau. New York: Barnes & Noble.

Van Wienen, Mark. 1992. Women's Ways in War: The Poetry and Politics of the Woman's Peace Party, 1915–1917. *Modern Fiction Studies* 38, no. 3: 707.

Wibaux Pioneer. 1918. Deer Lodge Prohibits Speech by Miss Rankin, April 26.

Zaeske, Susan. 1995. The "Promiscuous Audience" Controversy and the Emergence of the Early Woman's Rights Movement. *Quarterly Journal of Speech* 81: 191–207.

Chapter 4

Maria Pearson: A Warrior and Peacemaker in Two Worlds

Sheryl L. Dowlin

One spring day in 1971, Iowa Governor Robert Ray heard a commotion in his outer office and peeked around the door to observe. There, to his amazement, stood a Native American woman in her regalia demanding access to see him. As that woman recalls:

> I went to the Governor's office and I walked in. His secretary just looked at me. In 1971, in Iowa, you didn't expect to see an Indian woman walking around in cultural clothes. She asked, "Can I help you?" I said, "I've come to see the Great White Father. Tell him Running Moccasin is here." A guy in a black suit and tie came out and said, "Can I help you?" I said, "Are you the Great White Father?" He said, "No." I said, "Then you can't help me." "Well you know," he says, "he's a very busy man." I replied, "Well you know, I'm a very busy woman." I said, "You know, if I was an ambassador from a foreign country, you'd have that red carpet rolled out and all the way out the door and down the drive. You'd have a delegation come out to greet me." I said, "Well, I am an ambassador. I'm an ambassador for my people. And, if this man is over everybody in the state of Iowa, then he's over me, and I have a right to see who's over me." He turned around and went in the back. I looked up and the Governor was peeking at me around the corner of the door. So I thought, "Well, he can't be too bad, he's peeking around the corner." The man came back out and said, "The Governor will see you." . . . The Governor said, "Well then, how can I help you?" I said, "You can give me back my people's bones and quit digging them up." He looked at his aide and said, "Do we have her people's bones?" The aide replied, "I don't know, but I'll find out." He made a bunch of phone calls. . . . Then he wanted my phone number. He told me, "This may take a little longer than I thought and I'd like to keep in touch with you." (Pearson 1997a, 1997b)

Running Moccasin (*Haimecea Eunka*) walks this earth with the heart and spirit of a warrior and peacemaker. Maria Pearson (Running Moccasin), a traditional Yankton Sioux activist, changemaker, and community bridge builder, has made a positive difference internationally in peoples' lives, including Indians and non-Indians. Her warrior–peacemaker roles have challenged injustice and advocated just problem solving for the past forty years. Her words and actions speak out against values that encourage oppression, domination, and aggression; they embrace the values of courage, harmony, respect for diversity, empowerment, cooperation, and nurturance. They illustrate the comprehensive sentiments expressed in the ecofeminist Declaration of Interdependence "to create a new bond among peoples of the earth, connecting each to the other, undertaking equal responsibilities under the laws of nature, [and] a decent respect for the welfare of human kind" (as cited in Donovan 1998, 208).

This chapter humbly attempts to describe the development and interactions of a contemporary Native American communicator from an ecofeminist Native American warrior perspective that advocates all people and forms of life should be treated with equal concern, respect, and justice. Specifically, the focus here is to provide a description of Running Moccasin's warrior and peacemaking communicative actions and how they have influenced and brought about (1) a new consciousness of the interdependence among and between people (Indians, non-Indians), and (2) transformations celebrating the integrity and rights of all people.

Maria Pearson, from Ames, Iowa, has long been an activist for human causes advocating human dignity and justice, particularly in the area of protecting the burial sites of indigenous peoples. She is a traditional Yankton Sioux woman who, through a variety of personal and work-related actions over a forty-year period, has sought to foster and create links of shared meaning, understanding, and partnerships between cultures, Indian and non-Indian. Her professional life includes cooperative work in the areas of substance abuse, cultural observation, and the development of cross-cultural working relationships. Her interdependent warrior and peacemaker professional roles include the following: Iowa Governor's Indian Liaison for Indian Affairs, chair of the Iowa Indian Advisory Council, past president and member of the Governors' Interstate Indian Advisory Council, cultural preservation consultant for the State of Iowa, Iowa Coordinator of American Indian Conferences on Substance Abuse, and the Repatriation Advisor for the Yankton Sioux tribe in South Dakota. On a per-

sonal level, Running Moccasin's *tiospaye*, or extended family, includes a number of Indians and non-Indians whom she has adopted to be her brothers and sisters in the Indian way (Pearson 1997b).

THE DEVELOPMENT AND RHETORICAL ROLE OF A TRADITIONAL WARRIOR

According to Running Moccasin, the word *warrior* is a descriptive title—all Indians are warriors.

> I have five sons—all are warriors. They defend their home front; they are men of courage. Warriors are capable of love, concern for their family; they are family people. They have a readiness to help; they have gentle souls. They are also determined that justice is for everybody and they find just ways to solve problems. .
>
> Both our men and women are warriors. There were women warrior societies before the whites came. The women were always protectors of family. They were left to defend their camps. Our children are brought up with a sense of family—all are responsible for one another. (Pearson 1997b)

Maria maintains that female and male warriors display communicative acts of protection, courage, nurturance, and finding just ways to solve problems.

The development of Running Moccasin's warrior rhetorical qualities stems from modeled behaviors by the women in her family (e.g., her mother, grandmother) and her survival experiences in a racist environment. Of the women in her family, she reflects:

> My grandmother and especially my mom told stories about their mother and grandmothers. I learned a lot of things from my grandmother over the years. She used to talk to me. She taught me how to dry corn. She taught me how to dry apples and preserve squash, all the things to maintain a home. My mother used to tell me, "When you need to know something, go down to Grandma." So I'd go to Grandma and she would tell me. This taught me a lot of things about my heritage. (Pearson 1997a)

Oral tradition interactions provided direct ways to learn about her heritage and cultural values. Running Moccasin continues:

> I remember that one time I was sitting with grandma, and I said, "Grandma, I hope nothing ever happens to you because I don't know what would happen to me." She told me, "Well girl, when I die, don't you cry, because I'll be in a far better place than you are. When you get lonesome for me or when

you need me," she said, "listen for my voice and I'll come see you in the wind." She'd say, "Remember, keep the cottonwood sacred." The cotton-wood is a sacred tree to us. She told me a lot of things about the items she had in her trunk. She wanted me to understand and know about them and to know why she kept them. . . . My grandma said, "Some day, girl, you're going to have to stand up for what you believe." I always wondered about that. (Pearson 1997a)

Running Moccasin's grandmother's words and actions modeled war-rior values of courage and being prepared to stand up for the things she believed in. Her grandmother's words prepared her for things to come—fighting against prejudice and acts of racism and bigotry.

Running Moccasin's mother's words and actions modeled the war-rior values of nurturance in her efforts to preserve the family unit. She describes her mother:

Mom was really a warrior woman—she did all the things to preserve the family. We had a big family and it was in the depression years. It was easier to give kids up to an orphanage than keep them. Mom kept us all together—that was the reason she put us in the mission school. She said, "At least you'll grow up together knowing your brothers and sisters. They [the mis-sion] will hold you together. I won't have to worry about you kids being cold in the winter and hungry." She didn't like to hear us crying. I give my mother a lot of credit. The day I was to leave for the mission school, I saw my mom crying hard in the house in the middle of the room. I got a hanky for her off the line. She said, "You don't have to go if you don't want to go." I knew that I needed to go because it was something she needed to have happen—she was going to have a baby. I understood. I needed to make it as easy for my mom as I could. I really loved my mom. She always seemed to love me too and I was always the renegade—the black sheep. (Pearson 1997b)

Running Moccasin understood her mother's nurturing decision and actions to keep the family unit intact.

Running Moccasin's interdependent warrior qualities and recogni-tion of cultural differences were further developed while she lived in a racist environment in South Dakota.

I was raised in South Dakota. I was raised in a racist community—bigoted, redneck. I learned how to survive with it, and I learned how to keep low key in the community. It wasn't because I was accepting the prejudices [against my culture], but I knew it was because there was a lack of understanding from the white community. I was raised with a lot of Bohemian people; we used to call them Bohunks. They used to talk about the Czechs in the same way. It was no different in that I was an Indian. (Pearson 1997b)

Even in the face of bigoted treatment, Running Moccasin recognized and understood that prejudice stems, in part, from a lack of understanding. An attitude demonstrating an understanding and respect for diversity was evident early on, an attitude that later became evident in her role as peacemaker.

Running Moccasin's warrior spirit and courage were displayed when she challenged the social inequities she encountered. She reported:

> My first husband was Yankton. He was a preacher, an Episcopal. I remember he used to give sermons in Dakota. I remember my moments of rebellion because all the women had to sit on one side in the church and all the men on the other side. And so, when I came in as the preacher's wife, I sat up in the front on the men's side too—my little bit for equality. I think about these things today, about the spirit within me. (Pearson 1997a)

THE RHETORICAL ACTIONS OF A
TRADITIONAL YANKTON SIOUX WARRIOR

Running Moccasin's warrior role was evident in her early adult cross-cultural interactions. After her first husband died, she married a Norwegian man. After her children were all born, she discovered "he was a tipi creeper, so I had to let him go" (Pearson 1997a, 1997b). In 1969, she married John Pearson and moved to Marne, Iowa. She and John were married until his death in 1991. "The third time I married a Welsh man, and he was a wonderful man. He was a civil engineer. He was in charge of building the Interstate system in Iowa" (Pearson 1997b).

Running Moccasin and her family's years in Marne were hard. She recalls that the small town of Marne was one of racism "in all its glory and for a long time" (Pearson 1997b). Racism and bigotry were blatant in community attitudes, law enforcement, the church, and community services. Several incidents of racism and bigotry occurred, and Running Moccasin dealt with each one in a traditional Yankton woman warrior fashion. Racism and bigotry were evident in the way Running Moccasin and her family were treated. She reports, "When I first moved to that community, I was 'that Indian woman'; and I had 'those Indian kids.' We had no identity other than that" (Pearson 1997a). Running Moccasin and her family had no identity as individual human beings in this community.

Running Moccasin rose to the occasion to protect her family against unjust treatment by the local sheriff. She recalls:

> A series of ignorant things happened. For twenty years the sheriff invaded people's privacy everyday. At that time, I was the Governor's Liaison for Indian Affairs, but people in Marne never knew what I did. They just knew that I left town occasionally, but I always had a baby-sitter with my children. My civil and constitutional rights were violated constantly. I remember that every time a screwdriver was missing, the sheriff was in my house without a search warrant because it had to be those stealing Indian kids. (Pearson 1997a)

Not only was there a corrupt law enforcement system; there was evidence of bigotry and prejudice in the church and in the community health care system. Two examples illustrate this: "When I went to the Catholic Church, I faced bigots and racists. When I mentioned this to the priest, he said, 'Now, just get better acquainted. They're good people' " (Pearson 1997b). The priest discounted the seriousness of her observation and reported experiences and placed the responsibility for creating harmony within the community on her.

One 1971 long-term warrior–peacemaker action led to a new respect for the welfare of others and an increased consciousness of human rights on individual, state, national, and international levels. Messages communicated by her grandparents at an early age regarding the protection of the graves of one's ancestors influenced and guided Running Moccasin's adult warrior actions.

> In listening to my grandparents, I had the privilege of hearing my grand-parents when I was little. . . . I remember at some of the early meetings that we would have, grandpa would tell us, "Don't play around any of the graves." Grandpa instilled in us that we had to have respect and that there were things that happened to you when you didn't obey these rules. There were reasons for them. (Pearson 1997a)

These words influenced Running Moccasin's later courageous warrior actions. A white man's law was established to protect graves from grave robbers and prevent the use of cadavers for study without families' knowledge. Historians viewed this as a heinous thing to do. Laws were passed to protect people's final resting places. Knowing this law, Running Moccasin was confused and angered when it became apparent this law did not apply to her people. In 1971, the remains of twenty-six white people and an Indian girl and her belongings were disinterred during an Iowa highway construction project (O'Shea

1971; Raffensperger 1971). The remains of the twenty-six disinterred white people were reburied immediately in a nearby cemetery. The remains of the disinterred Indian girl and her belongings were sent to the Iowa state archaeologist for study. Running Moccasin said, "I could not understand why . . . this practice was going on so rampantly against my people. And I want to say 'my people' because then it's inclusive for all the people" (Pearson 1997a).

When her husband, John, heard of this incident, he was extremely disturbed. She told him, "That's discrimination. . . . You can't do any more than what a court order states" (Pearson 1997b).

Running Moccasin recalls that night when she went out in her backyard by the two-hundred-year-old cottonwood trees to pray:

> I had a rock garden out in my backyard. . . . That night, I was praying. I felt very strange inside of me. There was a heaviness that came down. I remember when I prayed, I said, "Creator, I know there has to be a peaceful way to solve the problem of why they need to dig up our ancestors. It isn't right. And I want to help." And I heard the wind coming from a long way. It came closer and closer to that tree and when it hit the tree, the cottonwood leaves started to rustle and they made kind of a tinkling noise. I remember it got real still; I didn't know what it was. Then, that was the first time I heard my grandma. She said, "I told you you would have to stand up for what you believe in. You must protect where your grandfathers lie." I said, "Grandma, I'm scared. I live with all these rednecks. I have babies. They'll hurt them. I'm afraid to do this." She said, "Don't be afraid. Your Grandfathers are here. They'll protect you." That night, she told me a lot of things. She said, "You won't be able to tell nobody this right now. There'll come a time when you can. But right now you just have to do everything one step at a time. Each day you get up and ask the Creator." (Pearson 1997b)

Her ancestor's words empowered Running Moccasin to stand up for what she believed, that is, the graves of her people should be protected in the same way the white man's graves were. This incident set into motion a transformation process that eventually led to a new respect and bond among peoples on state, national, and international levels. It marked the beginning of Running Moccasin's rhetorical power brokering to protect her peoples' graves and sacred artifacts.

The next day, she set foot on a warrior–peacemaker path that would forever change her life and those who have come to know her, such as politicians, archaeologists, anthropologists, international and national tribal members, and non-Indian community members. When asked by her husband, "What are you going to do?" she replied, "It's best you don't know what I'm going to do. You would feel like leaving

Iowa." The next morning after her husband, John, went to work and
her children went to school, she dressed herself in her ribbon skirt and
shirt. She braided her hair and put her hair in hair ties, something she
hadn't done in years. Then she drove ninety miles to the governor's
office in Des Moines.

When Governor Ray stepped into his outer office to receive Running
Moccasin on that spring day 1971, a new chapter in Native American–
white relations in America began. After she politely but directly
requested Governor Ray stop the desecration of Native American
graves in Iowa and he assured her that he that he would look into the
matter, she offered him a token of peace in the form of a friendship
ring and returned home (O'Shea 1971). That evening, she became ill
and ended up in the hospital for tests. Her fight for the immediate
reburial of the Indian girl's bones continued, however, from her hospi-
tal bed. Running Moccasin contacted representatives of the Bureau of
Indian Affairs Office and had ongoing conversations and correspon-
dence with Governor Ray's staff, specifically, Marshall McKusick,
state archaeologist (O'Shea 1971; Thompson-Pearson 1971). McKusick
maintained he was required by Iowa law to keep the remains and arti-
facts for study to determine their historical significance (O'Shea 1971;
Raffensperger 1971; McKusick 1971). Running Moccasin demanded
that the Indian girl's remains be returned to the proper tribe for Indian
reburial immediately (Thompson-Pearson 1971). She was reported to
say, "The [state archaeology officials] say they want to learn more
about the Indian. Well there is plenty of live ones around they can
come and talk to. They don't have to go poking their noses around in
our graves. If I did that to a white man's grave, I'd be arrested"
(O'Shea 1971).

Running Moccasin threatened to stage an all-Indian protest march
on McKusick's office (Raffensperger 1971). McKusick reacted with "I
don't want that woman to think in any way that if she raises a fuss,
I'll give her a couple of boxes of bones" (O'Shea 1971). In August, a
mutual agreement came about between the state and Running Mocca-
sin, and in September 1971, the Indian girl and her personal belong-
ings were reburied in the same cemetery as the twenty-six white
people (McKusick 1971). Headlines in newspapers calling attention to
the controversy generated a great deal of support for the issues advo-
cated by Running Moccasin. She reports, "All of the people just bom-
barded the Governor's office with letters. He got bags and bags of
mail. He said one person wrote, 'Get that devil out of there. And don't
be digging up people's bones in this state.' The onslaught from public

opinion really overwhelmed him" (Pearson 1997a). Running Mocca-
sin's persistent warrior-like actions demanding equal respect for her
people caught the attention of people around the world.

When Running Moccasin got out of the hospital, she corresponded
and met with Iowa state legislators and officials (McKusick 1971; Wil-
ley 1971). She spoke and participated in a number of meetings relating
to these issues.

> We had some of the first meetings in the nation. Talk about warriors. We had
> women and men warriors together under the roof for the first time in his-
> tory. They thought that I was radical. We had to physically hold down two
> people from Oklahoma because of this one man, Doug Ousley, who now
> works at the Smithsonian. He was the archeologist in Tennessee at the Tellico
> Dam site that had desecrated all of those Cherokee graves. When the [other
> tribal people] saw him, they wanted to rip his heart out. Over the years, I
> knew what that feeling was, to literally want to rip somebody's heart out.
> (Pearson 1997a)

One memorable meeting reported by Running Moccasin was with a
number of archaeologists, anthropologists, and physical anthropolo-
gists. They said, "Running Moccasin, we want you to come and tell us
why the Indian people hold their graves sacred" (Pearson 1997a). She
and Don Wanatee (Mesquakie) attended a meeting of two hundred to
three hundred people to speak. In a traditional Indian way, Running
Moccasin gave the floor to Wanatee to speak for the people; however,
he lost his voice during the meeting, requiring Running Moccasin to
speak instead. Running Moccasin describes the course of events: "Don
and I met in the parking lot. He said, 'Maria, I have to tell you I went
to the ceremony last night and the spirits told me that I would lose
my voice about the burial issue.' I said, 'Don't say that, Don. I really
need you.' He said, 'I just wanted you to know' " (Pearson 1997a).

When Don Wanatee and Running Moccasin entered the meeting
room, a woman who was sitting at the table with her legs over the
back of the chair said, "You wanted to know why those Indians hold
their graves sacred, well there they are. They can tell you." That was
her introduction. Don stood up and began talking about a time "when
we all went into the woods and we know why we went. There was a
time when we beat the drum and we knew what the meaning was
behind it. There was a time when we sang the songs and we knew
what it meant. There was a time when we knew the prayers."

The woman who had introduced them jumped up and said, "I'm
just sick and tired of you Indians trying to ram your culture down my

throat." She went on to say, "I don't give a damn whether you dig up my grandma and take her wedding ring" (Pearson 1997a). Running Moccasin responded:

> There was an audible gasp from the audience. I felt this surge of anger go through me. I knew at that moment that I could go right over there and rip that woman's heart out and eat it right in front of them. That was the way I felt. Behind me, I heard my Grandma. It was the second time I heard her. She said, "Never let anyone make you less than what you are. Your grandfathers are here." I took a deep breath. I looked at Don and Don went mute. He was so angry that his bottom jaw moved back and forth and nothing came out of his mouth. He stood there and he looked at her. He put that book down in front of me and he put his hand on my shoulder and said, "Maria, you're going to have to tell them for us," and he walked out of the meeting.
>
> My grandmother said, "Your grandfathers are here." I looked at that woman and said, "You invited us here to find out why we hold our graves sacred, and then you insult us." I said, "Well, I came to give you a message. You say that you don't give a damn whether we dig up your grandma and take her wedding ring. I'll tell you one thing; Indian people do not desecrate the graves. We do not desecrate the dead, nor do we steal from them." I said, "You say you do not care because your culture does not lie in this land; its lands are over this ocean." I said, "You go over there and dig and I won't bother you." And I said, "But I do give a damn whether you dig up my grandparent. I will tell you today that I will be here and I will fight until there's no breath left in me." And I said, "I will make one other promise. As long as I am alive and living in Iowa, you will never be permitted in our graves again." And she never was. Today, she lives in Arizona.

Despite the anger she felt toward this woman's words and behavior, Running Moccasin maintained a respectful composure and yet made her views about protecting ancestral graves adamantly clear. Running Moccasin explains her cultural perspective on this issue:

> There are ways for things to happen when you desecrate the dead. There are things that will happen to you and your loved ones. Not necessarily to you, but it can happen to your grandchildren; and it will come directly because of what you did. I hope and I pray that anything I have done in my life does not reflect upon my children, my grandchildren, or my great-grandchildren. I can honestly say I know the generations, the seven generations that I am responsible for. And I do tell my children and my grandchildren. My culture is something to be proud of and that I am a mother and a woman. I had to fight my whole community because of my nationality, because I was born an Indian. (Pearson 1997a)

The outcome of Running Moccasin's warrior actions of courage and her willingness to take responsibility to stand up and fight for equal

treatment led to the State of Iowa legislating the first laws in the nation protecting Native American graves. The State of Iowa also established four Native American cemeteries for the burials of prehistoric Indian remains (Knauth 1977). Iowa's action became a model for the nation, eventually impacting the landmark Native American Graves Protection and Repatriation Act (NAGPRA) of 1990 (Pearson 1997b). Running Moccasin's initial warrior role efforts have transformed and brought about a new consciousness of the grave protection issues and the civil rights of all people. Her understanding of treating others in respectful, cooperative, and assertive ways has created a bond among Native American people and nonnative county, state, and national officials.

THE ONGOING IMPACT OF A TRADITIONAL YANKTON SIOUX WARRIOR'S ACTIONS

Since the 1971 and 1974 incidents, Running Moccasin has continued to speak out for the protection of her peoples' bones and sacred objects. She is recognized and highly respected by many Indian and non-Indian people not only as a warrior but as a peacemaker—her words and actions have demonstrated a willingness to create new bonds of understanding, mutual respect, and friendship. This is clearly evident by the close associations and cooperative working relationships she has with various tribal groups and state and national officials. Following the 1971 grave-reinterring incident, Governor Robert Ray asked her to serve as the Iowa governor's liaison for Indian affairs. She continues to serve in this capacity twenty-six years later as Iowa Governor Branstad's liaison. In 1976, Governor Ray offered Running Moccasin a paid position to head an Indian Advisory Council. She accepted the position but refused the salary. When asked why she would not accept a salary, she stated:

> The only thing you're going to do with that is you're going to create jealousy among my people. Each one is going to say, "I'm more qualified to be. . . ." I said, "I'll do it for you for nothing." I just want to see that justice is done for Indian people in the State of Iowa. I will do it for nothing, but you have to make some concessions because of that. . . . You're going to have to talk to all of your agency people and you're going to have to listen to my advice and take it. I will not tell you to do something that I know will not work. It's going to be a big job and I won't get it accomplished in one year. It will have

to be done throughout every one of your agencies. (Carmack 1983; Pearson 1997b)

Governor Ray agreed, and since that time several things have been put in place. Sweat lodges, for example, are in place behind prison walls. Running Moccasin then and now serves as the chair of the Indian Advisory Office to the state archaeologist's office and as the governor's advisor for Indian affairs. The governor sits down with this group once a year and discusses all of the Indian-related problems that arise within or outside the state.

Over the years, Running Moccasin's work on grave protection issues has been recognized and appreciated worldwide. Those who have worked closely with her in Iowa have the utmost respect for her and her views even though there are differences of opinion. This was evident in 1983 at a symposium sponsored by the National Endowment for the Humanities, the Iowa Humanities Board, and the University of Iowa entitled "The Study of Ancient Human Skeletal Remains in Iowa" (Carmack 1983). Participants included directors and associate directors of state departments (e.g., archaeology, historical, transportation), archaeologists, attorneys, and professors of anthropology, directors of American Indian organizations and programs, and various tribal leaders (e.g., Athabascan, Cherokee, Mesquakie, Potawatomie, Yankton Sioux, and Winnebago). These individuals collaborated in a cooperative framework to find workable solutions for the preservation and protective treatment of ancient remains and cemeteries. Transcripts of this symposium reveal the cooperative and respectful working relationships between participants despite significant differences of opinion on what should or should not be allowed in the handling of ancient Indian remains. Archaeologists argued the value of being allowed to study ancient remains as a means of gaining an understanding of a culture and, the people's lifestyle and health status. Running Moccasin argued that digging into burials has created problems and mental anguish for Indian people. She stated:

> My ancestors did not donate their bodies to science. That is the difference. We already have all this vast educational material on the shelves, yet it's not reported on; it's not used. . . . From the Indian perspective, it is so useless to study bones. You know that the material things wasted are criminal, but to drain the human spirit is even worse. It is tragic. Even today, when any burial is opened, it causes pain. (Carmack 1983, 32–33)

Running Moccasin strives to find just and peaceful ways of solving problems. She understands the essence of cultural interdependence

along with showing respect and attempts to understand others' points of view. She said:

> I have learned that not all archaeologists are really my enemies. There are some that were just misguided. They didn't realize how deeply they offended the Indians. They want to do what is proper, but they don't know what the Indians want or consider to be proper. . . . It is our responsibilities to tell archaeologists what we want. . . . I've fought with Duane, not Duane the man, but Duane the archaeologist. Sometimes it's hard to separate the two. I've remembered the teachings and sayings; I've thought of my responsibilities to the children. I want them to have a better life. And I know that the blood of my white brothers is as precious as mine. (Carmack 1983, 37, 42)

Running Moccasin's rhetorical roles as warrior and peacemaker are evident in her words and actions. In her attempts to solve oftentimes very difficult human relation problems, she sees all people as valued human beings and shows respect for their perspectives. This is evidenced in her recorded statement:

> I've conferred with governors, legislators, all kinds of people. All the people I've met are human beings. Looking around at the group today, I see diverse tribes. I see youth represented. I am pleased because there is work for everyone here to do. The Great Spirit has guided this meeting and I thank him for uniting us. One unity and one thought—the preservation of ancient burials. My heart is full. And you know what? I can drop dead on the sidewalk tomorrow and I'll be happy, knowing that no archaeologist will get my bones! Don and I were the first two Indian activists in Iowa and I'm pleased, I'm tickled to death, we've survived this long. (Carmack 1983, 42)

Running Moccasin, as warrior and peacemaker, celebrates the diversity of the persons she works with and the things they have accomplished interdependently in their problem-solving efforts.

Running Moccasin's participating role as chair and member of the Indian Advisory Committee has been highly valued by state archaeologist Duane Anderson. He commented on the cooperative efforts of Running Moccasin and other members of the Indian Advisory Committee:

> You are trying to cooperate with us and finding some value in compromise. One of the things that has been most helpful throughout this whole process has been the Indian Advisory Committee. . . . They are in a position of responsibility, advising on the feelings of the Indian community in any given situation . . . when I have a problem, I refer to the committee. They are the pivot point of communication between the archaeologist and the Indian community. (Carmack 1983, 38)

The cooperative efforts between these two entities resulted in a practical solution that addressed both sides of the reburial issue. A cooperative decision-making process including the state archaeologist and the Indian Advisory Committee was developed. In the future, each reburial case will be dealt with on a case-by-case basis rather than applying a generalized policy to all cases. Steps were also made to ensure that the Indian Advisory Committee, originally recommended by Running Moccasin, be a permanent part of state government (Carmack 1983, 39). One participant offered his observation about the cooperative nature of this group. "The cooperation we have here in Iowa is unique and it sets the standard for the rest of the nation" (41). Another non-Indian participant commented on the demonstrated respect and inclusiveness of each other at this symposium:

> I felt privileged last night to be invited to sit in on the Indian meeting. One of the things that made it so pleasant was the sense of humor that pervaded the meeting. . . . Maybe only in acknowledging each other's and regaining our own senses of humor [can] we recognize each other's humanity. . . . We've made some real progress; there's more understanding when people can laugh together as well as philosophize and agonize together. It cannot be forced, but you can consciously prevent it from happening. Everyone here has a good sense of humor. (40)

One Native American participant noted the influence of a demonstrated respect shown among participants. His comments were as follows:

> Being here will give me a head start and we will look to Iowa for leadership when Alaska has to face these issues. . . . Wisdom to me is much more than intelligence. It is deeper than that. Respect and love make up parts of it too. I feel we've shown a lot of respect today and love for Mother Earth. It is hard on us to see not only our gravesites desecrated, but also our Mother Earth. Once our roots to Mother Earth are severed, we are no longer Indian. I appreciate being a part of this. (41)

Running Moccasin, like her ancestors, has modeled the ways of a warrior and peacemaker. Her rhetorical actions speak for the values of courage, nurturance, cooperation, and respect for the welfare of humankind and all life on earth. The work she has done for the last forty years has been recognized by many. Running Moccasin's warrior–peacemaker heart, spirit, and actions have been instrumental in the ecofeminist goals of "creating new bonds among peoples of the earth, connecting each to the other" (Donovan 1998, 208). In her role

as a female Native American warrior, she has made a difference on many levels, for example, individually, community-wide, statewide, nationwide, worldwide. In appreciation for her efforts, one symposium participant prepared and served an all-Indian meal to honor her for all of her peacemaking work (Carmack 1983). There have been many honoring feasts for Running Moccasin in the past several years.

Charlotte Black Elk (Lakota), a well-known Indian activist, writer, and good friend of Running Moccasin, referenced her civil rights work and said: "We had warrior women of old and we have warrior women today. The fight that you put on in Iowa would make every woman proud that they're Indian" (Pearson 1997a). Running Moccasin's efforts have empowered others.

In recent years, she was asked to chair the first meeting of the World's Indigenous People. At a later world meeting in Venezuela, she was honored by the Maori from New Zealand on behalf of all of the indigenous people of the world: "They said that every tribe in the United States and in the world wanted to pay their respects. They said that if it hadn't been for my courage before, none of them would be in that hall because that's what brought them there, the protection of our burials, and they were all fighting in their own countries for the same thing, to preserve their heritage" (Pearson 1997a, 1997b).

In 1995, a British Broadcasting Company (BBC) documentary entitled "Bones of Contention" was aired throughout the United Kingdom. This documentary featured Running Moccasin's grave protection and repatriation work in the United States, the issues involved, and the passage of the Native American Grave Protection and Repatriation Act (NAGPRA) laws (British Broadcasting Company 1995). Public viewings of this documentary sponsored by various groups in the United States have taken place as well (Pearson 1997a).

Between 1990 and 2000, Running Moccasin coordinated ten American Indian cultural training conferences for health counselors and therapists working with substance abuse clientele. The purpose of these conferences is to help participants identify the characteristics of traditional, semitraditional, urban, and lost Native American groups; identify spirituality and how it can be used as an effective treatment method as it relates to these groups; and identify appropriate communication skills when working with all groups of Native American clients (Governor's American Indian Advisory Council 1992; 1997). The coordination of these conferences is an extension of Running Moccasin's long-standing work to increase cross-cultural understanding through the training of professionals working with substance abuse

treatment groups. These efforts serve to bridge gaps of understanding between cultures.

Running Moccasin's roles as warrior and peacemaker have been instrumental in bringing about a new consciousness of the interdependence among and between people. Her words and actions have modeled a perspective and way of problem solving that empower people (Indians and non-Indians) to work together in just and respectful ways. The integrity, love, and respect she brings to work with others has enhanced the quality of life for all those who have walked along side her on Mother Earth. Her life work has instigated significant positive changes in the laws and treatment of individual's civil rights and it has significantly contributed to creating bonds among peoples of all cultures on this earth.

REFERENCES

British Broadcasting Company (BBC). 1995. *Bones of Contention*. United Kingdom: BBC. Documentary.

Carmack, P. J. 1983. The Study of Ancient Human Skeletal Remains in Iowa: A Symposium. Office of the State Archaeologist of Iowa, Des Moines.

Donovan, Josephine. 1998. *Feminist Theory: The Intellectual Traditions of American Feminism*. New York: Continuum.

Governor's American Indian Advisory Council. 1992. Substance Abuse: Modalities of Treatment/Prevention. Brochure for 2d Annual American Indian Conference, October 6–19, Ames, Iowa.

———. 1997. Preparing the People for the Winter Months: Putting Mother Earth to Sleep. Brochure for 7th Annual American Indian Follow-up Conference, November 6, Ames, Iowa.

———. 2000. Substance Abuse. Brochure for 10th Annual American Indian Conference, May 7–9, Ames, Iowa.

Knauth, Otto. 1977. 2 Secret Iowa Cemeteries for Prehistoric Indians. *Des Moines Register*, May 30.

McKusick, Marshall. 1971. Letters to Maria Pearson, June 24 and July 15. In Pearson's private papers.

O'Shea, J. 1971. Controversy over Bones of Indian. *Des Moines Register and Tribune Company*, July 11.

Pearson, Maria (Running Moccasin). 1997a. Bones of Contention. Presentation given for the Nicollet County Historical Society, April, at Treaty Site History Center, St. Peter, Minn.

———. 1997b. Interview and personal conversation with author, Mankato, Minn.

Raffensperger, G. 1971. Glenwood Reburial Seen in Indian Bone Dispute. *Des Moines Register*, July 13.

Thompson-Pearson, Maria (Running Moccasin). 1971. Letters to Marshall McKusick, July 12 and 16. In Pearson's private papers.

Willey. 1971. Letters to Maria Pearson, June 23, July 15 and 21, and August 19. In Pearson's private papers.

Chapter 5

Mary Lou Kownacki:
"Is This Not a Miracle?"

Cathy Sargent Mester and Miriam McMullen-Pastrick

It was the winter of 1983 and the National Conference of Catholic Bishops (NCCB) was meeting in an urban hotel to produce an important pastoral, a letter outlining to the faithful the official church position on a contemporary issue. This year, the issue to which they directed their attention was peace. The NCCB represents the most dominant voice in American Catholicism. Their pastorals, while not canon law, establish the teachings that dioceses and parishes are expected to follow.

Realizing the significance and opportunity of this moment, Mary Lou Kownacki, a sister of the Order of Saint Benedict (OSB), organized her sister members of Benedictines for Peace to conduct a prayer vigil in the same hotel. Hoping to emphasize to the bishops the importance of putting their deliberations in the context of prayer, the sisters began what would be a two-night vigil. When the hotel staff informed the sisters that there was no space for them in the lobby, the sisters responded that they could pray on the sidewalk just as easily. Upon hearing this news, the bishops arranged for the sisters to be given a room. "Those were holy nights. The incense. The chant. The Taize mantras. The flickering candles. The litany to peacemakers. The bishops dropping in to pray with us. Followers of Benedict gathered from so many monasteries in the country" (Kownacki 1999).

The pastoral letter that resulted from the two days and nights of prayer and deliberation was a satisfying articulation of the concerns of Kownacki and her Benedictine sisters. The letter's conclusion read, in part, "peacemaking is not an optional commitment. It is a require-

ment of our faith. We [all American Catholics] are called to be peace-makers" (McNeal 1992b). The 1983 pastoral was a watershed document leading to the legitimization of an activist Catholic peace movement, proclaiming peace to be a constitutive element of the faith.

This incident epitomizes both the challenges of working for peace within the Catholic Church as well as the wisdom, commitment, and courage of Mary Lou Kownacki, recognized by many of her colleagues as a mother of the Catholic peace movement.

PEACEMAKING AND THE
CATHOLIC CHURCH

While peace seeking is clearly a priority in the Christian scriptures, working for anything more nonthreatening than inner peace was not church policy until 1983. The earliest Christians espoused pacifism, but centuries of so-called righteous conflict gradually perverted the gospel message, culminating in the "just war" concept widely accepted by diverse church leaders. Those clerics and religious scholars active in anti-Vietnam demonstrations, for instance, did so without the support of their superiors and were ostracized as radicals.

The Catholic Church hierarchy was, and is, decidedly masculine. As such, not only has it operated with a disproportionate distribution of power, but has done so as a closed system. Meetings such as the bishops' 1983 conference did not encourage a significant amount of outside perspectives. Change happens slowly in the Church, and when it does happen, it is usually the result of a top-down decision-making approach without regular input from parishioners or priests and certainly not from women.

This is not to say that there have not been peacemaking highlights in the history of the Church. "The opposition to the arms race had been an important theme of Catholic doctrine for decades" (Cortright 1993). Certainly, the long missionary tradition of the Church has included many instances of individuals working for the kind of social justice that is the basis of peace. The religious women of the Order of Saint Benedict stand out in that history. Their long-standing tradition of peacemaking (the word *PAX* [peace] appears above the entry to every Benedictine monastery) and recent corporate commitment to peace have provided both spiritual and practical support for the pursuit of peace by many individuals, including Mary Lou Kownacki.

The Sisters of Saint Benedict are the oldest order within the Catholic

Church and have, since their establishment fifteen hundred years ago, followed the Rule of Benedict, which emphasizes the biblical mandate, "Seek peace and pursue it." At first glance, it may seem that membership in a monastic community and involvement in the politically charged global peace movement are incompatible. The testimony and insights of monastic leaders and the Vatican itself, however, speak to a fairly natural fit between the two callings. In its 1968 document "Justice in the World," the Synod of Bishops proclaimed, "Action on behalf of justice and participation in the transformation of the world fully appear to us as a constitutive dimension of the preaching of the gospel, or in other words, of the Church's mission for the redemption of the human race and its liberation from every oppressive situation" (Kownacki 1981). As Dom Leclerq of Luxembourg noted, "Monastic orders can be peacemakers if they identify less with power and affluence and become 'prayerful people' responding to the cry of the poor for justice and peace" (Kownacki 1981).

Moreover, active social justice organizations have actually operated within the American Church for a very long time. Most prominent among them was the Catholic Worker Organization originated by Dorothy Day during the Depression. Day and her colleagues (including the great peaceworker Eileen Egan) worked tirelessly for over fifty years to represent a Christian attitude of resistance to all forms of violence and a commitment to social justice, boldly proclaiming that "what we would like to do is change the world" (Vanderhaar and Kownacki 1985). That goal, however, would require the work of more hands.

An international organization founded in France shortly after the end of World War II calling itself Pax Christi would answer the need. Initially intended specifically to foster reconciliation between the French and German people, Pax Christi grew to include chapters throughout Europe and members numbering in the tens of thousands. "The main objective of Pax Christi is to work for peace as the fruit of justice for all people, always witnessing to the peace of Christ. Pax Christi believes that Christians should be in the forefront of the search for new approaches in the fields of demilitarism, security and arms trade, human rights and sustainable development" (Pax Christi 2000).

When the international organization grew to include a section in the United States in 1972, Mary Lou Kownacki was among its earliest active members, rising quickly to a position on the national council, elected for two terms and then to the position of chairperson.

While there have been other Catholic peace initiatives, suffice it to

say for our purposes here that Pax Christi has become a significant player in international peace efforts and has provided a forum for the writing and speaking of a significant woman who speaks for peace.

EVOLUTION OF MARY LOU
KOWNACKI, PEACEMAKER

Kownacki reports that she was first impressed by issues of peace and justice through her reading of *All Quiet on the Western Front* while a Benedictine novice. The provocative writing led her to reflect on what she came to realize as a mistaken concept of enemy. She began reading extensively to explore and grasp a tenable perspective on Christianity and war. As she read contemporary Christian writers such as Thomas Merton and Daniel Berrigan, Kownacki developed a scholarly and spiritual confidence in the complete incompatibility of Christianity and war. "Eventually I had a responsibility to speak out and work to eradicate war" (O'Brien 1986). This was to become her goal and the test of her rhetorical skills as a woman religious (member of a religious order) working for peace within the male-dominated Catholic Church.

The chronology of the Benedictines' work for peace is replete with examples of Mary Lou Kownacki's special rhetorical talents and skills as she responded to this call. Known best as a poet, mystic, visionary, author, orator, and convener (Doussan 1991) she has shared her gifts with a series of Catholic peace organizations, sustaining their growth and enhancing their impact. These have included local efforts via PAX Center and the Neighborhood Art House as well as her national and international work with Benedictines for Peace, Pax Christi, and the Alliance for International Monasticism (AIM).

Working for Social Justice

Kownacki's first organized efforts in peacemaking came via the establishment of PAX Center in Erie, Pennsylvania. Shaken by the implications of the assassination of Robert F. Kennedy, she had taken temporary leave from the convent and, on returning, sought the support of her religious community to establish a quasi-monastic peace and justice center. Because such an undertaking would require her physical departure from the convent, it was considered somewhat

unprecedented and risky. With the prayerful support of her community, it was able to come to fruition.

In 1970 with a small core group of sisters and laypeople, Kownacki established PAX Center as a place not just for the study of peace and justice, but also for its application. In response to the "cry of the poor," PAX Center began a soup kitchen, a shelter for homeless women, a store selling goods from Third World artists and craftspersons, a chapter of Amnesty International, and a semimonthly newsletter focusing on peace and justice issues.

Throughout the entire life and work of the center, Kownacki was the stabilizing and visionary leader. Her eloquent articulation of its mission provided internal clarification of the goals and objectives as well as motivation to external audiences who could support the center spiritually as well as financially. When supporters wondered, for instance, how sheltering homeless women was contributing to global peace, it was Kownacki who responded: "Peace has been defined as love made visible in the world. Therefore, whenever human life is fractured, peace has been destroyed. If there is any social implication to 'Pax' it is this: extend monastic peace to non-monks and you will have peace on earth" (Kownacki 1981).

Her consistent embodiment of this belief created such ethos that she was able to attract financial support for the center, recruit plentiful volunteers, and nurture what would become long-standing relationships with resource providers. The story of Zelda best illustrates the character behind that ethos.

Zelda was a homeless, mentally ill woman who sought help at PAX Center. As Kownacki wrote, "The lowest level of truth about Zelda is that I had never met such a repulsive woman." Zelda's hallucinations were legion. She experienced people stealing from her, ambulances chasing her, attempts to imprison her. When she first appeared at the center saying she needed to get to Cleveland, Kownacki went to get her money for bus fare, hoping Zelda would leave town. By the time she returned, Zelda had heard about the Sisters' women's shelter and decided she should go there instead. Reluctant at first, Kownacki personally delivered her to the shelter. For weeks, the only food Zelda considered safe to eat was eggs. She consumed six per day—fried. Probably because of the twenty-five years she had moved in and out of hospitals where she remembered being chained naked to the wall, Zelda refused to sleep in the shelter dorm. After repeated checks to make sure the doors and windows were locked, she and her paper bags settled on the couch for the night. After a while, Zelda would

leave PAX for a few months, then Kownacki would receive a phone call, Zelda screaming that someone was trying to mutilate her. Kownacki would arrange to get her to a mental institution and wait for the inevitable call from the social worker that Zelda was ready to be picked up. Kownacki would welcome her home and invite her to stay in Erie forever. Zelda would settle in for a year or so and then the cycle would begin again.

Working for the social justice that leads to peace one Zelda at a time is only part of Mary Lou Kownacki's response to the cry of the poor. She also was involved in Pax Christi, the international Catholic peace movement, almost from its beginnings in the United States. Her transforming service as its national coordinator ran from 1985 through 1991.

Most recently, she has addressed the cycle of poverty and injustice with the creation of the Benedicta Riepp Neighborhood Art House in Erie. Hearing the "cry of the poor" as a plea for a greater sense of self-worth, she returned to her roots as a teacher and artist to develop an after-school and summer arts program that would allow inner-city children to be creators of beauty. The project, made possible by the continuing support of the Benedictine community and Kownacki's civic connections, provides lessons in music, art, poetry, drama, and reading for children of poverty.

Not content to wage the battle against injustice with just one audience, while working with the Art House, Kownacki simultaneously holds the position of executive director of the Alliance for International Monasticism. Like the other organizations Kownacki has led, AIM addresses injustice, disempowerment, and violence. Of particular import is AIM's work on decreasing the widespread illiteracy that continues to keep African women impoverished, victimized, and powerless.

Writing and Speaking to Promote Peace

A gifted writer, Kownacki once worked as a newspaper reporter but found her most profound rhetorical expression as a writer of prayers, litanies, and essays created for the periodical publications of the three peace organizations she has led: PAX Center, Benedictines for Peace, and Pax Christi USA. By situating the message of peace within prayer and liturgical formats familiar to the reader, she enhanced the impact of the message because the words were more comfortable and the

message more absorbable. Her Prayer for the Decade of Nonviolence, for instance, includes the following petitions:

> I bow to the sacred in all creation.
> May my spirit fill the world with beauty and wonder.
> May my heart forgive without limit.
> May my love for friend, enemy and outcast be without measure.
> May my hands never harm a living being.
> May my steps stay on the journey of justice.
> And may I risk reputation, comfort, and security to bring this
> hope to the children. (Kownacki 2000)

Upon close examination, these are somewhat radical pledges. But their form is familiar enough to draw readers to recite the words prayerfully, thus internalizing the concepts without discomfort.

Her writing is remarkable not just for its literary and spiritual qualities, but also for its extensive reach. Kownacki has always been sensitive to the role of marketing the written word, realizing that the prayers that have an impact are those in the hands and hearts of thousands of ordinary parishioners, not just priests, monks, and religious women. So, for instance, when Pax Christi published the Prayer for George Bush and Saddam Hussein during the Gulf War, it was Kownacki who urged its transformation into prayer card form available for sale to parish groups around the world. Pax Christi, as a result, realized nearly $40,000 in income from sales of the prayer cards, and its message reached hundreds of thousands.

These rhetorical skills have enabled her to establish and extend the work of every peace organization with which she has been affiliated, not just Pax Christi. Her written reflection on her experience with Zelda, for example, speaks to many audiences:

> You don't care for someone—
> give him or her a home, some food, your time—
> in order that she or he gets better,
> or things turn out right.
> You care for someone because you care for someone.
> You love someone because you love someone.
> Is this not a miracle? (Kownacki 1986)

Is this also not an example of the feminism referenced by Julia Wood that puts a human face on an "active commitment to equality . . . respecting all people"?

Unquestionably skilled as a fiscal strategist and as a wordsmith,

Kownacki's greatest contribution, according to those who know her best within Pax Christi, has been her presence—her ethos. These friends and colleagues speak of a woman who models nonviolence in every aspect of her life, who is so disarming that others are brought into her cause almost without realizing it, whose commitment to the Gospel is always obvious, whose words and actions are totally consistent, and whose compassion and conviction make you believe that "if you think it, you can do it" (Chittister 2000).

In practical terms, Pax Christi provided a forum that allowed her presence to be felt in venues as diverse as small local parishes and the United Nations. Realizing that outreach and networking were keys to the continuing viability and success of the Catholic peace movement, Kownacki instituted a number of initiatives that would turn the organization's fortunes around. By enhancing contacts with the American bishops, with religious communities, with individual parishes, with Catholic universities, and with national policymakers, she brought the message of peace as a Gospel mandate to tens of thousands of persons "who would never fit the image of hard-core peace activists" (Dinn 2000).

With her gift for writing in a liturgical context, she was able to produce numerous prayers and litanies that loosened the stiff collars of the resistant, conservative Church hierarchy. They became secondary persuaders in the peace movement. By the end of her tenure as national coordinator, the number of bishop members of Pax Christi had grown from 40 to nearly 90, and the individual U.S. members had increased from 6,000 to 11,000. Such success came not just from choosing the best marketing strategies, but also from executing them with eloquence. Kownacki's words and presence made the difference, moving bishops and lay leaders from a grudging acknowledgment of the existence of a Catholic peace movement to becoming its advocates. Bishop Tom Gumbleton, a past president bishop of Pax Christi, recalled that her regular coordinator reports during annual business meetings were far from routine. Phrased so poetically that they became grippingly powerful calls to follow the Gospel of peace, these extraordinarily unroutine reports moved the membership to tears. An excerpt from her 1988 remarks framed as a response to the parable of the sower is illustrative:

> Jesus had us in mind
> because we too get weary
> with the work of peace;

we too long for the land
overflowing with milk and honey;
we too live with unfulfilled expectations;
we too wonder how, where, when
 —and yes, if—
the reign of God will come.
Jesus told this parable to people like us,
people who had to be convinced
that the reign of God
depends on you, depends on me, depends on us.
. . .

In St. Paul, MN, in Lansing, MI
someone must
 serve hot meals at soup kitchens,
 hold house meetings on the grape boycott,
 protest sexism in the church.
In Seattle, WA, in Memphis, TN
someone must
 open shelters for the homeless,
 resist the deployment of the Trident,
 join a nationwide march for nuclear disarmament.
. . .

It is a profound but simple truth,
one the religious peace movement
needs desperately to ponder.
Jesus is saying
that despite all our planning,
organizing and goal-setting,
we cannot predict or guarantee
the time, the yield
or even the certainty of the harvest.
. . .

The reign of God
is already happening.
You don't believe it? Ask Rosa Parks.
One day she said NO.
'NO, I will not be humiliated again.
I, too, have a right to a seat on the bus.'
And from this small seed of resistance
grew the gigantic oak tree
of the Civil Rights Movement.
. . .

The reign of God
is already happening.
You don't believe it? Ask Madame Dortel-Claudot and Bishop Theas.
Their simple idea:

> to gather a small group of Catholics together
> to pray for reconciliation
> between France and Germany after World War II.
> We are the fruit of that seed called Peace of Christ.
> Today Pax Christi has branches in 18 countries,
> 　　and we celebrate the flowering
> 　　of that single peace seed
> 　　which somehow was sown and nurtured in our hearts.
>
> 　　Look around . . . look inside.
> 　　The reign of God is already happening. (Kownacki 1988)

Note again the litany-like nature of this discourse. The words are stirring to read; imagine hearing them spoken aloud.

PRACTICING CIVIL DISOBEDIENCE

Compelled by faith to attend and witness for the holiness of antiwar efforts during the trial of the Harrisburg 7 in 1972, Kownacki committed her first act of civil disobedience (a simple trespass to pray). As a result, she was arrested and spent nearly a week in jail, released in the early morning hours of Easter Sunday.

This was a transforming and empowering experience for the soft-spoken writer and teacher. She refers to that time as one of purging her old self and "putting on someone new. I would never be the same again" (O'Brien 1986). There was a public price to be paid for this act as well. She was the first religious from Erie ever arrested and consequently became front-page news in this very Catholic city. The Benedictines as a community would, from that day forward, be perceived as willing to engage in dramatic devices, to stand courageous for peace and justice for all, to make personal sacrifices for the cause of peace.

Kownacki's personal sacrifices would include several more imprisonments over the years. A sample of her rhetorical actions that sometimes led to arrests and her words that described them illustrate the courage, commitment, and conscience underlying her rhetorical choices.

One of her most creative and provocative actions was a Washington prayer vigil and protest in 1980, planned as part of the 1500th anniversary of Benedictism. A week of demonstrations witnessing for nuclear disarmament involved sisters from nine priories who sang, chanted,

and held processions to represent the voice of nonviolence in the shadow of the ultimate violence establishment—the Pentagon. Wanting to leave an especially memorable message, the sisters distributed seedlings to Pentagon employees arriving for work each morning as a reminder to nurture, not end, life. Within the context of a final solemn ceremony, the sisters placed peace medallions deep in the soil at each exterior corner of the Pentagon. Contrary to one guard's assumption in questioning why they would plant something that couldn't grow, the sisters' dramatic gesture for peace received significant, positive media attention. The medallions did "grow," the message spread.

While the Pentagon vigil did not get Kownacki arrested, a subsequent Washington peace action she led while national coordinator of Pax Christi USA did. Listen to her own words describing the choices she and others made at Peace Pentecost in 1985:

> We stood on holy ground.
> Not only at the National Shrine of the Immaculate Conception . . .
> Not only at Metropolitan A.M.E. Church . . .
> But we stood on holy ground wherever we walked to resist injustice,
> militarism,
> violence.
> Those who came bearing the news that all life is sacred
> Consecrated the White House, the Soviet Embassy and other major
> buildings in
> Washington into temples of the Most High.
> For saying "no" to nuclear arms, the war in Central America, abortion,
> oppression of women, soviet intervention, the death penalty and
> Apartheid, 270 were arrested and the D.C. jail became a holy habitation.
> We stood on holy ground. (Kownacki 1985a)

The 270 were among the over 1,500 Christians who spent Memorial Day weekend in Washington to pray for, learn about, and practice nonviolence. By praying in places considered off-limits to ordinary citizens, they were arrested. If that were the end of the story, one would think that the results of their peacemaking discourse were insignificant. But it was not the end, for Kownacki wrote about the event in those tellingly poetic lines. Once again it is her trademark rhetorical style of speaking poetically that awakens the spiritual dimensions of the readers' souls. Written as prose, her rhetoric is more reminiscent of the mystical canticles of Teresa of Avila. Through her rhetorical skill, the reader can hear the grounding chantlike melody of the hymn to which Kownacki alludes "this is Holy Ground."

A similar trespassing episode led by Kownacki and her Pax Christi

colleagues later that same year landed them in another jail, this one in Nevada. The event was the fortieth anniversary of the bombing of Hiroshima, which the religious peace community had elected to observe by calling followers to the U.S. atomic weapons testing site in the Nevada desert. It was there she chose to join hands with a Benedictine sister and take the Vow of Nonviolence promoted by Pax Christi. She chose the desert setting to respect her monastic roots, noting, "all the ancient fathers and mothers who had protested the linkage of church and state and said no to militarism were present." She recounts the experience this way:

> We began, "Recognizing the violence in my own heart, yet trusting in the goodness and mercy of God, I vow for one year to practice the nonviolence of Jesus. . . ." We ended, ". . .by actively resisting evil and working nonviolently to abolish war and the causes of war from my own heart and the face of the earth."
>
> A simple "no" to death. Yet, one felt the tremors beneath the scorching sands, the gods of war thrashing wildly in sleep, nightmares beyond imagining.
>
> Seven of us—representing the sponsoring groups—joined hands and stretched across the highway. At 8:16 A.M., the exact time the first nuclear bomb turned Hiroshima to ashes, we stepped across the no trespassing line, knelt down and were arrested.

These are the actions of a true "witness for peace"—using symbolic speech to convey dramatically that there are better options than war, better ways to invest the nation's time, talents, and wealth.

ANALYSIS

Consideration of Kownacki's legacy at Pax Christi brings us to the question of the overall results of her discourse as a speaker for peace. It is fair to say that her presence, her leadership, and her words have contributed significantly to the legitimization of peacemaking within the American Catholic Church. The NCCB peace pastoral laid out the theology; organizations like PAX Center locally and Pax Christi nationally have translated that theology into daily action. Because Mary Lou Kownacki was there, Zelda had a safe place to sleep. Because Mary Lou Kownacki was there, workers at the Rawlings' baseball plant in Haiti had an articulate advocate. Because Mary Lou Kownacki was there, the bishops' deliberations were wrapped in prayer. Because Mary Lou Kownacki was there, Pentagon workers

started their day thinking of peace, not war. Because Mary Lou Kownacki was there, U.S. atomic weapons were silent long enough to honor the victims of Hiroshima.

The Art House illustrates particularly well her interpersonal approach to peacemaking. In her mind, helping one child or one family to realize they have worth leads them to a respectful attitude toward all people, and from that respect, peace grows. So, one day a week, every week, you will find this leader of the international Catholic peace movement sitting in a small chair at the Art House helping youngsters to write poetry. As she puts it, when a child hears someone read aloud the words he or she has written, that child sees a new self in the mirror—a valuable self, a beautiful self.

Her rhetoric integrates a generative theory challenging the established order without confrontation, focusing instead on reempowering those disenfranchised by the present system. She not only questions the present social structure and challenges what it takes for granted, but also creates fresh paradigms for just action. In so doing, her work has the characteristics lauded in feminist rhetoric of being systematic, comprehensive, and consistent.

Kownacki's rhetoric also displays elements of feminist standpoint theory, especially its revisioned ethical perspective of caring. Her rhetoric and its expression in her lifestyle include men in the subordinate category of caring, demonstrate caring informed by reason, and express the principle that the use of rationality in the process of caring is not necessarily difficult. The most notable evidence of feminist standpoint theory in Kownacki's works is the unlearning of privilege and knowledge to view spiritual, political, and economic decisions from the perspective of the poor and disenfranchised.

Kownacki, however, expands this process in a unique and salutary way. She not only teaches the powerful and the wealthy to be responsive to those whose deprivation is extensive; she teaches the poor their own power and dignity by relating to them with deep compassion. There is no difference in her acceptance of the lawyer, the beggar, or the thief.

Nowhere is this ethical perspective of relatedness more obvious than in the approach Kownacki and her colleague Joan Chittister, OSB, used in establishing the Neighborhood Art House. They invited sixteen prominent community women to serve as members of the Core Committee. These women possess authority, influence, dignity, and compassion and enjoy a status that gives them the leverage to act on behalf of those in less conspicuous social strata. They included the

state's secretary of aging, the matriarch of an influential minority fam-
ily, a social activist, a philanthropist, a world-renowned poet, a college
professor, and other business leaders. The result is a vibrant commu-
nity of learners, the poor and the privileged mutually committed to
the educational process that underlies the creation of social justice. For
example, most days of the summer you will find lawyers, architects,
professors, clerks, and retirees sitting on the ground reading books to
inner-city children who are experiencing first hand their dignity and
personal worth. Equally important is the learning and unlearning
occurring in the three-piece-suited readers, who know the poor have
inherent dignity and ability and deserve equal opportunities.

Even in her personal prayers, Kownacki manages to merge the
worlds of the insider and the outsider. She prays for the outsiders'
needs with the same intensity and urgency for which she prays for her
own. She petitions for mercy:

> I sit. Only candlelight and an icon of Our Lady
> of Tenderness. "Mercy, mercy, mercy," I repeat.
> Let the mercy of God rain down. Mercy on the
> corner tavern. Mercy on the crack house down the
> street. Mercy on prostitution lane. Mercy on the
> couple who rage at each other into the night.
> Mercy on the children who prowl the streets
> at 2 in the morning. Mercy, mercy, mercy.
> (Kownacki 1997)

Through her writing, her speaking, and her actions, Mary Lou Kow-
nacki has left her footprints—a path to be followed by others who
would seek peace. As Kownacki is fond of noting, peace is not just the
absence of war. Peace is stability; it is justice; it is empowerment. In a
recent speech accepting an award for her work in the inner city, she
again displayed the inspiring and poetic discourse that embodies her
spirit and demonstrates her ability to influence. We cannot shed the
sound of her words:

Someone wrote that loss of collective hope is the major plague attacking our
country today. People no longer believe that they can effect change. People
feel that the widening gap between rich and poor, escalating violence, dete-
riorating inner cities cannot be reversed. By losing collective hope, people
have sentenced today's children to violent and meaningless futures.

The Benedictine sisters are not among those people. We still believe in
children and in hope.

Let Jose come then and throw his arms around Benedicta Riepp Center

Rock. Let him hold tightly. There is no need to fear, Jose. Your father may not come home at night, your mother may be unable to cope, but this rock will never move.

Let Tia come then and hold tightly to the rock. There is no need to worry, Tia. Your gift of music will be nurtured here, your self-esteem will be strengthened here; the rock will center you forever.

Let the children come then. Let them climb the rock. Let them dance on the rock. Let them dance of hope, of trust, of security, of protection, of beauty.

Let them dance on the rock of the Inner-city Neighborhood Art House. (Kownacki 1999)

Many say that the creation of peace is a slow process, that it will come about "one child at a time." One who by her words and actions is making that happen is Mary Lou Kownacki, a rock, a spirit, a mother of the Catholic peace movement.

NOTE

The authors gratefully acknowledge the contributions through interviews and correspondence the assistance of the following members, staff, and friends of Pax Christi: Joan Chittister, OSB; James M. Dinn; Bishop Thomas Gumbleton; Bill and Mary Carry; Gerard Vanderhaar; and Mary Lou Kownacki, OSB.

REFERENCES

Chittister, Joan. 2000. Interview as former prioress of Mount St. Benedict by the authors, July, Erie, Pa.

Cortright, David, 1993. *Peace Works: The Citizen's Role in Ending the Cold War.* Boulder, Colo.: Westview.

Dinn, James. 2000. E-mail to author, June 22.

Doussan, Doug. 1991. A Tribute to Mary Lou Kownacki, OSB. *Pax Christi USA* 17, no. 3.

Hallstein, D. L. O. 1999. A Postmodern Caring: Feminist Standpoint Theories, Revisioned Caring and Communication Ethics. *Western Journal of Communication* 63, no. 1: 32–56.

Kownacki, Mary Lou. 1981. *Peace Is Our Calling: Contemporary Monasticism and the Peace Movement.* Erie, Pa.: Benet Press.

———. 1985a. One Day at a Time. *Peace Witness* 10, no. 2: 3.

———. 1985b. One Day at a Time. *Peace Witness* 10, no. 3: 3.

———. 1986. *The Blue Heron and Other Miracles.* Erie, Pa.: Benet Press.

———. 1988. Someone Must Sow the Seed. *Peace Witness* 13, no. 3: 2–3.

———. 1997. Breaking the Word. *Emmaus Newsletter* 7, no. 2: 4.

————. 1999. Nothing You Do for Children Is Ever Wasted . . . Nothing. *Erie Times News*, December 12, 2C.

————. 2000. Interview by authors, July, Erie, Pa.

McNeal, Patricia. 1992a. Erie Years 1985–Present. *Pax Christi USA* 17, no. 1: 17–25.

————. 1992b. *Harder than War: Catholic Peacemaking in Twentieth Century America*. New Brunswick, N.J.: Rutgers University Press.

O'Brien, William. 1986. Mary Lou Kownacki: A Vocation of Peacemaking. *The Other Side*, November, 10–13.

Pax Christi. 2000. Pax Christi International Home Page [online]. Available at www.paxchristi.net.

Pinski, Jeff. 1999. Peace Is a Year-Round Proposition for Mary Lou Kownacki. *Erie Times News*, December 12, 1–2C.

Vanderhaar, Gerard, and Kownacki, Mary Lou, eds. 1985. *Way of Peace: A Guide to Nonviolence*. Erie, Pa.: Benet Press.

Chapter 6

Helen Caldicott's Violent Rhetoric

Margaret Cavin

> We must take over the world because 53 percent of the world's popula-
> tion are women. We do two-thirds of the world's work. We are in 1
> percent of the world's assets, 1 percent of the world's wealth. That has
> to stop! We are not second-class citizens. We're third-class citizens. We
> have no power; period! We give birth to the new world with grunts. We
> bring up the children. And then we just give up. And you know, I'm
> saying me too. So I want to talk to you about the struggle I had with
> the men, what actually happened, and how I'm gonna resolve it.
>
> —Dr. Helen Caldicott, speech in Moscow, July 23, 1987

Helen Caldicott is known to be one of the most outspoken and inter-
nationally recognized voices for peace. She has written several books
and performed countless speeches on the subject. Many of the state-
ments from Caldicott are considered by both proponents and detract-
ors to be volatile and rife with controversy. A film that supplies an
example of this volatility is *If You Love This Planet: Dr. Helen Caldicott
on Nuclear War*. According to Cass Peterson (1983) in the *Washington
Post*, the film was produced by the National Film Board of Canada and
nominated for an Academy Award as best documentary short subject.
The United States Justice Department called it a "propaganda men-
ace," requiring a disclaimer be put on it, and ordered Direct Cinema
of Los Angeles to give it a list of organizations wanting to see the film
and names and addresses of any persons "receiving one hundred cop-
ies or more" (C1–3).

Caldicott is the founder of Women's Action for Nuclear Disarma-
ment (WAND) as well as the president emeritus of Physicians for
Social Responsibility (PSR). PSR came to prominence in the 1960s and
1970s with its investigations that brought to light health and environ-
mental threats created by the U.S. investment in nuclear war capabili-

ties. In the 1980s, PSR, along with the International Physicians for the Prevention of Nuclear War (IPPNR), won the Nobel Peace Prize. In the 1990s, it assisted an orchestrated movement to close several American weapons plants, which resulted in bringing nuclear warhead production to a halt. The organization has recently extended its work to include new issues related to human survival and health.

Caldicott enjoys support from highly visible and influential personalities. Senator Edward M. Kennedy has called her the "mother of the nuclear freeze movement" (*Los Angeles Times* 1984, 1, 6), and she is known for her "evangelical" and "charismatic" speaking style (Omang 1982, A2). In a telling compliment, Lila Garrett, a television producer and official of Voters to End the Arms Race, praises Caldicott while anticipating some of her criticism: "Helen Caldicott is not a politician. She's a very emotional and basically not a political person. She can afford to be sometimes factual and sometimes not factual. She can speak in broad emotional language" (Clifford 1988, 3).

Caldicott is not without detractors, however. She is criticized for having "slanted" presentations in which she gives information that has very little or no factual support and is often teeming with "errors." One critic, Charles Krauthammer (1986), charges in a *Washington Post* editorial, "Helen Caldicott announced in 1983 that 'if Ronald Reagan is reelected, accidental nuclear war becomes a mathematical certainty.' After a while, prophecy so smug takes on the aspect of misanthropy. People then give up marching and return to jogging" (A15). In another article written by Robert Coles (1984), she is called "elitist" and "arrogant" and is accused of using "forceful, exaggerated rhetoric of the polemicist" (D1). Taylor Branch (1984) states in a *New York Times* article, "Dr. Caldicott is a supercharged, melodramatic version of Dr. Spock" (13). There are also several accounts of politicians running for Senate who either wrote or spoke disclaimers after Caldicott's speeches were given in their behalf because of outraged audience members (Coles 1984, D1; Clifford 1988, 3).

In June 1986, Helen Caldicott gave an address to the annual meeting of the National Women's Studies Association in which she issued a resignation from the position as president of PSR. In her farewell speech, considered one of her most powerful, she discussed the reasons for the decision to separate herself from the organization she founded. Her retirement speech was premature, however; she returned to speak on behalf of peace issues on July 23, 1987, at the World International Democratic Federation Convention in Moscow. These two speeches (the farewell and the return) and some of her later

talks form the source material for this investigation of Caldicott's rhetoric and an attempt to identify her most frequently used metaphors. Examining her rhetoric from a feminist criticism perspective may allow us to determine possible reasons for her controversial persona and lead the study to its ultimate goal of determining components that should or should not be included in a language of peace.

The study of human communication systems focusing on the inclusion of progressive, cooperative, and peaceful effects has long been the focus of scholars from a variety of disciplines. All studies that attempt to identify the specific components and structures of peace discourse existing within a given society contribute important concepts toward the development of a language of peace. A necessary part of developing this language system is to discover forms of discourse that fail to communicate these ideas. I believe Helen Caldicott provides such an example.

Robert Ivie, considered one of the seminal scholars in the study of war discourse and who uses metaphorical analysis to examine the "failure" of antiwar "idealists," proves to be a valuable point of departure for this study of Caldicott. In a 1987 article (Ivie 1987a), he concludes that anti–Cold War "idealists" (among whom he names Helen Caldicott) fail to capture a larger audience beyond the peace community due to their choice of ineffective metaphors. Ivie maintains that Americans require what he understands as an ancient cycle of redemption to overcome transgressions. In this view of the process, participants at war must define the other as scapegoat so that their own "sins" can be destroyed. This creates, then, quite an appeal for combat. Caldicott, he maintains, does not utilize this redemptive process. Rather, she assigns guilt to the participants and calls for purgation through mortification (self-sacrifice of audience). This process fails, in Ivie's view, because it does not recognize the need (especially among cultures in the United States) to purge guilt through blame of an "other." This classic cycle structure may in itself determine a simplistic reading of the metaphors of Helen Caldicott and may also limit an understanding of the failure of her tactics. I believe Ivie is unable to fully appreciate the extent to which Caldicott's own symbolic constructs are not successful with a larger audience.

Examining the metaphoric configurations of Helen Caldicott is crucial when attempting to discover her particular language of peace and the reasons for its ineffectiveness. In Cavin, Hale, and Cavin (1997), an article that serves as a centerpiece for a forum about Helen Caldicott, the authors discuss the symbols present in much of Caldicott's lan-

guage. These symbols can be organized into three power-related categories: physician, mother, and deity. Such categories, which traditionally represent positions of authority, are at odds with her implicit goals of giving voice to marginalized peace seekers and crusading for the voiceless natural world. Cavin et al. (1997) investigate the metaphors Caldicott uses, giving specific attention to power images. It is obvious to any critic examining the rhetoric of Helen Caldicott that she finds symbolic speech useful and important when attempting to create new peaceful paradigms (model, prototype, ideal) in the minds of her audience members. This transfer of symbolic systems, however, is problematic in that Caldicott calls for a new paradigm while utilizing old paradigmatic structures that are patriarchal in form. In the speeches studied (Caldicott 1986, 1987, 1990, 1992a, 1992b), I have isolated those same three structural metaphors: (1) physician, (2) mother, and (3) deity.

In this chapter I revisit the power metaphors used by Caldicott and attempt to answer the two main criticisms of Cavin et al. (1997): (1) Caldicott's "need" for confrontational rhetoric, and (2) that Caldicott's ends justified the means. Feminist criticism is a useful lens through which to view Caldicott's rhetoric because it is helpful in identifying potential conflicts of interest between the pursuit of peace systems and the "fight" for equality for women and minorities, both of which coexist within Caldicott's language.

METHODOLOGY: FEMINIST CRITICISM

According to Sonja Foss (1989), there are three basic principles on which most feminists agree. The first is that "women are oppressed by patriarchy. Patriarchy is a system of power relations in which men dominate women so that women's interests are subordinated to those of men, and women are seen as inferior to men" (166). The second principle is that women have different experiences than men (166). The third principle is that women's perspectives are not included in our culture. This extends to our language systems as well in that the perspectives of women "are missing from language, which centers on men and their experiences" (167). Therefore, feminist criticism is a process that is dedicated to discovering "the rhetorical forms and processes through which oppression is maintained and transformed" (169).

There is much research that has shown the connections between

patriarchy, sexism, and war. This "war system," according to Betty Reardon (1996), is kept in power by aggressive force and even violence (10). Likewise, there is much research to support the connection between feminism, equality, and peace (97). In this chapter, I posit that Caldicott does not transform patriarchy but rather utilizes rhetorical methods that reflect a patriarchal system of aggressive force, which proves counterproductive to her message of peace. She accomplishes this contradiction by employing the three metaphors: (1) physician, (2) mother, and (3) deity.

According to Sonja Foss (1989), metaphoric criticism "constructs a particular reality for us according to the terminology we choose for the description of reality. It serves as a structuring principle, focusing on particular aspects of a phenomenon and hiding others; thus, each metaphor produces a different description of the 'same' reality" (189). If an audience accepts this "reality," the metaphor can then signify specific courses of action for listeners or readers. Not only is metaphor argument, according to Kenneth Burke (1970), but it is also a marker delineating the user's "perspective" (503–4). If we take Burke's position, it then follows that an analysis of the key symbolic constructs used by a given speaker enables the critic to understand motive, function, and effectiveness.

PHYSICIAN METAPHOR

I've met with Reagan in 1983 for an hour and a quarter. His IQ is at most 100. I had to speak to him in single-syllable words so he could understand me. He reminded me of the least intelligent person I've ever treated, like "Mrs. Brown, you put this tablet in your mouth," that level. He was clinically paranoid towards the Soviet Union. He's a nice, old, rather sick man. (Caldicott 1987)

In establishing the conflict in which she is engaged, Caldicott creates a medical drama in which she is physician to two patients: the earth and the audience. The earth is "dying" from a "terminal disease" and must be saved. Similarly, the audience is sometimes composed of patients who must accept her treatment, and sometimes audience members are among the evil carriers of the disease. The disease itself is defined as nuclear and other environmental hazards. The treatment for the disease requires Caldicott's personal protocol. Robert Ivie (1987a) documents Caldicott's use of disease metaphor in his analysis of her Cold War rhetoric.

In this "disease" symbolization of conflict, Caldicott's rhetoric is both ends and means oriented. She wants the earth saved at all costs, even though that cost may be "painful" or even "fatal" to those trying to save it. However, while the conflict is clearly about achieving those goals, she believes that only her proposed means can achieve those ends. Her "treatment" of the disease involves both general and specific actions of the audience. The "patients" must read Caldicott's book and go through the treatment prescribed therein. They must go through the "painful stages of dying and decision-making." They must be prepared to save the world, to engage in and lead a "global revolution." More specifically, the "treatment" requires them to avoid using such items as tissues, tampons, and toilet paper, to avoid drinking Cokes and beer, to avoid watching TV, and to fight against nuclear buildup and other environmental hazards. Within this metaphorical construct, Caldicott identifies three specific entities as being engaged in some sort of battle (a metaphor within a metaphor). The participants involved in this war are (1) herself and those who are capable of joining her, (2) the ill "patients" or victims of the disease, and (3) the "carriers of the disease" (Caldicott 1986, 1987, 1990, 1992a, 1992b).

Caldicott identifies herself as physician to the earth and to the audience. In the process of creating this persona, she positions herself as morally superior to both her patients and her fellow healers. This moral status is determined both by her use of the physician's philosophy that the body is "sacred" and that life is "holy" and by her insistence upon being perceived as an exclusive agency of that philosophy. She is "tough" with her patients, but claims that her approach "keeps them alive." At one point she states, "I am telling you that you have a fatal disease and unless you listen to me you are going to die, okay? The treatment is unpleasant, but you could survive if you accept the treatment." She goes even further in her statements of superior value by authoritatively pronouncing that she simply "won't let them die." Further, she indicates her exclusive morality by contrasting her practice with the practices of others (particularly male doctors) in that she considers herself a physician aided by female qualities, such as "intuition and vulnerability," as opposed to male doctors, who are removed from humanity and riddled with hidden agendas. She defines these inferior colleagues as "gods of politics." Further, Caldicott indicates her moral exclusivity through distancing herself from what she considers the medical practice in the United States: an "old-age industry" that has more to do with the stock market than with healing people (Caldicott 1986, 1987, 1990, 1992a, 1992b).

There are two interdependent patients in Caldicott's battle-of-the-disease drama. The first, and seemingly the highest priority, patient is the "terminally ill" planet earth and all its plant and animal life. The second patient is the set of human inhabitants, though in Caldicott's Gaea-influenced view of earth, there is no actual distinction, since "we are part of the earth and it is a part of us." Both patients, according to the constructs of Caldicott, are, like her, superior to the other figures in her drama—the "carriers" and "promoters" of the disease (Caldicott 1986, 1987, 1990, 1992a, 1992b).

While Caldicott's rhetoric identifies the audience (patients) as inferior to her in knowledge and in morality, they are clearly not the enemy. The patients are unified with her by virtue of a common goal—the fight against the disease. This united front, however, is jeopardized by the ignorance of those who are stricken and helpless in the face of the great foe. With this as the given state of affairs, Caldicott constructs a drama where the willing "ill" are to exclusively follow her instructions so that they may have a chance at survival. She warns, in these speeches, that the treatment will be "unpleasant," very "painful," and that it sometimes "leads to death." She adds that many patients will lack the moral commitment to follow through with the treatment but that a few will have the possibility, if they do as Caldicott instructs them, of "becoming a Joan of Arc" or a "Martin Luther King, Jr.," moving from inferiority and illness to superiority and wellness (Caldicott 1986, 1987, 1990, 1992a, 1992b).

Regardless of the condition of the particular patient's moral potency, there is no option for inactively joining the ranks of the noble. Caldicott makes it very clear that failure to act will ultimately move the uncommitted from the lionized ranks of patients/victims into the vilified number considered "carriers" of the disease and enemy. Her audience suffers this fate in her estimation when it either supports or fails to confront the major killer/carriers she identifies. Caldicott suggests that every individual can either "fulfill our soul's destiny to save the Earth, or live a totally selfish life, and in so doing, kill the earth." She polarizes the audience in this way, and she often assumes that many have fallen from the ranks and accuses them of participating in the spread of the disease: "You are paying the lobbyists to represent the corporations who are killing our earth. When are you going to stop it?" (Caldicott 1986, 1987, 1990, 1992a, 1992b).

Apart from the victims-turned-disease, the primary carriers and enemies are the media, "old men politicians," the military, corporations, nuclear power plants, Washington lobbyists ("Beltway Ban-

dits"), and religious fundamentalists. Individuals singled out for special blame include George Bush, Bill Clinton, Ross Perot, and Ronald Reagan (in one particular speech she warns: "You'll never recover from Reagan"). She counsels that these groups and individuals are "killing the earth" and must be stopped. They are morally inferior, not just from lack of commitment, but from active, evil deeds. They are "killers" of pensions for old people, of workers, unions, health care, and so forth. This demonization of the enemy is included with dehumanization in her frequent evaluation of their intellectual inferiority as in her "treatment" of Ronald Reagan (Caldicott 1986, 1987, 1990, 1992a, 1992b).

MOTHER METAPHOR

"I love those doctors, I nurtured them, I looked after them, I brought them in. . . . My baby was taken from me and it is now dying. I feel that I have been raped, psychologically raped" (Caldicott 1986).

The second control-driven structural metaphor used by Caldicott is that of mother. Caldicott casts herself in this maternal function as she speaks of her relationships to Physicians for Social Responsibility (PSR), to the peace movement, to the audience, and even to those "bad boys" doing all the damage to the earth. This particular metaphor can be subdivided into three components: (1) Caldicott as mother, (2) the audience as good but ignorant and immature children, and (3) the bad children (mostly "boys") who are actively destroying the world (Caldicott 1986, 1987, 1990, 1992a, 1992b).

In describing herself as mother, Caldicott again configures herself into an elevated status position. Defining herself as victim creates her positions of moral superiority; she is a mother who has suffered persecution for her efforts and her commitment. Caldicott's "baby" (the PSR organization) was "taken from me and it is now dying." She claims to have given birth to the organization, then was "forced out by the men." Her "grief" over losing the baby requires that she "go away and get over it"; Caldicott equates her loss to that of a woman who has lost an actual child, and if she does not allow herself the appropriate grief, she will "end up in a mental hospital." In addition, Caldicott seems to present herself (and potentially womankind) as morally superior to men because she believes women's nature as mothers gives them a greater concern for the health and nurturance of the earth. Caldicott refers to women as "the Curators of all life on

earth." "We hold it in the palm of our hand," Caldicott states, and "it is our decision whether it lives or dies" (Caldicott 1986, 1987, 1990, 1992a, 1992b).

Caldicott is superior in knowledge and maturity; while she was once "naive," a "little girl" when she first practiced medicine, she is now grown up and mature. Others who want to "grow up" must listen to her as "mother." The audience members must gain the maturity of adults so that they can be parents rather than children. She challenges the audience to "grow up and be really adults and take back your country." Women, particularly, must become "revolutionaries" and "take over the Congress, the medical profession, and the corporations" (Caldicott 1986, 1987, 1990, 1992a, 1992b).

Caldicott often defines women as little girls who have the potential to be mothers; she refers to them repeatedly as "sisters," and yet, currently, they are still children who must listen to her if they are to mature. According to Caldicott, women and the peace movement (inseparably linked for Caldicott) have "aborted ourselves" by not finishing the work they started. She encourages women to stop "acting like children" in "begging for abortion rights," but instead they must "take over the Congress and determine the law of the land ourselves." "Age is beauty, age is wisdom," Caldicott says, encouraging the audience to value maturity and responsibility. These female children are not seen to be evil by Caldicott, they are simply inferior due to their lack of maturity and wisdom. The evil is reserved for the male children (Caldicott 1986, 1987, 1990, 1992a, 1992b).

Caldicott refers to the Star Wars program as "run by little boys all aged from twenty to thirty, all from broken homes, all psychologically deranged, all brilliant" and who "live on Coke and ice cream all day." Caldicott labels lobbyists as "Beltway Bandits," thus defining what they do as a child's game involving good guys and bad guys. She repeatedly refers to Ronald Reagan as "Ronnie" and explains that he supported Star Wars because he likes weapons to "boink" and "bounce." According to Caldicott, the men who run the military and who escalate the arms race are like adolescents who have "missile envy." Caldicott portrays them using the missiles or weapons as penis substitutes in a kind of "macho" competitive game and quotes them as thinking, "Mine's bigger than yours," or "I want one as big as yours." Caldicott refers to this language as "testosterone-oriented." She provides as evidence of this orientation some of the phrases the soldiers use: "You know, 'missile erect,' 'soft lay down,' 'deep penetration,' 'penetration aids,' the whole deal. We've got to look at the

testosterone factor. It's very important in whether the world lives or dies. We need to balance it with the estrogen factor" (Caldicott 1986, 1987, 1990, 1992a, 1992b).

DEITY METAPHOR

I'm absolutely no different from any of you. And we mustn't put each other on pedestals because what happens with me is people put me up there and project a whole lot of feelings onto me which don't belong to me at all, but belong to other people. And I want you to see my clay feet today and to see my weaknesses and to know that you are me. And that you can do what I've done, and you have to do it! (Caldicott 1992a)

While Caldicott's view of herself as both mother and physician imply her superiority, she grants herself even more direct dominance with her deity/subjects imagery. Different views of deities emphasize different characteristics of those powers and different requirements for relating to them. One perspective that is offered by Anne Baring and Jules Cashford (1993) in their book *The Myth of the Goddess: Evolution of an Image* allows that the construct of deities may create "an image that inspires and focuses a perception of the universe as organic, alive and sacred whole, in which humanity, the Earth, and all life on Earth participate as 'her children.' . . . Everything is woven together in one cosmic web, where all orders of manifest and unmanifest life are related, because all share in the sanctity of the original source" (xii). In this morality, it is the responsibility of all of earth's inhabitants to sustain and nourish the earth as the source of life. A contrasting view of the deity function indicates a force external to nature, one that masters, or conquers, the "chaoticness" of nature (xii). This representation of the warrior or creator god focuses on omnipotence and authority rather than nurturance and inclusiveness. Caldicott claims for herself characteristics of both these views of the deity as she expands the image to include her resultant relationship with her subjects.

Caldicott defines herself as deity when she speaks of being the "life-giver" to and "healer" of both PSR, her followers in the peace movement, and ultimately the earth. She speculates about the advantages of the nonnuclear annihilation of human life and the return of the earth to the elephants and dolphins and invites the audience to "image" God through the symbolism of a rose and a baby (referencing the mother metaphors she has used for herself in the same

speeches), explicating her view of the related and sacred cosmic whole. She claims, "I have the Truth," and "I don't lie," which are obvious qualities of a supreme and moral god and beyond the scope of the human condition. Caldicott also claims the power of deity, both in her ability to dispense power ("I dropped a bomb on them") and in her ability to recover from attempts of "evil" people to seize her power. In an image of the fallen god or the pure sacrifice (a key role in many religious dramas), she decries that she "lost her power" at PSR, that she was "screwed" and "raped" and that she "gave them my power on a silver platter, I gave them my head." Attaching the deity function to that of the mother metaphor, Caldicott states that she is willing to "die for the children," and her most important "child" is the earth. She also frames herself as sacrificial victim in her power and morality of the deity metaphor, stating, "I sort of was assassinated, but I am alive and I can come back," here using language reminiscent of the Judeo-Christian Jesus, who said: "I am the resurrection and the life" (Caldicott 1986, 1987, 1990, 1992a, 1992b).

Caldicott demands that her followers too must sacrifice themselves. "We're all going to die. That's what your life is about. . . . Take what I said seriously and save the planet. You'll go down in history and be remembered forever by the higher power." Similar words can be found in the words of Jesus: "Greater love has no one than this, that he lay down his life for his friends. You are my friends if you do what I command" (John 11:25). Caldicott also advocates that women empower themselves and become "revolutionaries." They should not "ask" or "demand" rights or power, rather they should just "take over" the Congress, the Senate, the presidency, all the parliaments of the world, the corporations, the professions, the church, the world (Caldicott 1986, 1987, 1990, 1992a, 1992b).

For Caldicott, men represent the satanic force in the world and are responsible for the existence of most of the problems she's confronting both personally and globally. In addition to blaming men for her problems at PSR, Caldicott ultimately blames them for the condition for the world: "And the world is being destroyed by pollution and the nuclear issue by the men, and we've let them." She denounces their goals and their methods, several of which are their uses of "lies," their dependency on "statistics and facts," and their obsession with "power." She describes them as the "god of politics," "mentally sick," "crazy," "killing each other," "back stabbers," "distanced from their emotion and their fears," and the "aggressive competitive spirit of the males." This polarization effect positions Caldicott as the supreme

good against men as the supreme bad (Caldicott 1986, 1987, 1990, 1992a, 1992b).

ANALYSIS

"And you know, the thing is, once you stand up and talk, and you make a mistake, you never make that mistake again. It's like in medicine, when you kill a patient by mistake, you never make that mistake again. I haven't killed many patients. But that's the way you learn" (Caldicott 1987).

Caldicott's ideology is at odds with her symbolic communication. Caldicott performs a rejection of violence by wrapping a cloak of mother and healer around her public persona. While the metaphor, as discussed previously, can be described as typical of agitation rhetoric, which seems to function well to motivate people to social protest, war, and violence, it does not seem to be useful in the promotion of peace. Peace is certainly about social justice (often achieved, at least for one side of the argument, through social protest, war, violence), but peace, from a feminist perspective, is also considered to be about recognizing the legitimate needs and interests of a respected "other," successfully educating the "other" about one's own legitimate needs and interests, and attempting to create jointly constructed solutions rather than fighting a war. A peace rhetor, then, would not find effective the contrasting uses of polarization (particularly through dehumanization and denigration of the other).

Gregory Desilet's article (1989) provides a useful simplification of Kenneth Burke's melodrama. Burke explains that at the heart of melodrama are a hero and villain. Humans can choose their actions within this field of polarities and determine and assign dramatic roles to the players in an ever-changing metaphorical hero/villain formulation (65–83). The oppositional function of these two characters allows the hero/villain cycle to continue and thereby provide a means of perpetual destruction. Caldicott uses the polarization of the hero/villain metaphor throughout her rhetoric. She becomes hero when she makes self-referential statements of intellectual and moral dominance. The positions of villain and victimizer, with their attributes of demonized other, inferiority, and evil intent, are present as well in her symbolic language defining the opposition polarity. These positions are reserved for the disease, the destructive males with their phallic atomic toys ready to wreak havoc on the victim planet, and any other

person or group of persons who disagree with her, do not follow her, or who disallow her authority as physician, mother, and deity. She, in her role as hero, is the primary if not exclusive agent of change and the only one fit or willing to do battle with the disease and the world-destroying males. This maintains the violent cycle melodrama. The polarization of the hero/villain is a classic us-against-them stimulant for violence. This symbolic core of violence lies at the heart of Caldicott's speeches, though it is somewhat concealed in an incongruous mixture of justice and inclusivity that hides the effect of patriarchy and power.

In a further extension of the Burkeian methodology for analyzing symbolic acts, Caldicott's linguistic forms can be said to "debunk" rather than "demystify," a distinction made by Thompson and Palmeri (1993). In an attempt to establish a "poetic use of language" based in Kenneth Burke's poetics, Thompson and Palmeri create a methodology that argues that a "poet" or speaker should not debunk but demystify and that the poet who attempts to seek a poetic world "will not benefit from a dogmatic frame and debunking tactics." Rather than destroy or dehumanize the other, the poet should seek to clarify the given circumstances of the drama. If Caldicott is placed in the position of the poet, we see that she "debunks" rather than "demystifies." This, according to Thompson and Palmeri, typically leads an audience to perceive the "poet" as an extremist and to believe that "a more moderate course of action is needed. Then, typically, the moderate course is believed to be that of the corporate world and government officials adept in strategic ambiguity" (281–82). The very people Caldicott has attempted to polarize into a position of evil other have become, in the mind of the audience, the repositories of reason.

Furthermore, in using this debunking and mystifying language, Caldicott appropriates from her opponents the same forms and structures she has attacked. She wants to violently subvert (at least in symbolic terms) the structures of authority rather than change a nonpeaceful system to a peaceful one. In her symbolic world, she has replaced the present authority structure with a new authority (herself and other women "overthrowing" men). Martin Luther King Jr. (1963) would admonish that if one uses the same methods as the "oppressor," one becomes the "oppressor" (52). Another great voice of peace, Elise Boulding (1995) argues that women do not seem to have the confidence to act out their own metaphors, but rather, she states, they throw away their own metaphors (non-gender-exclusive collaborative/power-sharing behaviors) for the "metaphors of men" (non-

gender-exclusive competitive/dominant behaviors). To borrow from King (1963), Caldicott has become the oppressor, throwing away the female metaphor suggested by Boulding (1995). Caldicott appropriates the effects of the dominant and violent to call for collaboration and nonviolence. Carol Cohn (1990), in her study of military language, states, "If we refuse to learn the language, we condemn ourselves to being jesters on the sidelines. If we learn and use it, we not only severely limit what we can say, but also invite the transformation, the militarization of our own thinking" (120). As is indicated previously and clearly articulated by Cohn, Caldicott has indeed learned "the language."

There are many instances in the speeches of Helen Caldicott in which she makes references to her ability to heal. She explains that the "patients" must take her "treatment" and "unless you listen to me you are going to die, okay?" (Caldicott 1986, 1987, 1990, 1992a, 1992b). Her message is "prescriptive," which is also a feature of patriarchy. Patients must rely on the "expertise" and superiority of the physician for their well-being rather than sharing mutual dialogue and equality.

This physician metaphor has as its necessary counterpart a disease metaphor. Caldicott's use of the disease metaphor suggests another problem. In a study of the symbolic uses of this particular construct, Steven Perry (1983) writes, "Disease metaphors are the product of mysteries; they become in turn the producers of mystifications, insofar as they play upon our natural horror of the unknown in order to convey meanings which are left unstated" (229–35). Recalling Thompson and Palmeri (1993), the idea of the disease symbol as a tool of mystification illuminates the effect Caldicott produces with her insistence upon using the images of illness. While using these images produces the effect of fear with a concomitant dependence attaching the "patient" to the "physician" (conveniently, Helen Caldicott, in these cases), it does so at the expense of successful information transactions. Caldicott does not clarify the mystery. Perry (1983) also suggests that infestation metaphors are "dehumanizing" as they turn the human body into a host for other life forms that are invasive and require even more invasive acts to eliminate (229–35).

The dehumanizing effect is further heightened by the patient's belief that in an effort to cure the disease, any method will be performed regardless of the level of invasion, pain, or trauma. Perry states: "The only real priority is to provide a cure, and the means used to achieve this end are not in themselves very important. Any cure is acceptable which snuffs out the disease and stops short of killing the

patient" (229–35). Caldicott pushes the fear response in her audiences a step further, however, because she states many times that the patients must be willing to go as far as to relinquish their lives in their efforts to stop the disease. This total dehumanization represents a threat to the audience Caldicott seeks to embrace.

Recalling the Burkeian melodrama, dehumanizing the other is a critical step that must be taken before the violence begins. Still another incongruity is illustrated by Susan Sontag's (1979) combining of the melodrama and the disease metaphor. She writes, "The melodramatics of the disease metaphor in modern political discourse assumes a punitive notion: of the disease . . . as a sign of evil, something to be punished" (79). Punishment, while offering certain benefits to a would-be mother, does not create avenues of identification.

According to Foss (1989), "Women are often taught to be nurturing, affiliative, and cooperative, for example—qualities that are contrary to patriarchal values of competition, domination, and hierarchy. If women's values were incorporated into general cultural structures, they probably would produce more humane ways of living" (172). On the surface it would seem that Caldicott's embracing the role of mother is in keeping with Foss's dream for a better world. An important distinction here is that Foss is musing on the idea of the mother metaphor in discursive arenas in which there is a constant tension of dialogue present. Caldicott takes the mother role and simply inserts it into an existing power mechanism. When the mother is used as yet another tool of political maneuvering, that mother is more akin to the image of Medea than Mother Teresa. Caldicott seems to want to be a patriarchal matriarch.

Still the most dissonant force present in the failure of Caldicott is her use of violent means to eradicate what she sees as violent predispositions, in her role as "deity." Eastern philosophy, such as Buddhism, early modern philosophy, such as Schopenhauer, or even the prephilosophical systems of the Gaea thought all provide models in which polarities are rejected in favor of universal oneness. Any of these models, faithfully followed by Caldicott, might have proved successful for communicating her message of peace. Rather than adopt these systems in their entirety, however, Caldicott selects only the portion that serves to distance her from the polarized other. The misuse of these systems creates a fracture of thought that proves impossible to overcome. The audience members, wishing to become members of the unpolarized system, find themselves unwittingly cast in a violent melodrama. In the words of an audience member at Caldicott's 1982

presentation at the Salem State College graduation ceremony: "She talks down to you! She's telling us we should be like her in our ideas and what we do, or she'll call us 'sick' and the whole earth dying. Then she talked about these kids who think the world is coming to an end soon, because of a nuclear war, and that's mighty good and smart of them, and if we weren't thinking the same way, we're a bunch of saps!" (Coles 1984, D1). Another audience member, possibly responding to Caldicott's "disease" metaphor, "felt treated like a foolish, sick child by someone behaving high and mighty" (Coles 1984, D1). In addition, in her role as the warrior god or "deity," she places herself in a position of unlimited authority. Foss (1989) states, "In many popular artifacts, a masculine position is structured for the subject—audience members are asked to identify with a male protagonist who controls events and conveys a sense of omnipotence" (170). Again, we see Caldicott embrace patriarchal methods that are reflected in her metaphorical choice of deity.

In response to Cavin et al. (1997), respondents defended Caldicott's rhetorical methods by arguing that (1) women must have a rhetoric of "defiance" in order to "confront" male-dominated power structures (Gordon 1997, 269); and (2) Caldicott's ends justified her means because of the "urgency of her message" (Gordon 1997, 269; Sharoni 1997, 282; Summy and Neil 1997, 295). The call for the ability to make use of violent imagery indicates both a lingering desire for destructive force among those who search for alternatives and a lack of understanding of the force of perception and expectancy. Each audience member brings to an event a set of expectations about the rhetor with whom they intend to collaborate toward the creation of an artifact. Concomitant with these expectations is a moral encoding, a kind of ethical litmus test, which is applied to the speaker. If the members of the audience feel the speaker is betraying their expectations or, worse, lacks veracity, they tend to turn away from the speaker and his or her message. Caldicott effects arrogance, superiority, and violence. These attributes are at odds with the moral tests of her apparently desired audience members (an assumption that she would have enjoyed a broader audience base than just her ardent supporters or fans). When the test is failed, the speaker loses her effectiveness, and more, she runs the risk of alienating great numbers of those who were eager to follow her lead or to at least be persuaded to envision a shift in the dominant patriarchal order of things.

It would seem that if the peace movement desires to make progress in a cause it believes has moral and ethical good, then the individuals

in the peace movement must not only hold the world ethically and morally accountable, but themselves as well. This means that the means used for certain ends, in fact, do matter. It means that ethical guidelines must form a structure for any language used to communicate this very important message of peace.

The respondents Summy and Neil (1997), who are both Australian researchers, make an interesting point:

> The enticing suggestion that emerges from comparing the American and Australian reactions to Helen Caldicott is not that she resorts to power-related imagery that contravenes her long-term peace goal, but that the differences between the two societies tell us something about their unique society and manners. . . . Other peace leaders will come along and use similar authoritarian and vivid imagery; so the relevant question, as we see it, pertains to what makes the American peace constituency so susceptible to such devices? Why do many Americans respond to the message of the dominating personality? (299)

This chapter does not attempt to answer this question; however, it would be an interesting approach to a thesis for future peace research from a feminist perspective.

Caldicott's message of peace is established, nurtured, and executed in a language of hostile confrontation, if not actual war. Rather than transforming patriarchy, she perpetuates patriarchy. Caldicott polarizes, dehumanizes, assumes a superior and controlling posture, uses inflammatory and mystifying language, and "debunks" her adversaries. This tactic of taking on the tools of the empowered violent to destroy their system has resulted in her limited effectiveness as a peace activist. This clearly articulates the need for an entirely new linguistic and symbolic paradigm of peace action. Metaphors of dominance and violence are of little use to those wishing to construct symbolic worlds of peace and empowerment.

Carol Cohn (1990) immersed herself in the world of the military as an attempt to understand the constructs of detached violence. Upon the completion of her study, she confessed to the seductive nature of the dominant symbolic system. Cohn concludes that the seeker of peace must understand and resist that seduction to be effective in reconstructing worlds of nonviolence. She writes:

> The dominant voice of militarized masculinity and decontextualized rationality speaks so loudly in our culture that it will remain difficult for any other voices to be heard until that voice loses some of its power to define what we hear and how we name the world. The reconstructive task is to cre-

ate compelling alternative visions of possible futures, to recognize and
develop alternative conceptions of rationality, to create rich and imaginative
alternative voices—diverse voices whose conversations with each other will
invent those futures. (118)

The peaceful deconstruction of dominant voices of violence must be
carefully performed by those searching for persuasive tactics geared
toward enlisting the general public's support in the ways of nonvio-
lent transactions. Peace speakers must resist the seductive infection of
the dominant violent paradigm before administering metaphors of a
nonviolent future. Feminist rhetoric and criticism has a challenging
and exciting role to play in this worthy enterprise.

REFERENCES

Baring, Anne, and Jules Cashford. 1993. *The Myth of the Goddess: Evolution of an
 Image*. London: Penguin Books.
Boulding, Elise. 1995. Interview by Margaret Cavin and Katherine Hale, Boulder,
 Colo., April 25.
Branch, Taylor. 1984. Missile Envy: The Arms Race and Nuclear War. *New York
 Times*, July 29, vol. 133.
Brincat, Cynthia. 1997. Commentary: Moving beyond the Metaphors of Conflict
 toward a True(er) Peace. *Peace & Change* 22, no. 3 (July): 272–80.
Burke, Kenneth. 1970. *A Rhetoric of Religion*, rev. ed. Berkeley: University of Cali-
 fornia Press.
Caldicott, Helen. 1980. *Nuclear Madness*. New York: Bantam.
———. 1984. *Missile Envy*. New York: Morrow.
———. 1986. Farewell speech. Pacifica Radio Archives, Universal City, Calif.
———. 1987. Helen Caldicott in Moscow. July 23. Pacifica Radio Archives, Univer-
 sal City, Calif.
———. 1990. Let's Be Hot. October 27. Pacifica Radio Archives, Universal City,
 Calif.
———. 1992a. May Day, May Day. Pacifica Radio Archives, Universal City, Calif.
———. 1992b. *If You Love This Planet: A Plan to Heal the Earth*. New York: Norton.
Caldicott, Helen, with the assistance of Nancy Harrington and Nahun Stiskin.
 1994. *Nuclear Madness: What You Can Do.* 2d ed. New York: Norton.
Cavin, Margaret. 1994. Replacing the Scapegoat: An Examination of the Rebirth
 Strategies Found in William Sloane Coffin's Language of Peace. *Peace & Change*
 19, no. 3 (July): 276–95.
Cavin, Margaret, and Barry Cavin. 1998. The Usefulness of Rhetorical Critique
 toward Discovering Helen Caldicott's Effect. *Peace & Change* 23, no. 2 (April):
 201–6.
Cavin, Margaret, Katherine Hale, and Barry Cavin. 1997. Metaphors of Control

toward a Language of Peace: Recent Self-Defining Rhetorical Constructs of Helen Caldicott. *Peace & Change* 22, no. 3 (July): 243–63.

Clifford, Frank. 1988. Speaker Stirs Sparks at McCarthy Fund-Raiser. *Los Angeles Times*, April 8, 3.

Cohn, Carol. 1990. Nuclear Language and How We Learned to Pat the Bomb. In *Making War, Making Peace: The Social Foundations of Violent Conflict*, edited by Francesca M. Cancian and James William Gibson, 111–21. Belmont, Calif.: Wadsworth.

Coles, Robert. 1984. Freezniks Are Elitists: Workers Resent Being Told They're Dumb and Numb. *Washington Post*, November 11, D1.

Desilet, Gregory. 1989. Nietzsche Contra Burke: The Melodrama in Dramatism. *Quarterly Journal of Speech* 75 (February): 65–83.

Foss, Sonja K. 1989. *Rhetorical Criticism: Exploration and Practice*. Prospect Heights, Ill.: Waveland Press.

Gordon, April. 1997. Commentary: What Is an Effective Language of Peace? *Peace & Change* 22, no. 3 (July): 264–71.

Hatzenbueler, Ronald L., and Robert L. Ivie. 1983. *Congress Declares War: Rhetoric, Leadership, and Partisanship in the Early Republic*. Kent, Ohio: Kent State University Press.

If You Love This Planet: Dr. Helen Caldicott on Nuclear War. 1982. Los Angeles: Direct Cinema Limited. Film.

Ivie, Robert L. 1974. Presidential Motives for War. *Quarterly Journal of Speech* 60, no. 3 (October): 337–45.

———. 1982. The Metaphor of Force in Prowar Discourse: The Case of 1812. *Quarterly Journal of Speech* 68, no. 3 (August): 240–53.

———. 1984. Speaking "Common Sense" about the Soviet Threat: Reagan's Rhetorical Stance. *Western Journal of Speech Communication* 48 (winter): 39–50.

———. 1986. Literalizing the Metaphor of Soviet Savagery: President Truman's Plain Style. *Southern Speech Communication Journal* 51 (winter): 91–105.

———. 1987a. The Ideology of Freedom's "Fragility" in American Foreign Policy Argument. *Journal of the American Forensic Association* 24, no. 1 (summer): 27–36.

———. 1987b. Metaphor and the Rhetorical Invention of Cold War "Idealists." *Communication Monographs* 54, no. 2 (June): 165–82.

King, Martin Luther, Jr. 1963. *Strength to Love*. Philadelphia: Fortress Press.

Krauthammer, Charles. 1986. Apocalypse Then: The End of the End of the World. *Washington Post*, March 28, A15.

Los Angeles Times. 1984. Dr. Caldicott Diagnoses a Case of "Missile Envy," June 27, 1, 6.

Omang, Joanne. 1982. Reagan Again Says Soviet Union Influences Anti-Nuclear Groups. *Washington Post*, 106 December 11, A2.

Perry, Steven. 1983. Rhetorical Functions of the Infestation Metaphor in Hitler's Rhetoric. *Central States Speech Journal* 34 (winter): 229–35.

Peterson, Cass. 1983. Canada Asks State Department to Reverse Decision on Three Films. *Washington Post*, 106 February 26, C1–3.

Reardon, Betty. 1996. *Sexism and the War System*. Syracuse, N.Y.: Syracuse University Press.

Sharoni, Simona. 1997. Commentary: In Search of Counterhegemonic Discourses of Peace. *Peace & Change* 22, no. 3 (July): 281–92.

Sontag, Susan. 1979. *Illness as Metaphor*. New York: Vintage.

Summy, Ralph, and Hilary Neil. 1997. Commentary: Demystifying Helen Caldicott—The Australian Experience. *Peace & Change* 22, no. 3 (July): 293–302.

Thompson, Timothy N., and Anthony J. Palmeri. 1993. Attitudes toward Counternature (with Notes on Nurturing a Poetic Psychosis). In *Extensions of the Burkeian System*, edited by James W. Chesebro, 269–83. Tuscaloosa: University of Alabama Press.

Chapter 7

Betty Bumpers's Use of Myths and Metaphors

Anna L. Eblen and Lori Wisdom-Whitley

One of the final things that pushed me into this [peace activism] was my own nineteen-year-old daughter . . . after her first year away from home at college. We were on our way across Tennessee back to Arkansas to spend the summer and she said, "Mother, since we [family] are so scattered . . . while we're home together this summer we need to sit down and get each other thinking about what we would do in case of a national disaster, and we survived, where would we go to find each other again?" And you know it just took my breath away to think that here is a nineteen-year-old girl that I thought only had clothes and boys and a few serious subjects on her mind, that would be concerned with something like this, that it would consume her good mind and her energies. And I said to her in a very casual way, "We would just go back to Arkansas. . . ." She said, "Mother don't be ridiculous, with seventeen Titan missile silos, two SAC bases, one of the few storage places for . . . toxicological warfare . . . they're all triple-targeted with X number megatonnages of bombs. Arkansas wouldn't even be there. . . ." Think of those who don't have anyone to share their fears with and how much of our wonderful resource of young people is being consumed by dealing with that fear. It's not where I want to be . . . in my country, on my planet, with my future and more than anything else, my children's future and the future of all of the children of this world.

—Betty Bumpers, 1982

Peace activist Betty Bumpers has used myth and metaphors in public presentations to portray herself and her organization, Peace Links. Bumpers provided a "civilizing" vision as an alternative to the violent and tragic frontiersman image that Ivie (1987) and Carpenter (1990) saw as the predominant metaphor of Cold War nuclear proliferation.

123

This chapter suggests that Bumpers's "taming the frontier" myth and metaphor clusters were directed toward women and helped make this peace organization relatively acceptable to middle-class Americans. In addition, we show Bumpers's gender portrayals in myth and metaphors and speculate about effects.

During the last years of the Cold War, a number of peace movement organizations sought to counter nuclear proliferation. Communication theorist Ivie (1987) suggests that the movement suffered from an inability to counter the image of Soviet threat that drove the American arms buildup. Despite revitalized interest among both American and international movements (Falk 1987; Ivie 1987; Joshua 1983; Mechling and Auletta 1986; Salomon 1986; Williams 1984), peace movement groups continued to struggle with imagery that they hoped would be powerful enough to transcend the metaphor of Soviet "savagery" (Ivie 1986). Feminist theorists who studied contemporary social change also examined violence, militarism, and peace imagery among women and women's peace groups. For example, Ruddick's (1989) work on maternal thinking and peace states, "Although peace can be hinted at in a general vocabulary, peacemaking is always specific. . . . I grope for images of peace" (139).

Carpenter (1990) describes late twentieth century combatant metaphors as "tragic" examples of the frontiersman metaphor. The tragedy of the metaphor, according to Carpenter, arose from the violence inherent in the frontier marksman; he notes "our weaponry includes missiles [i.e., Minuteman] named metaphorically after mythic, sharpshooting riflemen from our earlier national experience" (17). This chapter follows researchers who have established that the frontier metaphor is so deeply entrenched in language and norms that it constitutes a myth about life in the United States (Carpenter 1977; Rushing 1983). Ivie argues convincingly that the nuclear proponents wielded the myth to their advantage by portraying themselves as "the frontiersmen" and the Soviet Union as "savages."

The renewed peace movement often promoted metaphors that were less effective than the violent frontier myths (Ivie 1987). Although many peace movement organizations offered metaphors, such as nuclear "madness," these did not directly counter the prevailing metaphors of the violent frontier. Carpenter (1990) advocates alternative frontier metaphors dominated by the ideas of progress—struggling pioneers and moving West, with values of freedom and democracy. In alternative metaphors, the frontier woman reappeared. Carpenter's example, from the play *Oklahoma!*, presents an older woman admon-

ishing a despairing younger one, " 'You gotta be hearty, you got to be. You cain't deserve the sweet and tender things in life less'n you're tough' " (16). In fact, a few peace movement groups, especially women's groups, had begun to present alternative mythic visions during the early 1980s. In addition to restoring women to the nuclear frontier, some began to provide metaphors that banished the savage enemy image and encouraged a more complex, humane view of the Soviets. Peace movement organizations provided metaphors that guided a transformation of frontiersman combat rhetoric.

This chapter utilizes feminist standpoint rhetorical analysis to examine the myth and metaphors used by Betty Bumpers to describe the peace movement organization that she founded, Peace Links, Women Against Nuclear War, and her world. Identification of myth and metaphors illustrates the rhetorical invention that made Peace Links relatively acceptable to middle-class Americans. Feminist analysis examines gender portrayal and describes possible effects of these images of women. Finally, the chapter discusses functions of Peace Links's metaphors after the Cold War. The analysis of myth derives from Shepler and Mattina's (1999) method of mythic analysis. Metaphors detection is based on contemporary definitions of metaphor and Ivie's (1987) methods of uncovering metaphorical concepts. The feminist analysis proceeds from Hallstein's (1999) and Donovan's (1985) explication of feminist theory, as well as Foss's (1989), Foss and Griffin's (1995), and Foss, Foss, and Griffin's (1999) descriptions of feminist rhetorical theory and analytic methods.

MYTH AND METAPHORS

A number of communication authors have contributed to current understanding of myth (Barthes 1983; Bennett 1980; Rowland 1990; Rushing 1983). Rushing's article discusses the frontier/Western myth in some depth. Defining *myth* as "a society's collectivity of persistent values, handed down from generation to generation" (15), Rushing goes on to point out, "These values [individuality and community] are in essence the points of opposition in the old frontier, 'the meeting point between savagery and civilization' " (16). Shepler and Mattina (1999) apply Rushing's definition of myth to their analysis of Jane Addams's peacemaking; they note, "Myths are not necessarily imaginary stories or fables, but can be imbedded in the very language of a culture." The following analysis explores metaphors in order to

uncover imbedded figurative language, as well as other "literal" images that appear in Bumpers's speeches.

Communication and language scholars have continued to study the occurrence and rhetorical applications of figurative language, especially metaphor. Turner (1974) describes social reality as largely determined by metaphorical communication. The following analysis uses Ortony's (1979) "comparison" and "interaction" views. The comparison view states that metaphors compare ideas of objects transferred to new contexts (Richards 1936). In the interactionist view, related concepts (vehicle and tenor) interact or blend to produce new meanings (Black 1962). For the purpose of this chapter, a variety of metaphorical language expressions or figures of speech (synecdoche, simile, metonymy, analogy) are categorized as metaphors (Manning 1979) and analyzed for meaning (Lakoff and Johnson 1981).

Researchers have noted that leaders use language devices, especially metaphor, to create and legitimize a social reality (Ivie 1987; Koch and Deetz 1981; Riley 1983; Smircich 1983a, 1983b; Turner 1974; Weick 1979). Riley (1983) and Pacanowsky and O'Donnell-Trujillo (1983) conclude that leaders create power structure through figurative language. Ivie (1986) suggests that metaphors, as public discourse, influence public policy. These issues of power, cultural values, and policy are of special interest to feminist theorists, particularly those who investigate war and peace policy (Reardon 1996; Ruddick 1989). Because of the importance of leaders' metaphor use, the following study focuses upon Betty Bumpers, Peace Links founder.

RHETORICAL ANALYSIS METHODOLOGY

This rhetorical analysis begins with the discovery of root metaphors, using Ivie's (1987) five-step process. Ivie's analytic technique includes familiarity with the speaker's context and text; selection of representative texts to identify vehicles; clustering metaphorical concepts; compiling concept files; and analyzing each file for patterns of vehicle usage. To establish background familiarity, we examined several Peace Links artifacts from 1982 to 1988, including local and national printed materials, newspaper and magazine clippings about national and local campaigns, and electronic resources.

For the current study, we selected one videotaped and five audiotaped speeches or interviews by Betty Bumpers, founder of Peace Links. The six artifacts, video- and audiotaped interviews from 1982

through 1988, were copies of the only taped speeches attributed to Bumpers available from the Peace Links Records at the University of Arkansas Library Special Collections. We repeatedly listened to the tapes, then independently identified vehicles. Later, an assistant transcribed the tapes to check for accuracy of the lists of metaphors. Together, the authors clustered the metaphors and analyzed the patterns of usage.

After the metaphors had been clustered, the authors interpreted the metaphors around the issue of the frontier myth, which Ivie (1987) and Carpenter (1990) had identified as dominant within U.S. nuclear proliferation rhetoric. Bumpers did not use direct stories of the frontier, but the imbedded language demonstrates that she availed herself of the powerful images.

In addition, we applied feminist theory to analyze the implications of these myths and metaphors for the women involved and for effectiveness in their peacemaking efforts. Ruddick (1989) notes the many ways in which feminism and peacemaking connect, when she cites the poster slogan "A feminist world is a peaceful world" (242). At the same time Ruddick acknowledges that many peace metaphors do not capture the wide range of feminist viewpoints. Standpoint theory, according to Hallstein (1999), states:

> As "outsiders within" patriarchy, women's standpoints and visions are distinctively different and less distorted that those of men, whose visions are, according to Hartsock (1983), always partial and interested in preserving their position . . . standpoint theorists recognize that within the structural positions "men" and "women" there are multiple differences among men and women based on power relations attendant to race, ethnicity, class, and sexual orientation. (36)

Thus, Bumpers's peacemaking talk reflected her experience as a middle-class, middle-aged, white woman with unusual, although limited, access to the political elite. Her talk maintained a difficult balance between claiming the need for equal political participation in the democratic process and claiming special feminine moral authority. Reardon's (1996) work on sexism and the war system describes the juxtaposition of equality and difference this way: "Differences . . . whether biologically based or culturally derived . . . do not and should not constitute grounds for discrimination against women . . . [feminists] seek to introduce feminine values into the social or political realms" (20). Although Betty Bumpers did not identify herself as a feminist, nor Peace Links as a feminist organization, the speeches provide evidence that feminist analysis can illuminate the frontier myth,

metaphors, the portrayal of women, and potential impacts of Bumpers's rhetorical invention upon audience and the position of women in society.

BETTY BUMPERS

Betty Flanagan Bumpers, born in 1925, grew up on a farm in Franklin County, Arkansas. She studied at Iowa State University, the University of Arkansas, and the Chicago Academy of Fine Arts. In her hometown, Charleston, Arkansas, she taught art in the public schools. Her 1949 marriage to Dale Bumpers, who became governor of Arkansas, then a U.S. senator, permitted a continuation of her public service. Along with raising three children, Betty Bumpers created a state childhood immunization program that became a national model. She encouraged volunteers and local organizations to come together to immunize Arkansas children against dangerous childhood diseases; this volunteer network approach later helped develop Peace Links.

In 1982, Betty Bumpers and a group of friends in Little Rock, Arkansas, began to meet about their concerns over possible nuclear war. They organized Peace Links with the goal of increasing awareness and education about peace and nuclear war. Like the immunization program before it, Peace Links made use of women's organizations that were already in place. Peace Links women took discussions of the nuclear arms issues to their churches, PTAs, garden clubs, and book clubs in order to raise awareness about the arms race. Peace Links described its goals: "By providing educational materials and working through traditional community organizations . . . to establish a network of women involved in activities to prevent nuclear war" (Peace Links Inc. n.d.).

The Peace Links organization primarily recruited middle-class, adult, white American women. Although the group included a substantial number of U.S. Senate and congressional wives, Betty Bumpers addressed her invitation to nonactivist women outside the power structure (Foss and Griffin 1995). According to Totenberg (1986) and Walgren (1983), Peace Links sought to encourage American women to take part in the democratic process by expressing their concerns about nuclear war and peace. In addition to challenging the early Reagan years' rampant militarism and nuclear proliferation, exemplified in the violent frontier myth, Bumpers's rhetoric had to establish credibil-

ity and overcome the negative connotations of peace activism during the height of the nuclear arms race.

The following analysis describes the myth and metaphors that Betty Bumpers used in a representative sample of public presentations. This analysis suggests that Bumpers's imagery provided viable alternatives to the Cold War metaphors of the violent frontiersman by interjecting women and women's activities into the prevailing frontier myth, transcending fatalism about nuclear war. Betty Bumpers used a set of "civilizing" metaphors that were fairly consistent during her public presentations about Peace Links. Her speeches and interviews demonstrate metaphors about women who help tame the "tragic metaphor" of America's frontiersmen.

According to this analysis, Bumpers and her colleagues visualized nuclear proliferation as headed toward an accidental but catastrophic showdown. Peace Links offered new characters and outcomes that helped tame the frontier. In doing so, Peace Links provided a template of metaphors about women, children, and a more humane frontier; similar metaphors would be useful during the transition in American/Soviet relationships in the post–Cold War era.

WOMEN TAME THE FRONTIER

Rushing (1983) suggests that women in the frontier myth usually appear in one of two roles: the "good girl," representing family and community, and the "bad girl," representing individualism. The good girl "is stereotypically the schoolmarm or the rancher's daughter" (17), while the bad girl, alone and independent, inhabits the dance hall or brothel. Rushing notes feminists' reluctance to accept this dichotomy and their challenge to the myth to include more unsung heroines. She recognizes the historical exceptions to these roles, "wild women" figures such as Calamity Jane, but reflects that most were caricatures of heroic behavior (23). Thus, in tapping the frontier myth, Bumpers needed to choose her language carefully in order to emphasize the good frontierswoman role, with the good of the community and family as central metaphor.

We categorized Bumpers's metaphoric language into five representative clusters, with linguistic and nonverbal vehicles: (1) traditional womanhood, (2) handwork, (3) places and moving, (4) having a voice, and (5) Soviet humanity. Feminist analysis suggests that the first three clusters emphasize women's experiences within a division-of-labor,

"domestic sphere" social structure. Conversely, the last two clusters emphasize the "public sphere," advocating equality of participation in democratic institutions. Tables 7.1 through 7.5 show the representative linguistic vehicles and mythic images.

Traditional Womanhood

Betty Bumpers's primary cluster metaphors identified with traditional "domestic" womanhood and this image permeated her public presentations; it made sense for a middle-class woman of her generation. The most frequent metaphors involved the roles of mother and nurturer. (See table 7.1.) Her appeals to protection for children—not only one's own, but all children—pervaded the public messages; for example, "I refuse to look at extinction for my children and other children"

Table 7.1 Traditional Womanhood Metaphor Cluster

Source	Vehicle	Connotation
"Woman's World"[1]		
	"we shrink from peace"	Small, fearful
	"the fabric of life"	Domestic; pattern
	"wanted someone else to take care of [arms race]"	Sought protection
	"simple when you boil it down"	Recipe; cooking
WALC Call-in Show[2]		
	"take to breast"	Nurture
	"swept it under the rug"	Housekeeping
	"sixth sense tuned in"	Women's intuition
A Time to Make Peace[3]		
	"rocking the dog"	Play on nurture, boredom
	"poisoning our milk"	Life-threatening
	"a delicate role"	Petite, fragile
	"pull it out from under the rug"	Housekeeping; cleaning up
	"we [mothers] can't do it alone. It takes those we can get behind us as parents"	Motherhood, community
	"I was teaching . . . in a little town"	Schoolmarm; one-room school
	"I refuse to look at extinction for my children and other children"	Motherhood, protection of young

1. Bumpers 1983. 2. Bumpers n.d. 3. Betty Bumpers 1982.

(Bumpers n.d., *Betty Bumpers and Nancy Ramsey*). In stories about her own family, she traced the roots of her own activism to her daughter's fears of nuclear war. Bumpers referred to raising healthy children with a series of suckling metaphors, applying the concept to peace activism: "Most of you women in here, I know, remember the test ban, when we women of this country effectively got the atmospheric testing stopped for nuclear weapons because it was poisoning our milk, that we nurtured our babies with. It was poisoning the milk of the cattle even that were nurturing their babies and our babies" (Betty Bumpers 1982).

Bumpers added many protection metaphors and anecdotes about her work with immunization programs, but her message went past the usual concerns about children's welfare. She asked, "Why should we go to all the trouble to protect the health of our children if we are going to incinerate them?" (Betty Bumpers 1982). This paradoxical and disturbing image juxtaposes the protection sought for children in Bumpers's early childhood inoculations program with fears for children that led to her peace activism. Protective mothering contrasts with the horror of a mother who envisions her children killed in a nuclear shoot-out.

Several traditional womanhood metaphors presupposed male–female division of labor, in that women were portrayed in domestic work and men in public work. Bumpers pictured household activities metaphorically (nuclear weapons concerns "swept under the rug," [Bumpers 1983]), and literally, when she talks about herself prior to activism: "But after my youngest child grew to maturity and left home two years ago to go to college, I thought that I would have time, at last, to involve myself in all of the selfish things that I enjoy doing and felt like I didn't have time to do, such as my patchwork quilting and gardening and flower arranging and all kinds of arts and crafts" (Betty Bumpers 1982).

Bumpers occasionally created metaphors that some critics might see as essentialist—relying upon a definition of gender difference as innate. She encouraged the women she addressed not to "shrink away from peace" (Bumpers 1983), and this expression, along with others, summons the vision of women as small or frail. In a bow to the concept of women's intuition, she attributed women's superior recognition of nuclear danger to a "sixth sense tuned in" (Bumpers 1983). When asked about why she recruited women to the peace movement, Bumpers alternated between essential differences and socialization argument:

I was a housewife, an elementary school teacher, an artsy-craftsy person that was very content with that area of life . . . which is the fabric of life, and women represent that. I wanted someone else to take care of national security issues . . . we [women] have our own area of interest, basically, and . . . we have been socialized and trained in our upbringing . . . to be involved in other areas. (Bumpers 1983)

Bumpers used many metaphors expressing her former assumption that men would "take care of" the public sphere. She talked about her abandoned hope that political and scientific men would protect her and her family ("experts lulled us"), but she presumed that men would take over some of the public labor role later: "we have wonderful, brilliant men who can find solutions" (Bumpers n.d., *Betty Bumpers and Nancy Ramsey*). However, she also envisioned women working in public for the good of the community. She often referred to her own work as a schoolteacher, part of "good woman" frontier myth. When Bumpers evoked the brave schoolmarm image—"I was teaching in a little town"—she placed herself among the good women who educated and civilized society and countered frontier violence metaphors (Bumpers n.d., *Betty Bumpers and Nancy Ramsey*).

Handwork

Perhaps related to traditional womanhood was a metaphor cluster regarding hands or working with the hands. (See table 7.2.) One persistent metaphor concerned "take into our hands the shaping of the future" (Bumpers 1983). While Bumpers urged women to take on this responsibility, she used a counterpoint metaphor that implied men have failed at the task. She did not, however, state the accusation in harsh terms, so that no one person, not even the male gender group, got blamed outright. Bumpers instead used the passive voice, "[nuclear policy is] not being handled properly" (Bumpers 1983).

Bumpers also invoked the hand metaphors when she asked women to "hold our country together" (Betty Bumpers 1982). One story repeated on several tapes described handwork by a spunky woman at the first meeting of Peace Links. The story contains elements of "good girl" myth in that the hero is a teacher, but she is also rough, a bit of the wild woman. In this story, women at the meeting had been arguing that "peace" could not appear in the group name because of the bad connotations of radical activism: "But there was a young woman there who teaches gifted children . . . and she banged my coffee table and made everything on it jump up and down. And she said,

Table 7.2 Handwork Metaphor Cluster

Source	Vehicle	Connotation
"Woman's World"[1]		
	"wring my hands"	Anxiety
	"take into our hands the shaping of our future" [3 times]	Creation
	"not being handled properly"	Censure
	"someone had their hand on the helm"	Trust [misplaced]
	"we may as well fold it up"	Give up
	"banged my coffee table"	Determination
	"hold our country together"	Unity; comfort
	"hold on to this"	Stability
A Time to Make Peace[2]		
	"off the cuff"	Spontaneity
	"turn it around"	Positive change

1. Bumpers 1983. 2. Betty Bumpers 1982.

'Do you women realize how important what we're talking about is, when we can't even use the word peace in a title for our organization.' And we used it anyway" (Betty Bumpers 1982).

Bumpers described the disappointment of women who believed that "someone had their hand on the helm of the great ship of state." This metaphor also recalls the division of labor from the womanhood cluster and resonates with the cluster about moving. When she concluded that there was no one at the helm "except who we put there," Bumpers used the occasion to encourage women's political participation as a remedy (Bumpers 1983).

Places and Moving

Bumpers's third most frequent metaphor concerned places and moving, another image consistent with frontier taming. (See table 7.3.) On the frontier, open land always lay ahead. Bumpers talked about being in a bad place ("I'm in a position I don't want to be in") and about moving along ("go in a new direction" [Bumpers 1983]). "We want another direction to go in . . . we the people can say . . . to our leadership, it's not the direction we choose to go in. And they will respond to us and give us a new direction" (Betty Bumpers 1982).

One of Bumpers's most challenging rhetorical decisions involved her insistence upon the value of women's participation in the demo-

Table 7.3 Places and Moving Metaphor Cluster

Source	Vehicle	Connotation
"Woman's World"[1]		
	"[I don't like it] where I am."	Closed in
	"I'm in a position I don't want to be in."	Trapped
	"facing extinction"	Threatened
	"women need to make a move"	Preparation for travel
	"[Peace Links] provided a place"	Safe space
	"not in the direction . . . they will give a new direction . . . change direction . . . go in this direction."	Open frontier, travel a new way
	"take the step"	Begin a journey
	"another direction"	Travel a new way
	"get behind us"	Support needed
WALC Call-in Show[2]		
	"turn a corner in this country . . . women will lead us around this corner"	Women find promised land
"Woman's World"[3]		
	"who to turn to"	Patriotism, heroism
	"the direction we want to go in" [2 times]	Desirable travel, change
	"I'm glad I've reached a point in my life"	A good place
	"I don't want to put our country in a position of danger . . . trying to get us out"	Patriotism and safe changes

1. Bumpers 1983. 2. Bumpers n.d. 3. Bumpers 1983.

cratic process. The dilemma existed because democratic participation moved women from the private sphere into the public. Public participation required individualism, in that a woman had to make independent decisions and take independent, often lonely, action. By integrating these individualistic actions into metaphors about the good of the greater community, Bumpers attempted to transcend the problem. For example, sometimes Bumpers indicated that women would guide the change of direction ("women will lead us around this corner," [Betty Bumpers 1982]). Women, according to this metaphor, should adopt the responsibility and heroic task of moving the people

through the wilderness toward peace. Her rhetorical device of integrating individual action and responsibility for the community spilled over into the "have a voice" metaphor cluster.

Having a Voice

Democratic participation for women remained central to Bumpers's message and she depicted it with the "having a voice" metaphor cluster. Bumpers exemplified the frontier virtues around community responsibility and neighbors caring for each other in her use of this metaphor. (See table 7.4.) This vision corresponds to Carpenter's (1990) call for "ethically more responsible uses for frontier metaphors" (17). "Voice" metaphors revolved around feminist issues of

Table 7.4 Voice Metaphor Cluster

Source	Vehicle	Connotation
"Woman's World"[1]		
	"addressing our fears" [2 times]"	Clarity, reassurance through talk
A Time to Make Peace[2]		
	"want to have a voice"	Determination
	"stand up and say"	Forwardness
	"turn the hum into"	Creating with song
	"having a dialogue"	Interaction
	"let voices be heard"	Performance
	"democracy speaking"	Patriotism
	"increase this hum for peace"	Performance, singing
National Public Radio[3]		
	"make it begin to sing"	Performance, creation
A Time to Make Peace[4]		
	"[hum] becomes a shout" [2 times]	Courage, determination
	"I'm glad I can speak out; I'm glad I have the courage to speak out"	Courage, uppity
	"dare to have a voice"	Participating unexpectedly
	"public debate"	Argument, persuasion
	"have a say"	Participation, access
	"a new voice"	Adding to public dialogue

1. Bumpers 1983. 2. Betty Bumpers 1982. 3. Bumpers n.d. 4. Betty Bumpers 1982.

equal participation and institutional equity. For example, Bumpers described Peace Links as a "new voice" and urged other women to "speak out" and "have a say" about their government's policies (Bumpers n.d., *Betty Bumpers Interview*). The most consistent use of the metaphor appeared in a series of exhortations to participate: "This [political activism] is the kind of thing that will increase the hum for peace in this country. It will make it begin to sing and then shout, but it will only be when enough of us in this country speak, and speak to our elected membership" (Betty Bumpers 1982).

Another important use of the voice metaphor occurred when President Reagan had publicly accused antinuclear activists of weakening the U.S. position. Bumpers, who must have been alert to the political attack because of her family's position in Senate politics, was interviewed on a PBS radio talk show. She emphasized the importance of a "public debate" and defended the difficult position of women who "dare to have a voice" (Bumpers n.d., *Betty Bumpers on National Public Radio*). In several interviews and speeches, she referred to the unpleasant reality of public criticism of peace activists' patriotism. Even though she cautioned potential activists about the pain of "red baiting" accusations, Bumpers said, "I'm glad I can speak out. I'm glad I have the courage to speak out" (Bumpers n.d., *Betty Bumpers and Nancy Ramsey*).

Soviet Humanity

Despite attacks on her patriotism, Bumpers used humane metaphors about the Soviet Union, directly confronting the prevailing Cold War "savages" metaphor. (See table 7.5.) The connections that Peace Links developed internationally included interactions with Soviet women and children, including visits, exchanges, and pen pal programs. This face-to-face personalization strengthened the perception by U.S. Peace Links members regarding the humanity of the Soviets. Bumpers's metaphors reinforced this "humanity of the Soviets" theme. The most common metaphors concerned the U.S./Soviet similarity of feelings, especially parental feelings. For instance, Bumpers related a story of meeting a woman cosmonaut, who told her, "I, too, want to raise my family . . . to have grandchildren." This metaphor resonated with the traditional woman theme.

Even when directly discussing nuclear war and weaponry, where the dominant metaphor of the era portrayed the Soviets as aggressive and evil (Ivie 1987), Bumpers asked for empathy rather than fear. She

Table 7.5 The Soviets Metaphor Cluster

Source	Vehicle	Connotation
"Woman's World"[1]		
	"link with each other"	Connection
	"superpowers indulge in confrontation"	Childish
	"they are like us"	Similarity
	"[woman cosmonaut] said, 'I, too, want to raise my family . . . to have grandchildren"	Motherhood, nurture
	"I know the Russian people don't have the same kind of privilege to vote"	Sympathy
	"they fear us . . . they think we're aggressive"	Empathy
WALC Call-in Show[2]		
	"the Russians want to live as badly as we do"	Similarity; likeness

1. Bumpers 1983. 2. Bumpers n.d.

asserted, "They [Soviets] are like us" (Bumpers n.d., *Betty Bumpers and Nancy Ramsey*). She reversed the usual accusations about the Soviets, saying, "they fear us . . . they think we are aggressive" (Bumpers n.d., *Betty Bumpers and Nancy Ramsey*).

Rather than vicious savages, the Soviets are to be pitied because they have not achieved the level of Americans ("they don't have the privilege to vote" [Bumpers n.d., *Betty Bumpers and Nancy Ramsey*]). In fact, in a metaphor reminiscent of frontier manifest destiny, Bumpers said that American women "have the burden" of speaking for Soviets, who cannot speak through a democratic process. This metaphor recalls the notion of white man's burden, wherein savages were to be civilized and reshaped to be more like white peoples. In the case of the Soviets, this metaphor seems to have carried through the post–Cold War transition.

CONCLUSION

Feminist standpoint theory implies that metaphor clusters in Bumpers's public presentations contained patterns unique to this speaker, this time, and this movement. However, the consistency of her mythic

images and metaphors contrasted with the frontier images that surrounded nuclear armament rhetoric show that she wielded the language effectively. She used metaphors that tap "the common standpoint that women, as a group, occupy in a patriarchal culture" (Hallstein 1999, 38). The surprise during the analysis was how successfully Bumpers had managed the frontier myth and metaphors; she used the myth to confront the powerful with another version of their frontier story. In Bumpers's version of the mythic American frontier, women were a civilizing force; they tamed the excesses of sharpshooters and nuclear wilderness. In attempting to tame the violent frontier, Bumpers brought in women by encouraging them to use their womanhood to save their families. She evoked frontier values of courage by asking women to find their voices; she extolled the value of hard work by asking women to take the job into their own homes and relationships. She urged women to examine the dangerous place they had settled, the place where they might be wiped out in an instant, and then to lead the move in a new direction. She described the Soviet people, portrayed by official policy as savages, as people similar to our own people in many ways.

Feminist analysis yields several impressions of these metaphors. First, the dialectic tension between equality and essentialist feminine uniqueness played out in Bumpers's metaphors. There is no perfectly comfortable fit between a traditional U.S. middle-class, middle-aged female role and political activism. Tonn (1996) described perhaps the best combination as "fierce" protective mothering. But the dialectic tension increases when the women's activism is peace activism. Peacemakers must confront without falling into violent rhetorical means. Bumpers's resolution was in seizing and transforming the patriarchal violent frontier vision into a more civilized frontier with women at the center, protecting the community.

Second, the metaphors provided a means of invitational rhetoric so that middle-class, uninvolved women could understand the perspectives of other women who decided to oppose nuclear buildup (Foss and Griffin 1995). Bumpers relied heavily upon first-person accounts of her own life, her own fears for her children, her own efforts to fathom nuclear "mutually assured destruction" and weaponry. Her metaphors portrayed herself and her worldview. Standpoint theory recognizes that "there are differences among women occupying that subordinate social location" (Hallstein 1999, 38). Like many representations of the mythic frontier, ethnic and racial minority characters, "bad" women, noble savages, and other complications were left out.

Bumpers dealt with the mythic elements that she knew best. To the extent that she resolved the tensions between her own public and private lives, between community and individualism, her metaphors succeeded. Her speeches and her grandmotherly persona attracted attention in the popular press as well as the peace community. Because of her own political celebrity and the fact that her group included a significant number of political wives, her words reached audiences that might not otherwise have had access to their invitation.

At the time of the breakup of the Soviet Union, the U.S. political establishment found itself in the awkward position of trying to normalize relationships with a nation official rhetoric had portrayed as savages. Peace movement rhetoric, such as Bumpers's mythic change of direction and new frontier, may have led the way. Certainly, the "humanity of the Soviets" appears to have become a transitional theme. Perhaps future analysis can illuminate whether other "taming the frontier" metaphors allowed the more avid cowboys and frontiersmen to ride gracefully into the sunset while the women settled in.

REFERENCES

Ashera, Diana. 1989. From Caterpillars to Butterflies: Evolving Metaphors in Peace Research. Paper presented at the Speech Communication Association Convention, San Francisco, Calif.

Barthes, R. 1983. *Mythologies*. New York: Hill and Wang.

Bennett, W. Lance. 1980. Myth, Ritual and Political Control. *Journal of Communication* 30: 166–79.

Black, Max. 1962. *Models and Metaphors*. Ithaca, N.Y.: Cornell University Press.

Bowers, John W., Donovan J. Ochs, and Richard J. Jensen. 1993. *The Rhetoric of Agitation and Control*. 2d ed. Prospect Heights, Ill.: Waveland Press.

Bumpers, Betty. n.d. *Betty Bumpers Interview*. Fayetteville: University of Arkansas Peace Links Special Collection. Video recording.

———. n.d. *Betty Bumpers on National Public Radio*. Fayetteville: University of Arkansas Library Peace Links Special Collection. Cassette recording.

———. n.d. *Betty Bumpers and Nancy Ramsey on WALC Call-in Show*. Fayetteville: University of Arkansas Library Peace Links Special Collection. Cassette recording.

———. 1982. *A Time to Make Peace*. Fayetteville: University of Arkansas Library Peace Links Special Collection, Sept. 11. Cassette recording.

———. 1983. *Betty Bumpers on "Woman's World."* Fayetteville: University of Arkansas Library Peace Links Special Collection, Dec. 18. Cassette recording.

———. 1986. *Citizen's Responsibility to Peace*. Fayetteville: University of Arkansas Library Peace Links Special Collection. Cassette recording.

Bumpers, Dale. 1982. Remarks. Senate proceedings. *Congressional Record*, October 1, 97–134, 513140.

Carpenter, Ronald H. 1977. Frederick Jackson Turner and the Rhetorical Impact of the Frontier Thesis. *Quarterly Journal of Speech* 63: 117–29.

———. 1990. America's Tragic Metaphor: Our Twentieth-Century Combatants as Frontiersmen. *Quarterly Journal of Speech* 76, no.1 (February): 1–22.

Chaika, Elaine. 1982. *Language, The Social Mirror*. Rowley, Mass.: Newburg House.

Coffman, Steve L., and Eblen, Anna L. 1987. Metaphor Use and Perceived Managerial Effectiveness. *Journal of Applied Communication Research* 15, nos. 1–2: 53–66.

Donovan, Josephine. 1985. *Feminist Theory: The Intellectual Traditions of American Feminism*. New York: Frederick Unger.

Dragonwagon, Crescent. 1983. I Couldn't Just Sit Around and Wring My Hands. *McCall's*, January, 42–45.

Eisenberg, Eric M. 1984. Ambiguity as Strategy in Organizational Communication. *Communication Monographs* 51: 227–42.

Falk, Richard. 1987. The Global Promise of Social Movements: Explorations at the Edge of Time. *Alternatives* 7: 173–96.

Foss, Karen A., Sonja K. Foss, and Cindy L. Griffin. 1999. *Feminist Rhetorical Theories*. Thousand Oaks, Calif.: Sage.

Foss, Sonja K. 1989. Feminist Criticism. In *Rhetorical Criticism—Exploration and Practice*, edited by Joseph A. DeVito and Robert E. Denton, Jr., 151–60. Prospect Heights, Ill.: Waveland.

Foss, Sonja K. and Cindy Griffin. 1995. Beyond Persuasion: A Proposal for an Invitational Rhetoric. *Communication Monographs* 62: 12–16.

Frank, David. 1981. Shalom Achschav—Rituals of the Israeli Peace Movement. *Communication Monographs* 48: 165–82.

Hallstein, Lynn O. 1999. A Postmodern Caring: Feminist Standpoint Theories, Revisioned Caring, and Communication Ethics. *Western Journal of Communication* 63, no. 1 (winter): 32–56.

Hartsock, N. 1983. The Feminist Standpoint: Developing the Ground for a Specifically Feminist Historical Materialism. In *Discovering Reality*, edited by S. Harding and M. Hinkitikka, 283–310. Boston: Reidel.

Joshua, W. 1983. Soviet Manipulation of the European Peace Movement. *Strategic Review* (winter): 44, 46.

Ivie, Robert L. 1986. Literalizing the Metaphor of Soviet Savagery: President Truman's Plain Style. *Southern Speech Communication Journal* 51: 91–105.

———. 1987. Metaphor and the Rhetorical Invention of Cold War "Idealists." *Communication Monographs* 54: 164–82.

Jelinek, M., Linda Smircich, and P. Hirsch. 1983. Introduction: A Code of Many Colors. *Administrative Science Quarterly* 28: 331–38.

Koch, Susan, and Stanley Deetz. 1981. Metaphor Analysis of Social Reality in Organizations. *Journal of Applied Communications Research* 9: 1–15.

Lakoff, G., and M. Johnson. 1981. Conceptual Metaphor in Everyday Language. In *Philosophical Perspectives on Metaphor*, edited by M. Johnson, 286–325. Minneapolis: University of Minnesota Press.

Manning, Peter K. 1979. Metaphors of the Field: Varieties of Organizational Discourse. *Administrative Science Quarterly* 24: 660–71.

Mechling, E. W., and G. Auletta. 1986. Beyond War: A Socio-rhetorical Analysis of a New Class Revitalization Movement. *Western Journal of Speech Communication* 50: 388–404.

Ortony, A. 1979. Metaphor: A Multidimensional Problem. In *Metaphor and Thought*, edited by A. Ortony, 1–16. Cambridge, U.K.: Cambridge University Press.

Pacanowsky, Michael E., and Nick O'Donnell-Trujillo. 1983. Organizational Communication as Cultural Performance. *Communication Monographs* 50: 126–47.

Palmer, F. R. 1981. *Semantics*. 2d ed. New York: Cambridge University Press.

Peace Links, Inc. n.d. Power of Attorney and Declaration of Representative Form 1023 (Rider no. 1, Form 1023, Part III). The Peace Links Papers. University of Arkansas Libraries, Fayetteville, Ark.

Peters, Thomas J., and Robert H. Waterman. 1982. *In Search of Excellence*. New York: Harper and Row.

Reardon, Betty A. 1996. *Sexism and the War System*. Syracuse, N.Y.: Syracuse University Press.

Richards, I. A. 1936. *The Philosophy of Rhetoric*. London: Oxford University Press.

Riley, Patricia. 1983. A Structurationist Account of Political Cultures. *Administrative Science Quarterly* 28: 414–37.

Rowland, Robert C. 1990. On Mythic Criticism. *Communication Studies* 41, no. 2: 101–16.

Ruddick, Sara. 1989. *Maternal Thinking: Toward a Politics of Peace*. Boston: Beacon Press.

Rushing, Joyce H. 1983. The Rhetoric of the American Western Myth. *Communication Monographs* 50: 14–32.

Salomon, Kim. 1986. The Peace Movement—An Anti-establishment Movement. *Journal of Peace Research* 23: 115–27.

Shepler, Sherry R., and Anne Mattina. 1999. "The Revolt Against War": Jane Addams' Rhetorical Challenge to the Patriarchy. *Communication Quarterly* 47, no. 2 (spring): 151–65.

Smircich, Linda. 1983a. Concepts of Culture and Organizational Analysis. *Administrative Science Quarterly* 28: 339–58.

———. 1983b. Implications for Management Theory. In *Communication and Organizations: An Interpretive Approach*, edited by L. L. Putnam and M. Pacanowsky, 221–42. Beverly Hills, Calif.: Sage.

Stewart, Charles J., Craig A. Smith, and Robert E. Denton, Jr. 1989. *Persuasion and Social Movements*. 2d ed. Prospect Heights, Ill.: Waveland Press.

Tonn, Mari B. 1996. Militant Motherhood: Labor's Mary Harris "Mother" Jones. *Quarterly Journal of Speech* 82, no. 1: 1–21.

Totenberg, N. 1986. Mrs. America for Peace. *Parade Magazine*, March 2, 16.

Turner, V. 1974. *Dramas, Fields, and Metaphors: Symbolic Action in Human Society*. Ithaca, N.Y.: Cornell University Press.

Walgren, D. 1983. Extensions of Remarks. *Congressional Record*, February 8, 99–023, E721.

Wehr, Paul. 1986. Nuclear Pacifism as Collective Action. *Journal of Peace Research* 23: 103–13.

Weick, Karl E. 1979. Cognitive Processes in Organizations. In *Research in Organizational Behavior*. Vol. 1, edited by B. Staw and L. Cummings, 41–47. Greenwich, Conn.: JAI Press.

Williams, Phil. 1984. *The Nuclear Debate: Issues and Politics*. London: Routledge & Kegan Paul.

Wood, Julia T. 1999. *Gendered Lives*. 3d ed. Belmont, Calif.: Wadsworth.

Young, Nigel. 1986. The Peace Movement: A Comparative and Analytic Survey. *Alternatives* XI: 185–217.

Chapter 8

Abraham's "Dysfunctional Family" in the Middle East: Sis Levin's Peace Rhetoric

Margaret Cavin

My growing conviction was that a woman's way is a different way—a voice that should be heard and used as much as humanly possible. I, of course, am not talking about the passivity, the submissive posture, that many men in authority expected of us during the hostage crisis— sitting, quietly watching, waiting, crying softly and reading our Bibles as we remain harmlessly on the sidelines. What I'm learning and am still learning is that there is a valuable way to communicate that comes naturally to women, if it is not stifled. It's easier to describe what it is *not* that what it actually *is*. It is not threatening. It is not posturing in Rambo-like revenge rhetoric, nor is it so terrifying that it encourages lying responses. . . . The voice is not defensive so it doesn't have to lie. It's caring and intuitive, so it doesn't have to threaten. It's confident, because it has learned from experience about pain and about healing. It's the voice of a Southern Christian woman who loved a Yankee Jew and found no contradiction at all in loving and working with Muslim friends to help him. And yes, it's a female voice. I cannot help but believe it can bring something special to the world's hope for peaceful coexistence among different people.

—Dr. Sis Levin, *Beirut Diary*

The U.S. Department of State warns U.S. citizens of the risks of travel to Lebanon and recommends that Americans who travel there exercise caution. In the past Americans have been targets of numerous terrorist attacks in Lebanon. The perpetrators of these attacks are still present in Lebanon and retain the ability to act (United States Department of State n.d.).

It is clear by this travel warning issued by the State Department that terrorism continues to be a serious threat both in the United States and throughout the world. The methods of peace and their potential solutions are as relevant today as they were on March 7, 1984, when Jerry Levin, Cable News Network bureau chief in the Middle East, was abducted by Shiite gunmen and became one of the first hostages in what would become a long season of hostage taking and hostage killing. For months, Lucille "Sis" Levin (referred to as "Sis" in this chapter to distinguish her from husband, Jerry) obeyed the American government and waited for "quiet diplomacy" to work. When she determined that it was not working, she resolved to do something proactive to secure her husband's release. The lessons that can be learned from the communication choices that Sis made are relevant today because terrorism continues to exist, due many times to ethnic conflict. According to Sis:

> There is no substitute for going yourself and experiencing the amazing fact that ethnic conflict, be it in South Central Los Angeles, or the settlement ridden area called "Occupied Palestine," it all has a certain basic similarity. It simply is a fact that injustice will lead to violence inevitably. And if we cannot find the courage, the honesty, and the political will to analyze root causes and face the fact that we may be part of the problem through our actions or our inactions, then for sure we will not have solutions. (Levin 1993d)

She also stated, "Further, as critics, you can take the formula and apply it to any peace and justice issue God puts on your heart or conscience. I've worked through it with South Africa and Latin America, just so my critics in Peace Education couldn't say I was a 'one issue teacher' " (Levin 1993d).

This challenge led me to attempt a discovery of the rhetorical choices Sis made in order to identify potential peace rhetoric that can be applicable to other situations in the world today. I first met Sis when I was giving a presentation at a peace workshop in Los Angeles. As a result of that and subsequent meetings, she provided me with some of her speeches for analysis. These speeches were presented from 1990 to 1995 to diverse audiences such as peace and justice organizations, educational groups, religious conferences, and media organizations. I also personally interviewed her on several occasions and some of the information is provided in this chapter as well.

HOSTAGE DRAMA

I went from Birmingham to Madrid by way of Beirut and Baghdad, and now Bosnia.

—Sis Levin, speech given at All Saints Episcopal Critical Mass, 1992

Sis Levin's life changed when Jerry was taken hostage. She states in most of her speeches, "I am a southern conservative evangelical Christian woman who fell in love and married a Yankee, liberal, intellectual Jew who was kidnapped and held hostage in a Muslim country. I had no experience in international relations" (Levin 1993e).

Jerry was the first to be taken by Islamic jihad terrorists in Beirut as he was walking to his CNN office. He was kept chained to a radiator for more than eleven months. Once Sis became aware he had been abducted, she was told to wait for her government to let "quiet diplomacy" work. When she felt that this was failing, she began a media campaign to seek Jerry's release. She began by speaking on the *Today Show* to create a network of Muslim, Christian, and Jewish friends throughout the United States and the Middle East who assisted in the search. She spoke to individuals, groups, national leaders, and anyone else who would listen. She was working for peace, which she did until her husband was released in February 1985. Once the ordeal had come to an end, Sis and Jerry worked to get the other hostages released. Since that time, Sis wrote a book about her experience, titled *Beirut Diary* (1989), which was made into an ABC television movie starring Marlo Thomas. The film has been seen not only in America, but in other nations as well. In addition, Sis subsequently completed an Ed.D. in peace studies at Columbia University. She has since continued to speak about peace issues to groups throughout the country, has been a visiting professor at major universities in various cities, and is currently living in Birmingham, Alabama, where she is creating a peace resource center.

METHODOLOGY: FEMINIST CRITICISM

Feminist criticism is a useful starting point for the analysis of a language of peace. The approach taken by feminist criticism is outlined in Sonja Foss's (1989) book titled, *Rhetorical Criticism*. Foss (1989) states, "Feminist criticism is rooted in the same commitment to the elimina-

tion of oppression that characterizes feminism, but its focus is on the rhetorical forms and processes through which oppression is maintained and transformed" (168). Historically, we tend to find the cause of oppression in a structure of patriarchy. Patriarchy is a system that places value in male authority, a single voice and narrative. Feminist criticism determines how a rhetor both adds to our understanding of patriarchy or transforms patriarchy and offers creative new perspectives or visions (Foss 1989, 171–72). It also should be noted that feminist criticism seeks to identify oppression in a particular situation, which includes but is not exclusive to women. It includes any group of people that is treated differently or less than any other group.

There is much research that has linked patriarchy, sexism, and war. Betty Reardon (1996) states in her book *Sexism and the War System*, "My use of the term war system refers to our competitive social order, which is based on authoritarian principles, assumes unequal value among and between human beings, and is held in place by coercive force" (10). In opposition to this war system, many researchers have documented the historical connections between feminism and peace systems. Simply put, to quote Reardon, "Feminism chooses life" (97). Whereas patriarchy places value in one perspective and one type of voice, feminism, on the other hand, places value on multiple voices and narratives. When multiple narratives are valued, there is an opening for understanding, life, and peace. In this chapter, I explain how Sis Levin's rhetoric transforms patriarchy and war systems to offer a new vision of a peaceful environment in which all individuals have equal worth, voice, and relationship.

Sis uses metaphor to communicate this message. According to Sonja Foss (1989), metaphoric criticism "constructs a particular reality for us according to the terminology we choose for the description of reality. It serves as a structuring principle, focusing on particular aspects of a phenomenon and hiding others; thus, each metaphor produces a different description of the 'same' reality" (189). If an audience accepts this "reality," the metaphor can then signify specific courses of action for listeners or readers. Not only is metaphor argument, according to Kenneth Burke (1945), but it is also a marker delineating the user's "perspective" (503–4). If we take Burke's position, it then follows that an analysis of the key symbolic constructs used by a given speaker enables the critic to understand point of view and to draw certain conclusions about motive, function, and effectiveness.

Sis Levin found symbolic speech useful and important when

attempting to create new paradigms in the minds of her audience. Focusing on the speeches mentioned previously, which reflect years of activism, I have isolated one structural metaphor that Sis consistently uses: the "dysfunctional family." Sis uses this metaphor to reveal her "reality" of the problem that exists in the Middle East. She then explains possible peaceful strategies in response to the problems the "dysfunctional family" faces, which are to analyze, moralize, verbalize, and exercise. Sis created these phases of forgiveness as potential strategies to be used in the Middle East drama. This chapter shows how this metaphor of "dysfunctional family" leads to the transformation of patriarchy.

SIS'S METAPHORS

Metaphor: Dysfunctional Family

> Our famous neighbor in Beirut, Tom Friedman, began his novel *From Beirut to Jerusalem* [1995] with the statement that nothing in his life prepared him for Beirut. My daughter said, "Horse feathers, mama, everything in your life prepared you for Beirut."
>
> —Sis Levin, speech given at Valley Dale Baptist Church,
> August 26, 1992

Sis explained to her audiences that she came to understand the conflict in the Middle East through her own personal experience in a dysfunctional family. Her own personal "reality" became the lens through which she saw the "reality" in Beirut. Sis explained that her mother "roared through the twenties and crashed" (Levin 1991). Sis describes her mother as "beautiful, witty, popular, phony, and terribly unhappy" (Levin 1991). She divulges that her father, a prominent trial attorney, "was addicted to power" and "controlled everyone" (Levin 1991). In fact, she claims, "The first person I ever saw argue with him and win or leave the room feet first was Jerry Levin" (Levin 1991). Her first husband, after five children and twenty-two years of marriage, had left her for another woman, and her parents expected her to work in an "appropriate" position in the community (Birmingham, Alabama) and "raise the children" (Levin 1991). Sis states, "My dream was dead. My personal life was over" (Levin 1991). She explains, "I was divorced, a single parent with five teenagers and although this particular social catastrophe had never happened in our family, we were 'survivors,' sort of" (Levin 1991). It was at this time

that she met and fell in love with Jerry Levin, who, according to Sis, "my mother loved to say he was a 'Yankee Jew in show business' as she scornfully dubbed broadcast journalism" (Levin 1991). Jerry had come to Birmingham as the local NBC director. Sis remembers:

> To cut short my favorite story, I fell in love with the most interesting, exciting man I'd ever met and a whole new world opened, or tried to, I should say. I was young again. My children were disgusted, patronizing; and my parents just laughed. It was an arrangement that was absolutely out of the question, to them, absolutely. My mother trilled, "Be not yoked to unbelievers."
> (Levin 1991)

Sis's family was conservative Christians, and her mother believed that Sis should not be joined in marriage to a Jewish man. This difficult situation did not deter Sis from the relationship. Once she decided to marry Jerry, her father immediately changed his will with the intention of denying her part of his wealth. Sis concluded, "Jerry then acquired a sudden family with all of its dysfunctional problems, a dress rehearsal for the big story" (Levin 1991).

Jerry's job took them away from Birmingham to Houston, Washington, and Chicago. Eventually, in 1984, CNN sent Jerry to Beirut. As a result of Sis's relationship with Jerry, she developed what she called "a healthy awe for the influence of mass communication that has never left me and would stand me in good source later" (Levin 1991). Sis's "perspective" of her personal family experience being dysfunctional helped shape her "perspective" of the conflict in the Middle East, a conflict in which she would play a small but significant role.

Sis's perspective incorporates a personal human view of others. Reardon (1996) explains this view when she writes, "As noted, women tend to identify with others' experiences such as bereavement, joy, motherhood, illness, and so on. One suspects, for example, that this personal human view led the white women of the southern United States to accept, encourage, and cooperate with the Civil Rights movement before the 'liberal' men" (71). Sis's experience with a dysfunctional family, which included a controlling father and an alcoholic mother, allowed her to empathize with the crisis in the Middle East.

Metaphor: Children of Abraham

Sis's perspective is that the Arabs, the Jews, and the Christians are a family. She uses the term *Arab* to refer to all non-Jewish Semitic people

regardless of their nationality. According to Sis, it all began with Ishmael and Isaac, the children of Abraham. Ishmael was the son of Hagar, and she was the handmaiden of Sarah, who was Abraham's wife. Hagar agreed to let Abraham "come to her" with the intention that she would become pregnant (his wife could not have a child because she was past childbearing age). As a result, Hagar gave birth to Ishmael. However, in spite of the fact that God had promised Sarah that she would give birth to a son, Abraham and Sarah had not believed that God would keep his promise. Sarah did eventually become pregnant, and Isaac, who is called "the child of Promise," was born. Abraham then sent Hagar out of the home because Sarah was jealous of her. Hagar probably would have died in the desert, but God came to her and ministered to her, according to the biblical account. He promised that he would take her seed and make a great people, representing the Muslim descendants of Abraham. Both sons eventually battled over the land. Abraham was given Canaan and that passed to Isaac, and this represents the Jewish descendants of Abraham. It states in Genesis 17:8, "And I will give to you and to your descendants after you, the land of your sojournings, all the land of Canaan, for an everlasting possession, and I will be their God." God promised Canaan to Israel, yet eventually others came to live there, and this led to what Sis calls a "turf war" between the two brothers. In many of Sis's speeches, she explains that historically there has been a "linkage" of the "turf fight" to Lebanon. It began in 1948 when Israel began to occupy Palestine. Thus began the "turf war" that she experienced in 1982 and that continues today (Levin 1992a). The brothers in the Bible story were literal brothers as well as symbolic brothers, representing the Arab and Jewish peoples.

Sis explains that the dysfunctional family no longer includes only the two brothers, but that the United States has become a part of the family. She states, "And we, who've been grafted into the dysfunctional family, what is our role in all of this?" (Levin 1991). Therefore, Sis unites the Arabs, Jews, and Americans into this dysfunctional family.

It is interesting to note that the "reality" Sis creates with her dysfunctional family metaphor involves males rather than females or a combination of both. One reason is clearly because in the biblical account, the characters are male. However, it is also evident that Sis refers to the male paradigm in reference to violence rather than the female paradigm, which she identifies with peace. The fact that the

family members are male and they are in a "turf fight" is provocative from that standpoint.

Sis makes a connection between past, present, and future when she extends the family metaphor regarding the two brothers, stating, "It is my premise that the classic textbook example is the Middle East. If we can't solve this one, we haven't much hope of solving any. All of the domestic paradigms are present: the family of Abraham is having a turf fight. Can it be mediated?" (Levin 1993a). Sis explains the situation in the Middle East as one that involves a family that needs to be reunited rather than enemies who have no connections and history with each other.

Dysfunctional Family: Breaking the Silence

Sis's personal dysfunctional family "reality" again informed her definition of the conflict in the Middle East. She described her personal experience in one speech by stating:

> When mama tried to roar, she crashed. Medical people would say today that she had congenital inability to process alcohol, and so we became a dysfunctional family; but we never talked about it. Proud and silent, and thoroughly dysfunctional. So we couldn't, we didn't heal. And mama died of it, finally. What I encountered years later was very familiar to me. (Levin 1991)

Sis believes that part of what occurs in a dysfunctional family is that many times members will protect each other by keeping silent about the conflicts (chemical, physical, emotional, etc.). This, in her opinion, is harmful rather than productive, and it eventually hinders the healing process and can ultimately lead to death. When she became involved in the conflict in the Middle East, she began to witness similarities to her earlier personal experience.

"America was almost totally silent that first year. And it was, believe it or not, and it still amazes me, me who broke the silence" (Levin 1992a). When Sis first learned of Jerry's captivity, she was told by the State Department in Washington, D.C., to remain quiet while they let "quiet diplomacy" work. They explained that they believed Jerry to be alive and well and that if she went to the media, Jerry might be killed. Later, she discovered that the State Department had a handbook on hostage taking that gives practical suggestions to the families. This was not given to her. She also discovered later that it was a typical practice for the State Department to appoint a media liaison, but in this situation the media was not given any information about Jerry.

Sis contended, "If the media discussed it at all, it would quote Mr. Reagan's 'mindless, groundless, terrorism' (Levin 1991).

In July 1984, Jerry's captors demanded that in return for his release he record a message asking the United States to request the release of seventeen Shiites being held by the Kuwaiti government. A cassette addressed to Ted Turner was sent to the State Department in July. Sis explains that Ted did not receive it until she demanded that the State Department forward it. Also, the State Department had a videotape of Jerry, which explained who the hostage takers were and what their demands were. Sis and other hostage family members were brought in to make an identification of the hostages. She explained to me in a telephone interview on February 10, 1999, that at that same time Reagan stated on television to the American people that he did not know who the terrorists were or what they demanded. The cassette and the video were never played for the American people, according to Sis. She was beginning to believe that keeping silent was not providing Jerry's safe return.

Further, in the same telephone interview, Sis said that it was troubling to her and the other hostage families that very little had been said or written about the Americans abducted until after the hijack of TWA Flight 847, when thirty-nine Americans were held captive for seventeen days. Further, Sis did not hear from President Reagan until Christmas, nine months after Jerry had been taken hostage. The communication came in the form of a telegram, informing Sis that the hostages were a top priority. Many of the other hostage family members, according to Sis, became bitter about this type of treatment when Reagan was meeting personally with the families of the men from Flight 847.

According to Sis, at the time, CNN's motto was "You have a right to know." She decided that, keeping that motto in mind, she needed to communicate with Ted Turner about the hostage situation. At that meeting, Sis explains that Turner asked her, " 'What do you want me to do? People get killed in this business every day.' Ted cared, but I think he was very frightened." She went on to explain that she felt Turner should communicate the information provided in the tapes to the American people. Sis explains that Ted responded to her request by stating that she was being "un-American." She retorted, "No, Ted, silence of a free American is un-American" (Levin 1993b). According to Sis, soon after her meeting with Turner, the CNN motto "You have a right to know" was changed. All of these examples and more led to the creation of the description of the hostages as "the forgotten hos-

tages." She had finally come to the conclusion that she should no longer remain silent, that she must instead break the silence.

An interesting note regarding silence is that, according to Sis, when Jerry was finally released, it was big news in the United States because he was the first hostage to be taken, the first to be released, and he was CNN's "man." According to Sis, CNN had leverage and when Jerry landed on American soil, it arranged to have the telephone wires opened between President Reagan and Jerry. Jerry took that opportunity to say to the president that he hoped Reagan would examine what was happening in the Middle East. Sis states that Reagan told Jerry on live hookup to "Keep your mouth shut." She laughed when telling the story and said that Jerry later stated that "I am probably the first journalist the president told to shut their mouth" (Levin, telephone conversation, November 10, 1999).

When discussing links between feminism and Freudianism in her book *Feminist Theory*, Josephine Donovan (1992) explains that many French feminists believe that patriarchy must be deconstructed by feminists and that requires speaking and not remaining silent (114–15). The notion of "silence" and its destructive power are emphasized in feminist research. Silence is in large part due to the restrictive power of patriarchy, power that does not allow multinarrative voices to be heard and respected.

TRANSCENDENCE

Transcending through Analyzing

For Sis, breaking the silence regarding this "dysfunctional family" she loved meant discovering creative and peaceful action rather than silent inaction. The first step was to analyze the problem and look at root causes. Sis explains, "We have to dare to know the truth" (Levin 1991). She says that rather than embracing education, it is easier to avoid facing the truth and embracing hatred. When she was willing to develop an education about the "real" situation in the Middle East, that education led her to discover what was necessary in order to secure Jerry's freedom. She began to believe that the problem was not the hostage takers, but the problem was that Jerry was gone. The solution then was not to retaliate; the solution was to get him back. She returned to the Middle East, where she began to meet and communicate and network with Jews and Arabs in order to understand them

as well as seek their help. She met secretly with top leaders in Syria and she continued to speak through the media whenever the opportunity was present. In addition, while in Damascus, she worked with burn victims at Children's Hospital and communicated with them through arts therapy and music in spite of her inability to speak Arabic. Throughout this time, Sis was discovering, analyzing the problem through self-reflection as well as connection with others.

Sis talks about how she draws crowds because of their fascination with a "hostage wife," not only what she looks like, but also what she "feels" like. "There is a certain fascination with the pain of it, the strangeness, the fears, and there's that curiosity that exists, from a safe distance, about the foreignness, the 'other' world inhabited by 'them,' those who 'we' are not like" (Levin 1992b). Sis warns in one speech about the "fading image of the 'Evil Empire' " that is being replaced by "an active manipulation to label Arabterrorist, one word, as the new enemy, and the dangerous consequences of such a technique." She explains further that there is much to learn from the Cold War as we "look at the nuclear weaponed Middle East and its shifting populations and politics" (Levin 1993a).

She then explains that Arabs are not really "foreign," but they, along with Christians and Jews, belong to the "family" of Abraham (Levin 1992b). This is what she discovered when she began to "analyze" the problem. She believes that analysis leads to discovery and truth. Eventually, she came to believe that "the truth made Jerry free" (Levin 1991). The system of patriarchy not only values one voice over all others, but it intimidates those who are different into silence. Sis points to a different perspective that rejects hatred in favor of analysis of multiple perspectives that may lead to understanding and care for one another.

Transcending through Moralizing

Once Sis began to analyze the problem, this led to the second step, which was to "moralize" the situation. She believes that in a dysfunctional family blame needs to be assessed and each person must take responsibility for his or her part. It is sometimes a painful process because it requires individuals to assess their own guilt and judgment as well. Sis defends, "I knew my American history. My country was born in revolution and we fought a bloody Civil War. I didn't like what I saw in Lebanon, but I understood it" (Levin 1993c). She was able to identify her experience with the one in the Middle East nation-

ally as well as personally because America has had similar conflicts. She again thematically returns to the family metaphor nationally when she refers to the American Civil War as well as the one in Lebanon because in both, brother is fighting brother.

She informs audiences that when in the Middle East she will often say, "Look, if you won't judge me by the Ku Klux Klan, then I won't judge you by Hizballah. The terrible behavior of some of us must not become the world's symbol for a whole culture. And, as for the few who are driven to extreme, they too must be understood, and loved if they are ever to change" (Levin 1993c). She maintains that all of the family factions are guilty. Sis asserts, "One nations' freedom fighter is another nation's terrorist" (Levin, telephone interview, February 10, 1999).

When she "moralizes" in her speeches she spends a relatively short time discussing the guilt of the Arabs. Instead, she focuses primarily on the guilt of Jews and Christians. It could be argued that she strategically chooses to do so because she feels that the American public is already clearly biased against Arabs and need to be educated away from that viewpoint. When she discusses the need to "moralize," then, she argues that there are clear Jewish and Christian abuses. Sis asserts:

> They [Jews] are slaughtering Palestinians. The Jewish Country Codes of Human Rights Abuses are all there, they don't eve try to hide it. Anyone can research and see. If a child threw a rock at an Israeli, the whole street is blown up. Israelis call it "collective punishment." It's outrageous. They [Palestinians] are living in concentration camps with raw sewage in the streets. The Jews are torturing people, innocent people are being thrown in jail. It's terrible. If you comment then you are called Anti Semitic. (Levin, telephone interview, February 11, 1999)

She explains that while many Americans believe that Jews are united in the killing, that is not the case. There are many "courageous" Jews who are standing against the violence. For example, she states, "The Women in Black [a Jewish women's group against the violence] demonstrate all the time and urge Jews to live with Palestinians." Sis explains that the women maintain, "We are losing our soul." Sis has joined them in their protests in the streets of Jerusalem and states that she has watched as school buses drive by and Israeli children call the women "whores" (Levin, telephone interview, February 11, 1999).

Further, Sis explains that Rabin was killed by one of his own Jewish "brothers." She asserts, "It is complicated but simple. It is a dysfunctional family in the Middle East." She maintains that Israelis and Arabs have required that other countries "take sides." She argues, "We must not take sides. We are on the side of peace." She asserts that as long as we do takes sides we are in the wrong (Levin, telephone interview, February 11, 1999). This again points to the metaphor of dysfunctional family in that many times in an interpersonal family situation, members may feel forced to "take sides," which then escalates the conflict. In fact, Sis explains that many Americans believe that because Israel has suffered much, we must understand its violent position in the Middle East. However, she states that "an abused child will usually grow up to become the abuser" (Levin, telephone interview, February 11, 1999). She believes that America must stop defending the "abuse" in which both Jews and Arabs as well as the United States have played a part. Again, in this instance, she refers to the dysfunctional family metaphor by describing Israel as an "abused child."

She describes the U.S. guilt by explaining that after Israel invaded and occupied Lebanon in 1982, there were demonstrations in Israel against that decision, and the UN voted almost unanimously to censor Israel, except for one vote that belonged to the United States. She goes on to argue, "In Lebanon, the Christian Army (the Phalange) massacred hundreds of women and children in the Refugee camps called Sabra and Shatilla. The Israeli forces lit torches when it grew dark so that the Christians could see to do their bloody work" (Levin 1991). She describes how the American battleship *New Jersey* hit a schoolhouse. She contends that "it remains a fact that we 'the peace keepers' officially struck first militarily" (Levin 1992a).

She concludes in one speech that this "turf war" exists in Palestine and has extended into Lebanon. She adds, "And not to be left out, the American battleships were firing into the midst of it" (Levin 1993c). Sis "moralizes" that all three "brothers" are guilty of abuse. Patriarchy is a system that rewards violence and superiority of one group over other groups of people. Patriarchy values one group over others; it holds one group in value while devaluing and blaming others. Sis rejects the idea that one group is superior to any other group. Instead, all are guilty of immorality and all must take responsibility. There is equal blame for all. Once all realize their equal immorality, there is the possibility for transcending to a better more peaceful world where all can live together.

Transcending through Verbalizing

The third step is to verbalize the guilt and create continued dialogue. Sis states that "conflict resolution" is a cliché term. A better and more useful phrase is "conflict management" because conflict will return in the future (Levin, telephone interview, February 10, 1999). She further believes that it is counterproductive to say, "I have to win." She argues, "Not true. Both can win, both have to win. One plus one does not equal two, but rather one plus one equals three. There is a creative answer, better than one or two separately. The old way no longer holds up, we aren't playing with pistols any longer. Now we have totally destructive weapons" (Levin, telephone interview, February 10, 1999).

Again, she makes reference to "pistols," carrying the metaphor of dysfunctional brothers engaged in a violent conflict, playing with guns. The answer is to verbalize instead, which Sis believes is the most difficult step in the process, and she maintains that it has been a difficult process for her personally. She asserts:

> Although I'm often invited, I can't really get very far in talking with the Jews, even in my own family. I weep for the Holocaust, and then I can't understand why that has not taught them to help outlaw all killing, rather than participate themselves. And I can't really talk as well as I'd like to with my Muslim friends. I want them to get on with cleaning up their family act and stop the black sheep from this terrorism. But I can and I must and I will talk to my own part of this family. (Levin 1993c)

Again, the suggestion of the family metaphor is present because in many dysfunctional families there is a tendency to find it difficult to verbalize the guilt. Many times individuals will go to great lengths to avoid this step.

While it is difficult for her to "verbalize," Sis claims, "All are guilty here. Confess it, outloud. 'Come to the table.' It's got to be a big table" (Levin 1991). She returns to the family metaphor by suggesting the return "to the table." One experience that tends to be linked to the family experience is to have family discussions, which may occur "at the table," for example, at meal times. Sis welcomes this experience, which has the potential for dialogue. Again, a system of patriarchy allows voice for a select group and silences others. Sis rejects this system in favor of one that allows for multiple narratives and voices in dialogue.

Transcending through Exercising

The final step of the process, according to Sis, is exercise. She asserts, "And when I begin to see clear injustice, to pray about it and to name it, the rest, the action will follow" (Levin 1993e). Exercise may involve actively forgiving one another. Sis states that if an individual claims to be a Christian, then he or she must forgive. "It is impractical as well as immoral" not to engage in this exercise (Levin, telephone interview, February 10, 1999). Sis's doctoral dissertation focused on forgiveness as a peace strategy. "At Columbia I transposed this forgiveness 'paradigm' for other foreign conflicts, as well as the American urban domestic scene, and especially the church's often dysfunctional community. It's family" (Levin 1991).

Further, Sis describes the step of exercise as "walk the talk" (Levin 1991). In her own situation during Jerry's captivity, she explains that she discovered creative ways to "exercise." Sis made friends with both Arab and Jewish people in the Middle East. She communicated and networked for peace and for Jerry relentlessly. She discovered later that during this time, Jerry's captors began bringing him warm clothing and blankets. They also began feeding him hot, nutritious food and allowing him to exercise. Later, she and Jerry speculated that this was done in order to help him gain strength so he could "escape." Then the day came when he worked free of his chains and tied three blankets together and lowered himself through a window (which was left unlocked by his captors) in his prison in Lebanon's Bekaa Valley. He walked for two hours through the Bekaa, which is occupied by the Syrian Army. The Syrians welcomed him warmly and took care of him, eventually sending him home. Sis and Jerry believe that it is in large part due to Sis's efforts that led to Jerry's ultimate dramatic release. That he was, in fact, allowed to "escape" because of her words and actions.

Sis believes Reagan found the "forgotten hostages" useful ultimately in directing attention away from the true import of the Iran-Contra "scandal," in which drugs were traded for guns. Sis believes Reagan received political support in the Iran-Contra scandal because of the hostage situation. She argues, "At the heart of the scandal was drugs and guns" (Levin, telephone interview, February 10, 1999). She says the irony is that Reagan had criticized Jimmy Carter for failing to handle hostage situations in a timely manner. Then, according to Sis,

Reagan laughed and stated that "No American will be taken again." And yet, from the day Jerry was taken until the day Terry Anderson, the final hos-

tage, was released, it was eight years. There were more hostages taken under Reagan and they were held longer. Reagan prolonged their stay by having no negotiation. (Levin, telephone interview, February 10, 1999)

Sis believed that the situation had been preventable and she believes Reagan is in large part responsible for the tragic results. She claims, "Reagan looked into the camera and lied." She concluded that while the Iran-Contra scandal is not as "sexy" as the recent Clinton scandal, it was far more damaging (Levin, telephone interview, February 10, 1999). The system of patriarchy many times encourages inaction so that the dominant group may prosper and stay in power. However, Sis argues for a system that embraces action and "exercise."

TRANSCENDING PATRIARCHY

Earlier, I discussed how Sis articulates a personal human view of feminism. She identifies her personal experiences as child, sister, wife, and mother with the political situation in the Middle East. This "maternal thinking" leads to a "reverential" perspective toward other individuals in other situations, according to Donovan (1992, 175). It is characterized by a deep "humility" that leads to greater understanding of differences. Donovan explains this outlook, which is a perspective taken by what she calls "the new feminist moral vision" (173–83). This vision is one that Donovan says unapologetically admits that women's experiences and thinking are different from men's. It is a vision that adapts to the diversity of environmental voices and seeks a "holistic" understanding of the reality of experience (173–83). Reardon (1996) agrees that "feminine visions of transformation are less precise and abstract, more organic and behavioral than are masculine visions. The images tend to be of convergence, healing, wholeness, birth, and new life" (91). Sis's dysfunctional family metaphor is an example of this type of vision.

Sis's rhetoric transcends patriarchy by "demystifying" the enemy rather than "debunking." This is a distinction made by Timothy Thompson and Anthony Palmeri (1993). In an attempt to establish a "poetic use of language" based on Kenneth Burke's work, Thompson and Palmeri argue that a "poet" should not debunk but demystify. Rather than destroy or dehumanize the "other" (debunk), the poet should seek to clarify the given circumstances of the drama (demystify). If the "poet" "debunks" the "other," then this typically leads an

audience to perceive the "poet" as an extremist and to believe that "a more moderate course of action is needed. Then, typically, the moderate course is believed to be that of the corporate world and government officials adept in strategic ambiguity" (281–82). The resultant effect, then, is one of inversion, the very people the "poet" wants to portray as evil, may then become, in the mind of the audience, the repositories of reason. Sis brings the groups of "enemies" together and renames and defines their relationships to be not only friendly but also a family bond. This clarity reorders those relationships to negotiate alternative solutions that transcend violence and war. For further discussion of this topic, see Cavin, Hale, and Cavin (1997).

Reardon (1996) explains that this personal human view is what leads many women to their involvement in the peace movement. However, Reardon points out that there may be an implication to this perspective. She writes, "But it must be recognized at the same time that the personal view permits liberated women to engage in a drive for individual success and personal fulfillment without regard to the effects of this drive on women in general and on the total social system" (71) The danger is to stop working at the point of one person's experience of oppression. However, in Sis's case, once her husband was released she continued to work toward peace not only in the Middle East but in other situations and places as well. Once she completed her graduate degree in peace studies at Columbia, she worked in Los Angeles and more recently in Alabama to bring about systemic change in race relations.

Sis's perspective and work has been that personal and relational change leads to institutional change rather than the other way around. Reardon (1996) explains that this is a strategy employed by many feminists of this perspective. She writes:

> Most women spend their efforts in areas for change where they can see the results. They work to change the particular circumstances in their local, daily environments and to change personal and social relationships; feminists add to this effort that of changing themselves. They make connections, both analytic and actual, among and between behaviors and consequences and most especially among and between individual persons. Their lives are made up of connections and linkages, circumstances affecting their visions of the future and their behaviors and decisions in the present. These feminine behaviors also reinforce the hypothesis of connection between personal change and structural change. (86–87)

Sis effected change in her personal drama in the Middle East and now she has returned to her roots in the South to continue change.

One of the ways personal change can lead to structural change, according to Reardon (1996), is through education. Sis has been committed to educating for peace since Jerry's return. She is currently working in Birmingham, Alabama, to bring peace in the conflict-ridden cities where race relations are tense and troubled.

CONCLUSION

From Birmingham to Baghdad, a very short, very predictable, very preventable path if we can only study it, as we really must if we're ever going to learn.

—Sis Levin, speech given at Valleydale Baptist Church, 1992

When I asked in a telephone interview if Sis believes the dysfunctional family metaphor is still useful today, Sis stated, "All the more so. There is still unfinished business. It is still dysfunctional, the family of Abraham, people of The Book. The classic elements of conflict are all there" (Levin, telephone interview, February 11, 1999). She then described her belief that continuing this metaphor was important in terms of understanding the solution today as well. She believes that change must come through education and it must have two criteria. Peace education must be systemic and comprehensive. She believes it must be taught in our schools and parents must be trained to teach it in the home. In fact, it must be a community effort with the school the center of the learning process. She also states that peace education should not be left to the "jolly volunteer" that is not trained and can "do more harm than good." She asserts that trained professionals must teach. She says that this is a "new territory, a new field. Schools are in denial" (Levin, telephone interview, February 11, 1999). She believes that peace work must be "preventative" rather than "crisis management" in order to stop "children" from killing each other.

Sis Levin's rhetoric transforms patriarchy by creating a metaphor that demystifies the conflict in the Middle East. This metaphor of a dysfunctional family is one she recognizes and identifies with humility from her own personal narrative. She points to a new vision that will allow this "family" to break their silence and engage in a peace process that may include these steps: analyze, moralize, verbalize, and exercise. Sis's multiple-narrative approach, which is key to feminism, would encourage rather than silence the Arab voice and give it value in the "family" of the Middle East.

Sis laments, "I am convinced 'the truth' would have set them all free and changed the course of a bloody history, but another path was taken in full knowledge of our success. And the tragic Iran-Contra Hostage Scandal stands as a reminder that God is not mocked" (Levin 1992a). While, the ending to her own story was successful, in large part because of her feminist moral vision, the larger story had a sad, bloody, and violent ending. The challenge is to continue the work, the education, and the vision. Reardon (1996) writes:

> It may well be one of the messages of the Christian injunction to love your enemy. If indeed the terrifier is within us, the healing process requires us truly to love ourselves with all our complexity and weaknesses, and both our feminine and masculine sides. This extension, this attribution of humanity to the enemy (the other), is the essential requirement needed to transcend sexism, liberate women from the ever-present possibility of rape, and free the human family from its thralldom to the war system and from the threat of annihilation posed by the nuclear arms race. (59)

REFERENCES

Burke, Kenneth. [1945] 1969. *A Grammar of Motives.* California Edition. Berkeley: University of California Press.

Cavin, Margaret, Katherine Hale, and Barry Cavin. 1997. Metaphors of Control toward a Language of Peace: Recent Self-Defining Rhetorical Constructs of Helen Caldicott. *Peace & Change* 22, no. 3 (July): 243–63.

Donovan, Josephine. 1992. *Feminist Theory: The Intellectual Traditions of American Feminism.* New York: Continuum.

Foss, Sonja K. 1989. *Rhetorical Criticism: Exploration and Practice.* Prospect Heights, Ill.: Waveland Press.

Friedman, Thomas L. 1995. *From Beirut to Jerusalem.* New York: Anchor Books, Doubleday.

Levin, Sis. 1989. *Beirut Diary.* Downers Grove, Ill.: Intervarsity Press.

———. 1991. Speech given at National Episcopal Convention.

———. 1992a. Speech given at All Saints Episcopal Critical Mass.

———. 1992b. Speech given at Valleydale Baptist Church. August 26, Birmingham, Ala.

———. 1993a. Speech given at Arab Friends Service Committee Annual Gathering, May.

———. 1993b. Speech given at Biola University, October, La Miranda, Calif.

———. 1993c. Speech given at Caux Conference, August.

———. 1993d. Speech given at Quaker American Friends Service Committee Annual Gathering, May.

———. 1993e. Speech given at the World Vision Chapel Service.

Reardon, Betty A. 1996. *Sexism and the War System*. Syracuse, N.Y.: Syracuse University Press.

Thompson, Timothy N., and Anthony J. Palmeri. 1993. Attitudes toward Counternature (with Notes on Nurturing a Poetic Psychosis). In *Extensions of the Burkeian System*, edited by James W. Chesebro, 269–83. Tuscaloosa: University of Alabama Press.

United States Department of State. n.d. <www.travel.stage.gov/lebanon _warning.html>

Chapter 9

A National "Mother" Scolds for Peace: Liberia's Ruth Perry

Colleen E. Kelley

African women cannot be let off the hook for their contribution in making Africa what it is today. How can we talk about empowerment or development of women when our societies are surrounded by men who could kill at any time? Aren't we the very women who bring up such men?

> —Gertrude Mongella, Secretary General
> of the UN Conference on Women, "Women: Africa's Harbingers of
> Peace?"

Chairwoman Perry, you don't need all the answers. You need only to assemble our children. You have a mother's authority. When you exercise it fairly, all the children—including the naughty ones—will know it.

> —T. Teh, "Open Letter to Ruth Perry"

For essentially all of its 150-year history, Liberia has been a macabre playground for "African Big Men" (Rupert 1997)—authoritarian militia leaders and tyrants who have violently fought each other to maintain dictatorships. These power battles resulted not only in the replacement of one dictator after another, usually by assassination, but also in the displacement and murder of hundreds of thousands of human beings. Liberia's most recent civil war began in 1989 when militia leader Charles Taylor assaulted the dictatorial regime of President Samuel Doe and executed Doe the next year. By 1996, more than 150,000 Liberians had died and more than half the country's 2.6 million people had been left homeless ("Liberians Are Starving in Area Cut Off by Civil War" 1996) including 800,000 forced to flee as refu-

gees (Washington Office on Africa 1997). The Big Man tradition was shattered when, in August of that year, Ruth Perry was inaugurated as head of Liberia's interim government. The first African woman to attain such a post, Perry was called to direct a nine-month mandate agreed upon by the faction leaders and the Economic Community of West African States (ECOWAS) to disarm all rebels and organize democratic elections by 1997 ("Milestones" 1996).

This chapter examines Ruth Perry's efforts to wage peace in Liberia. It begins with an examination of the rhetorical metaphoric power of the "Mother Persona." Then, the sociopolitical exigences that produced Perry's appointment are discussed. Next, her rhetorical persona and primary strategy are explored. Finally, discussion follows regarding the success of Ruth Perry's rhetorical efforts. The chapter concludes with a discussion of the legacy created by Liberia's first "national mother."

THE MOTHER METAPHOR

Stearney (1994, 2) argues motherhood is an "enduring ideal," an archetypal image that transcends cultural boundaries and particular situations. The generally panhuman experience of this maternal archetype, of "being mothered," creates an "ideational standard"(7). In Tonn's (1996) view, the influence of motherhood as a social symbol cannot be divorced from what "real" mothers do. The iconic status of motherhood therefore is both an idealized ideological construct and rooted in emotional responses to caregivers who have provided nurturing and protection (Tonn 1996, 17). As such, the terms *mother* and *motherhood* are sources of rhetorical power (Stearney 1994, 6). For example, Tonn (1996) notes that Mary Harris "Mother" Jones's nurturing and "fierce protection" eased the initial resistance of mine workers to her prounion efforts and also "imbued her with authority sufficient to lead an economic revolution" (1).

Militant motherhood refers to women's assumption of maternal roles to bolster their ethos and deflect criticism of their speaking. For example, Tonn (1996, 5) notes that symbolic motherhood was a "central and constant rather than occasional strategy" in the careers of labor figures and strike leaders such as Mary Harris "Mother" Jones. Such "militant protective love" broadens the traditional maternal "ethic of care" to include aggressive confrontation. Such "mothers" on occasion embrace literal self-sacrifice as a means to check the excess of the

state. As such, there is a tradition of women discursively managing motherhood as a rhetorical strategy to accomplish a goal. And one specific variation of that tradition is the utilization of maternal practice as a "natural resource" for peace politics. In Ruddick's (1989) view, the "peacemaker's hope is a militarist's fear: that the rhetoric and passion of maternity can turn against the military cause that depends on it" (157).

BLEEDING LIBERIA

The Republic of Liberia, on the Atlantic coast of West Africa, was founded in 1847 by freed slaves and a few African Americans who had been born free. The first settlers were sponsored by the American Colonization Society, founded by James Monroe and other such "notables" as Andrew Jackson, Henry Clay, and Daniel Webster. The motives of these society organizers were "decidedly mixed." Some wealthy plantation owners feared the impact on their slaves of free African Americans and others saw African Americans as a "beachhead in West Africa for Protestant Christianity" (Kramer 1995, 2).

The "Americo-Liberians" emulated the United States, "however painful their experience in the New World had been": the American Constitution was the model for their own government, the currency was the American dollar, and the capital named after the fifth president of the United States (Kramer 1995, 2). They became Liberia's elite, ruling over and excluding a population that was 95 percent indigenous (Washington Office on Africa 1997). The preamble of their constitution made this exclusion of African Liberians clear with the phrase "We the people of the Republic of Liberia formerly citizens of the United States of America" (Nubo 1997).

The Americo-Liberians and their descendants imposed a "kind of apartheid" ("Liberia Torn by Long Civil War" 1996), practiced "politics of exclusion, corruption, humiliation, greed and selfishness" (Nubo 1997) and scripted a history for their country dramatized around a "rift that has never healed" ("Liberia Torn by Long Civil War" 1996). Over the years, Liberians sang American music, read American books, watched American movies, and were educated in the United States, as were the majority of the country's presidents (Kramer 1995, 2).

A shift in power and acceleration of violence occurred in 1980 when native Liberian Samuel K. Doe and seventeen army officers of indige-

nous descent (Kramer 1995, 6) overthrew and assassinated the American-descended president, William Tolbert, and imposed martial law. A new constitution restored civilian elections in the mid-1980s, but Doe remained in power ("Liberia Torn by Long Civil War" 1996). The U.S. Green Beret–trained Doe (Kramer 1995, 6) established his own arbitrary military rule, favored his own ethnic group, and set the scene for continued factionalization of his country (Washington Office on Africa 1997).

BOY SOLDIERS

In late 1989 insurgents led by American-educated Charles Taylor, a descendant of the Americo-Liberians, crossed into Liberia from the Ivory Coast and began a war against the Doe Regime (Gedda 1996). Considered by some to be the head of the "most violent group" yet (Pewu 1997, 2), Taylor initiated a conflict marked by high levels of atrocities against civilians by Taylor's own National Patriotic Front of Liberia forces, the remnants of Doe's army, and several other armed factions (Washington Office on Africa 1997). Doe had been executed by Taylor's loose coalition of rebel leaders in 1990, which "cut [Doe's] body into slices while video cameras were rolling" (Gedda 1996).

One of the most controversial components of Taylor's war was his use of "Small Boys" units. Of the sixty thousand Liberian combatants between 1990 and 1995, as many as six thousand were estimated to be "boy soldiers," all under fifteen years old (Washington Office on Africa 1997) with some as young as ten (Gedda 1996). Many of these children joined one of the factions for survival or for revenge (Washington Office on Africa 1997). Some have argued that this use of child soldiers not only contravened the Geneva Conventions but also threatened Liberia's future by condemning it to a "violent course for generations to come" (Nyanseor 1996).

Although the United States supplied millions of dollars in "humanitarian relief" from 1990 through September 1995, the peace brokering with Taylor was left to the sixteen-nation Economic Community of West African States (ECOWAS), with Nigeria playing a leading role. The West African intervention force (ECOMOG) arrived in late 1990 and negotiated a 1995 peace accord in Abuja, Nigeria, that established an interim state council involving all faction leaders, including Taylor (Washington Office on Africa 1997) and envisaged disarmament and

elections by August 1996 ("U.S. Throws Weight behind Liberia Peace Effort" 1996).

The Abuja Accord vested power in the warlords with Wilton Sanka-wulo as chair. Originally considered a strong but neutral presence to spearhead peace initiatives, Sankawulo was forced to step down because of his alleged role in Charles Taylor's April 1996 attack on another warlord (Nubo 1997, 2). Shortly after the attack, gunmen from Taylor's National Patriotic Front of Liberia displayed the severed head of one of their victims and said it belonged to a member of the Butt-Naked Brigade captured in fighting the previous day. The brigade gets its name from its fighters' preference for wearing few or no clothes while fighting (Shiner 1996). Although a cease-fire was called—after street battles left over one hundred dead and thousands homeless (Shiner 1996)—fighting continued and meetings were held to get the peace process back on track and keep Liberia from returning to civil war once again ("Liberia Torn by Long Civil War" 1996). A consensus was developing, just as the twelve previous plans for peace in Liberia had, that would also fail (Wells 1997).

WOMEN'S ROLES IN LIBERIA

The material conditions under which most African women live and work remain in a virtually continual state of deterioration due to economic and social decline, AIDS, and war. African women also constitute the majority of the poor and illiterate in both urban and rural areas throughout the continent (Manuh 1998, 2). Female illiteracy rates in Africa were over 60 percent in 1996, compared to 41 percent for men. In many African nations, parents still prefer to educate only boys, seeing little value in educating girls. Furthermore, factors such as adolescent pregnancy, early marriage, and female children's greater burden of household labor are roadblocks to the formal schooling of girls. While most girls do not go beyond primary education, school curricula content generally fails to help them acquire even basic life skills. The curriculum, when it exists at all, is also often gender biased, leading many girls into stereotypical "feminine" jobs in teaching, nursing, and clerical work. As a result, it is often rare to find African women in scientific or technical education programs where they might develop skills to secure higher-paying jobs (Manuh 1998, 10).

Women's lives in most African nations have been affected by three

main developments linked to onset of social and economic decline in the 1970s and 1980s. First, structural adjustment programs implemented throughout Africa have emphasized export-led growth, to the detriment of social welfare. Because of their specific roles and positions within society, many African women have been among the worst affected by cuts in social sector spending, where costs have shifted from the state to the household. Women have been forced to take on increasing unpaid work such as caring for the sick, obtaining food, and ensuring the literal survival of their families. Second, because of increased civil war and conflict, the majority of the estimated 8.1 million refugees, displaced persons, and postconflict returnees in Africa in 1997 were women and children. Such increased conflict has worsened violence against women and the social and economic conditions under which they live. Third, over half of the estimated twenty million cases of HIV in Africa are female. In addition, women and female children are particularly vulnerable because of their lack of power regarding their sexuality and reproductive functions (Manuh 1998, 5).

About half of the women in Africa are married by age eighteen while one in three of these women is in a polygamous union. In 1995, estimates of average total fertility rates in Africa were 5.7 children per woman. Manuh (1998) suggests such high fertility arises from the economic value of children, high infant mortality, and low levels of contraceptive use. Furthermore, it is as mothers that women in many African nations achieve security within their husband's domains (5). In many rural areas, African women also contribute unpaid labor to the household's agricultural production and spend up to fifty additional hours a week on domestic labor and subsistence food production, with little sharing of tasks by spouses or sons. In general, women from the poorest African states labor twelve to thirteen hours a week more than men, as economic, civil, and environmental crises have increased their working hours. With the decline of national and local economies in many African nations, many men have been unable or have refused to contribute their share of household expenses. As a result, there has been an increase in the numbers of African women living in poverty as well as the numbers of households in the poorest categories headed by women (Manuh 1998, 6).

The status of Liberian women varies greatly by region, ethnic group, and religion. Before the outbreak of the civil war, women held one-fourth of the professional and technical jobs in urban Monrovia. Domestic violence against women is extensive and has yet to be seri-

ously addressed by the Liberian government, courts, or media. While in some urban areas, women are permitted to inherit land and other property, in rural areas—where traditional practices are stronger—a woman is generally considered the property of her husband and his clan and usually is not entitled to inherit from her husband or to retain the custody of her children if her husband dies. As the Liberian civil war eased, there continued to be few programs to help former combatants to reintegrate into society, and by 1998, there were still none specifically to benefit former female combatants and victims of the war (U.S. Department of State 1999, 12).

Estimates by the World Health Organization suggest that, during the eight years of civil war in Liberia, more than one-third of the more than 500,000 displaced women and children were raped (Achtelstetter 2000, 1). In addition, prior to the onset of the war in 1989, approximately 50 percent of Liberian women in rural areas between the ages of eight and eighteen were subjected to female genital mutilation (FGM), a practice widely condemned by international health experts as damaging to both physical and psychological health. The war virtually eradicated traditional village life, disrupting social structures so that the incidence of FGM dropped dramatically during the early and mid-1990s. However, after 1997, traditional societies began reestablishing themselves throughout Liberia to the extent that the U.S. Department of State (1999, 13) predicted a rise in the incidence of FGM.

A MOTHER'S VOICE

Liberians were ready for peace and the plan for peace was in place, but some thought the ability of the West African troops to "wage peace" was doubtful and that, "without some strong force," achieving it was "going to be difficult" ("Anarchy's Children" 1996). Instead of choosing this option to counter Taylor's return to violence, ECOWAS encouraged the faction chiefs to appoint Sankawulo's successor. In a "surprise move," a fifty-seven-year-old mother of seven, grandmother of twelve, and widow was chosen to head the Council of State (Wells 1997) and guide a Liberian interim government toward peace in the immediate aftermath of Charles Taylor's "two-month frenzy of killing and looting" (Rupert 1997).

Despite a number of warrior queens in precolonial days, African government has been the almost-exclusive domain of men since the

1960s ("Africa's First Woman Head of State Pledges to Work for Peace" 1996). Ruth Perry's selection was a recognition of the active involvement of Liberian women in the peace process. As a symbol of this involvement, she demonstrated that the resolution of Liberia's conflict was no longer to be argued from or determined by a singular male perspective ("Ruth Perry at the United Nations" 1996). Through Ruth Perry, African women's voices were going to be heard, their visions considered, and their peace efforts taken seriously.

Perry had been a supermarket cashier and bank employee before winning the senate seat left vacant by her husband's death in 1985. Her Unity Party refused to take up the places they had won in Samuel Doe's administration. Ms. Perry rebelled and sat as an independent. She was later expelled by her party and joined Doe's National Democratic Party (Wells 1997).

During the civil war, Ruth Perry refused to declare any alliances, a fact that partly explains her appointment as chair of the ruling Council of State. While politically known and credible, she "had never been part of the fight and the factions thought she represented no danger to them" (Rupert 1997).

Charles Taylor, known for his desire to occupy her seat, criticized her for procrastination over the issue of punishing those who tried to kill him in October 1996 (Wells 1997). However, when he learned that Perry refused to move to the presidential residence, preferring to remain in the bungalow where she houses displaced people from her home country, he also sent his security team to guard Perry and "offered to pave the road to her house and to furnish it" because her house "wasn't befitting a president of Liberia." She refused his offer as well as those of any other faction leaders (Rupert 1997).

Although she did not campaign for the position, Perry used her office to become the warlords' most prominent opponent, campaigning to force them to give up their guns and submit to an elected government (Rupert 1997). She had little formal authority, almost no assistance, financial or otherwise, and faced an interim government at "odds with itself," made up of men who spent almost a decade "making the country ungovernable while lining their own pockets and who hate each others' guts" (Wells 1997). Breaking with tradition, Perry opted for her voice rather than others' weapons as her instrument of persuasion and peace. Even that resource was limited because Taylor controlled most public information, running all of Liberia's rural radio stations plus a newspaper and an FM radio station in the capital (Rupert 1997).

Perry said she did not really see herself as a president or political leader, and "I just feel that there has been a task given to me to perform and that task I must accomplish. Then I will go back to my little normal life as before" (quoted in Wells 1997).

Arguing that "we have to educate people to know even their basic rights," Ruth Perry traveled Liberia's counties demanding that the factions implement the peace accord (Rupert 1997). Women seemed to give her the most support and to best recognize the "daunting nature" of maintaining some sort of stability prior to elections (Wells 1997; Siapoe 1996). That Perry is both a woman and a mother became crucial to her credibility. In May 1997, she joined women from more than twenty other nations during a three-day meeting of African First Ladies as part of a follow-up to the 1995 World Women's Conference held in Beijing, China. Topics discussed included the refugee situation in Africa, health of the displaced people, the recruiting of child soldiers, implications of conflicts, and the political and economic empowerment of women, all issues close to her as the leader of Liberia (Ejime 1997a). It is not insignificant that after one speech, Ruth Perry was presented with an award from a New York City–based group called "The Mother of Liberia, Inc." (Siapoe 1996).

After sending Taylor's guards away, Ms. Perry told Taylor and the other warlords that "I will treat them like a mother and, if necessary, that means discipline" (quoted in Rupert 1997). Arguing that it is difficult to be "tough" with faction leaders or others who step out of line, Perry tried not to think of herself but of the Liberian people, because "making decisions for them you had to be tough" (Wells 1997). She said, "Liberians know that I am one of them, that I have suffered as they have suffered and they haven't forgotten" (quoted in "Africa's First Woman Head of State Pledges to Work for Peace" 1996).

Perry maintained that she expected other members of the Council of State, whether they agreed with her or not, to "give her the respect they would give their mothers" (Wells 1997). One diplomat noted that Ruth Perry spoke "like a grandmother, scolding her children who misbehave and trying to teach them by her example" (quoted in Rupert 1997).

When asked to describe her relationship with the "male warlords" in Liberia and how she thought she could bring them together for peace, Perry replied that "as a mother" she would be "a stabilizer" for her male counterparts. She had been working with the faction leaders and "on political issues," especially on children, the elderly, and

women; the men knew that "if they did not agree, the women would take the lead" ("Ruth Perry at the United Nations" 1996).

Typical of Ruth Perry's rhetorical management of her position was a New York speech to Liberian Americans from her county in Liberia. Some argued "it was a bad precedent for a national leader to have met with her people (Cape Mountainians) first" instead of meeting with all Liberians generally, and others noted her reluctance to address certain "top-heavy political questions," including their safety should the expatriates return home. However, her appeal to Liberians abroad to help effect peace and security in their country was met with a standing ovation. Ms. Perry asked for their help much as a parent might plead for a wayward child to return to the fold: "Come home and help us stop the war. Give us suggestions in our weak way to stop the war. Pray for us. We will not tolerate further recalcitrance from any warlord" (Siapoe 1996).

In an October 1996 United Nations speech, Ruth Perry again rhetorically framed herself as the "Mother of Liberia" when she argued, "Our leadership is challenged with the difficult tasks of pursuing national reconciliation, reunification, repatriation and resettlement. This task requires us, as a matter of urgency, to first disarm our children and redirect their lives" ("Ruth Perry at the United Nations" 1996).

Ruth Perry's image as a stern, albeit loving, mother disciplining her children became a metaphorical as well as a literal peacemaking tool. As an ordinary person in an extraordinary situation, she lacked external resources to wage peace, so turned to her own resources and argued that as a mother, both to her children and to Liberia, she deserved both respect and attentiveness. Weapons had not secured peace in Liberia. The "boy's toys" just became bigger and meaner. Perry's weapon of choice in her war for peace and her chief rhetorical device was her ability to recast herself from mother of children to mother of Liberia, a wise move according to some.

With a "voice that does not epitomize the tones of tough world female leaders like Indira Ghandhi, Benazir Bhutto, or Margaret Thatcher," her "motherly figure" contrasted with all of the previous Big Men Liberian leaders and served simultaneously as an indicator of and reason for Ruth Perry's strength and skill: "I told the faction leaders I have the touch of velvet, but when it comes to taking a firm line I am as hard as steel" (quoted in Nubo 1997, 2). "They told me they respect me like a mother, and I hold them at their word, I will treat them like a mother, and if necessary that means discipline"

(quoted in "Africa's First Woman Head of State Pledges to Work for Peace" 1996).

In an open letter to Ms. Perry, one Liberian man wrote:

> I am a Grebo man. In Greboland, a warrior on his conquest is lured home with his mother's breast milk. I believe it is that same notion which prompted the Abuja Conferees to pick a woman to call home our fighters; call them back into their mother' s bosom to nurse their wounds and to nourish their souls after they have gone for too long without her care. (Teh 1997)

The long-term success of this rhetorical technique as a device for persuading Liberians to a permanent peace will not be known for years. However, there is evidence that Ruth Perry did succeed in using her generally "soft spoken" (Nubo 1997, 2) "mother's authority" to discipline "all the children—including the naughty ones" (Teh 1997) and held her country together long enough to have democratic elections.

RHETORICAL CONSTRAINTS
TO CALLS FOR PEACE

After a postponement to "ensure a credible electoral process whose results will be acceptable to the Liberian people and recognized by the international community," the presidential election originally planned for May 30 took place on July 19, 1997 (Ejime 1997e). With the August 2, 1997, inauguration of forty-nine-year-old economics graduate and warlord Charles Ghankay Taylor as president (Ejime 1997c), Ruth Perry's tenure as Liberia's first female head of state came to a successful end.

There are at least three issues that might call into question the extent to which "peace" and justice were brokered by this election. First, there was criticism of the election itself. While international observers, including Jimmy Carter, endorsed it as "free and fair" and an "important step for lasting peace" ("Taylor to Include to Include Rivals in Liberian Government" 1997), others, including Taylor's political rival Ellen Johnson Sirleaf, accused him of election irregularities and of abusing the democratic process (Ejime 1997g). His campaign featured slogans such as "You killed my mama, you killed my papa but I go vote for you," a reference to the young Liberians orphaned by the war Taylor began in 1989 (Ejime 1997c).

Arguing that complete disarmament before elections was not possible, he created a ECOMOG-backed plan to disarm only guerillas

located in densely populated areas that would be declared "safe havens." In so doing, the guerillas that were scattered in the interior, the bastion of his National Patriotic Front of Liberia, were untouched and remained armed. As a result, Charles Taylor was able to "appear as allowing the democratic process to proceed and at the same time ensuring himself of disproportionate advantage over other candidates [who] would not be able to articulate pertinent issues [or] freely travel around the nation to present their vision of the future to the voters" ("Partial Disarmament: A Prescription for Disasters in Liberia" 1996).

One observer believes Liberia's "onerous peace process" was capped by the election of Taylor. He was the wealthiest of all the candidates, had the most means to travel throughout Liberia "unmolested," had the most name recognition, "virtually monopolized the airwaves" with his radio broadcasts and threatened that if the election was further delayed only an "angel" would be able to protect its chairperson. For many Liberians, the election may have been a case of "your vote or your life" and they chose their lives ("The End Justifies the Mean" 1997).

A second deterrent to creating a real peace in Liberia is the fact that there is very little country left in which to create that peace. The civil war begun by Charles Taylor in 1989 has taken the lives of one out of every seventeen Liberians, uprooted most of the rest, and destroyed the economic infrastructure (Kramer 1995). Many of the more than 35,000 ex-combatants roam Liberian streets without jobs (Ejime 1997f) or education or housing; public water and electricity supplies have collapsed, as have education and health facilities; almost 800,000 persons are internally displaced, including thousands of abandoned children, and another 600,000 Liberians are refugees across West Africa (Ejime 1997b).

A third constraint is that, although there are no restrictions on the participation of women in politics, they remain underrepresented in the Liberian government. The sole female candidate in the 1997 presidential election finished a distant second behind President Taylor. In addition, the overall numbers of women in high-ranking positions in the Taylor administration and in various parties are low. Two of the twenty cabinet positions are held by women, a woman serves as chief justice of the Supreme Court, and a woman chairs the National Reconciliation Commission (U.S. Department of State 1999, 1).

Although the Liberian vote for peace may not have been "exactly" free and fair and Taylor's election hardly an "exercise in democratic liberties," Liberians did choose a leader through the "consent of the

people." Force may have compelled some to endorse his candidacy but ultimately "the ballot box not the bullet made Taylor's day" ("The End Justifies the Mean" 1997).

Liberia has been compared to a patient whose malady is "stark madness that requires a crazy cure" (Ejime 1997f). The Liberian people have articulated their choice for a "peace-cure," albeit in a perplexing and even ironic voice. Whether that choice will ultimately kill or heal now rests with a leader who must "rebuild what he has destroyed" ("The End Justifies the Mean" 1997) and so prove there is a difference between "Taylor the ex-warlord and Taylor the president of Liberia" (Ejime 1997c).

CONCLUSION

Despite constraints such as Taylor's manipulation of "democracy" to achieve his presidency and the logistical quagmire of rebuilding a devastated nation, a serious call for peace has been rhetorically constructed in Liberia. In Tonn's (1996) view, while the maternal persona may be nurturing, it also may be confrontational in challenging those who threaten the rhetor's constituency. This is particularly the case in circumstances in which physical and psychological survival of children is not guaranteed (3), as in Ruth Perry's Liberia. Her nurturing, strong, unwavering maternal voice, inspired by the threat to all of her country's "children," singularly contributed to that vision.

Ruddick (1989) queries how the innate "peacefulness" of maternalism might be "realized and then expressed in public action so that a commitment to treasure bodies and minds at risk can be transformed into resistance to the violence that threatens them" (157). A decade later, it appears this query has been answered by an African woman. A Liberian mother, Ruth Perry rhetorically became Liberia's mother and coaxed, cajoled, and parented her country through a transitional period bridging civil war to at least a promise of civility.

REFERENCES

Achtelstetter, K. 2000. "Liberia's Female Face." World Council of Churches Office of Communication WCC feature, August 9. Online at Accessed April 2, 2001.

"African Leaders Stream in for Summit." 1997. Africa News Service, May 1. Online at <http://library.northernlight/2219970807620000018.html> Accessed October 23, 1997.

"Africa's First Woman Head of State Pledges to Work for Peace." 1996. Reuter Information Service, August 18. Online at <www.reuters.com/world5_25110. html> Accessed October 23, 1997.

"Anarchy's Children." 1996. Transcript for *Online NewsHour*, May 1. Online at <www.pbs.org/newshour/66/africa.ca/liberia_background> Accessed October 23, 1997.

Ejime, Paul. 1997a. "Africa Women Seek Bigger Role on Humanitarian Issues." Panafrican News Agency, May 6. Online at <www.library.northernlight/ xx19970808050010024.html> Accessed October 23, 1997.

———. 1997b. "The Challenge Ahead of Taylor's Government." Panafrican News Agency, August 6. Online at <www.africana.com/pana080697.html> Accessed October 23, 1997.

———. 1997c. "Charles Taylor's Rough Road to Liberian Presidency." Panafrican News Agency, July 24. Online at <www.northernlight/2219970807150008597. html> Accessed October 23, 1997.

———. 1997d. "ECOWAS Summit on Liberia Planned for Abuja." Panafrican News Agency, May 15. Online at <www.northernlight/FD20010328100000231. html> Accessed October 23, 1997.

———. 1997e. "Liberian Elections Shifted to July 19." Panafrican News Agency, May 22. Online at <www.northernlight/2219970807710005331.html> Accessed October 23, 1997.

———. 1997f. "Liberians Mark 150 Years of National Independence." Panafrican News Agency, July 27. Online at <www.northernlight/2219970807110001914. html> Accessed October 23, 1997.

———. 1997g. "Taylor Promise Government of Equal Opportunity." Panafrican News Agency, July 24. Online at <www.northernlight/2219970807150010395. html> Accessed October 23, 1997.

"The End Justifies the Mean." 1997. Africa News Online, August 4. Online at <www.northernlight/dg19970822010001014.html> Accessed October 23, 1997.

Gedda, G. 1996. "Saving Liberia from Itself: Has U.S. Abandoned Its 'Best Friend' in Africa During 8-Year Civil War?" *Foreign Service Journal*, June. Online at <www.afsa.org/fsj/june/junefeature.html> Accessed October 7, 1997.

"Hope for Africa Lies in Embracing Democratic Values." 1997. *The Times of Zambia* (Africa News Online), October 3. Online at www.allafrica.com/9971003 _feaat3.html> Accessed October 23, 1997.

"Kofi Annan to Convene Liberia Conference." 1997. Africa News Online, Sept. 15. Online at <www.allafrica.com/9970915_feat1.html> Accessed October 23, 1997.

Kramer, Reed. 1995. "Liberia: A Casualty of the Cold War's End." Africa News Service. Online at <www.ucmodl.che.uc.edu/gbatu/liberia.html> Accessed October 23, 1997.

"Liberians Are Starving in Area Cut Off by Civil War." 1996. *Seattle Times*, Sept. 9. Online at <www.seattletimes.com/extra/libe090906.html> Accessed October 23, 1997.

"Liberia's Ex-presidential Hopeful Wants Strong Opposition." 1997. Africa News Online, Sept. 29. Online at <www.allafrica.com/9970929_feat1.html> Accessed October 23, 1997.

"Liberia Torn by Long Civil War." 1996. CNN Interactive World News, April 30. Online at <www.cgi.cnn.com/WORLD/9604/30/liberia/background.html> Accessed October 23, 1997.

"Liberia: U.S. Policy (part 1)." 1995. All Africa Press Service, Sept. 16. Online at <www.africapolicy.org/abcs95/lib9509.1.htm> Accessed October 7, 1997.

Manuh, T. 1998. "Women in Africa's Development: Overcoming Obstacles, Pushing for Progress." Africa Recovery briefing paper, April. Online at Accessed April 2, 2001.

"Milestones." 1996. *Time*, September 16 [online]. Available at <www.time.com/16/milestones.html> Accessed October 23, 1997.

Nubo, George H. 1996. "Alligator and Shark." Online at <www.theperspective. org/alligators.html> Accessed October 23, 1997.

———. 1997. "Ruth Perry: Modern Africa's First Female Head of State 1997." Panafrican News Agency. Online at <www.theperspective.org/ruthperry.html> Accessed October 23, 1997.

Nyanseor, Siahyonkron. 1996. "The Bleeding Liberia Celebrates 149th Independence." Panafrican News Agency. Online at <www.theperspective.org/bleeding.html> Accessed October 23, 1997.

Ohene, E. 1997. "Chosen by God." BBC World Service. Online at <www.bbc.com/focus/chosen.html> Accessed October 23, 1997.

"Partial Disarmament: A Prescription for Disasters in Liberia." 1996. Online at <www.theperspective.org/disarmament.html> Accessed October 23, 1997.

Pewu, D. S. 1997. "Yvette Chesson-Wureh's Activism Questioned." Online at <www.theperspective.org/wureh.html> Accessed October 23, 1997.

Ruddick, Sara. 1989. *Maternal Thinking: Toward a Politics of Peace*. New York: Ballantine.

Rupert, James. 1997. A National "Mother" Scolds for Peace. *Washington Post National Weekly Edition*, February 3, 17.

"Ruth Perry at the United Nations." 1996. Online at <www.theperspective.org/ruthun.html> Accessed October 23, 1997.

Schulz, W. F. 1997. Women Who Fight for Human Rights. *Parade*, January 19, 6.

Shiner, C. 1996. "Neb Bid to End Liberian Conflict." Panafrican News Agency. Online at <www.theperspective.org/liberiasumit.html> Accessed October 7, 1997.

Siapoe, B. 1996. "The Liberian Leader Meets with Liberians in New York." Online at <www.theperspective.org/liberians.html> Accessed October 23, 1997.

Smith, J. D. 1996. "Liberia's Ugly Past (Part I)." Online at <www.theperspective. org/uglypastI.html> Accessed October 23, 1997.

Stearney, Lynn M. 1994. Feminism, Ecofeminism, and the Maternal Archetype: Motherhood as a Feminine Universal. *Communication Quarterly* 42, no. 2: 145. Online at Accessed October 10, 2000.

"Taylor to Include Rivals in Liberian Government." 1997. Africa News Online, July 28. Online at Accessed October 23, 1997.

Teh, T. 1997. "Open Letter to Ruth Perry." Online at <www.theperspective.org/letter.html> Accessed October 23, 1997.

Tonn, Mari B. 1996. Militant Motherhood: Labor's Mary Harris "Mother" Jones. *Quarterly Journal of Speech* 82, no. 1: 1–21.

U.S. Department of State. 1999. Liberia Country Report on Human Rights Practices for 1998. Bureau of Democracy, Human Rights, and Labor, February 26. Online at <www.state/gov/www/global/human-rights/1998_hrp_report/liberia.html> Accessed April 2, 2001.

"U.S. Throws Weight behind Liberia Peace Effort." 1996. Yahoo Headlines: Reuters, May 3. Online at <www.reuters.com/liberia.18.html> Accessed October 23, 1997.

Washington Office on Africa. 1997. "Liberia: More U.S. Support Needed." Africa News Online. Online at <www.allafrica.com/LR/95.10.25.txt> Accessed October 7, 1997.

Wells, R. 1997. Lady at the Top. *Focus on Africa Magazine*, January/March, 32.

Williams, A. 1996. "The Truth About Forming Government in Exile." Online at <www.theperspective.org/exile.html> Accessed October 23, 1997.

"Women: Africa's Harbingers of Peace?" 1997. Africa News Online, September 22. Online at <www.allafrica.com/9970922_feat5.html> Accessed October 23, 1997.

Chapter 10

Peacemaking in Burma: The Life and Work of Aung San Suu Kyi
Rod Troester

For millennia women have dedicated themselves almost exclusively to the task of nurturing, protecting, and caring for the young and the old, striving for the conditions of peace that favor life as a whole. To this can be added the fact that, to the best of my knowledge, no war was ever started by women. But it is women and children who have always suffered most in situations of conflict. Now that we are gaining control of the primary historical role imposed on us of sustaining life in the context of the home and family, it is time to apply in the arena of the world the wisdom and experience thus gained in activities of peace over so many thousands of years. The education and empowerment of women throughout the world cannot fail to result in a more caring, tolerant, just and peaceful life for all.

—Aung San Suu Kyi, keynote address to
NGO Forum on Women, Beijing, China, 1995

In 1991, a relatively unknown forty-three-year-old Burmese woman, who had then been held under house arrest for three years by her own government for her prodemocracy activities, was named as the recipient of one of the world's most prestigious awards, the Nobel Prize for Peace. The remarkable story and journey as a peacemaker of Aung San Suu Kyi, or as she is referred to by the people of Burma, "The Lady," begins almost at her birth. Barbara Victor (1998) states: "It [the title of 'The Lady'] is a respectful title bestowed on her by the people who are reluctant to mention her name out loud for fear of reprisal by the military regime [the State Law and Order Restoration Council, or SLORC]" (7). An unusual combination of heritage and circumstance converged in such a way as to call a wife and mother from her quiet

life in England to return to her native Burma to confront a repressive government and demand freedom and democracy. This chapter begins by briefly tracing the journey of The Lady from the tragic death of her father, through her upbringing and education, to the time when circumstance called her home to care for her ailing mother, and heritage called on her to assume leadership of the prodemocracy movement in Burma. The brief history that follows was abstracted from "My Country and People" (1995) by Aung San Suu Kyi, herself a recognized scholar of Burmese history and culture. The second part of the chapter addresses how Burma's leading spokesperson for democracy rhetorically confronted the oppression of the government and continues to speak out for peace in her country.

HERITAGE AND CIRCUMSTANCE CONVERGE

Heritage and birth have inextricably linked the life of The Lady with the political life of Burma. Independence from historical colonialism for Burma came as a result of a nationalist movement spearheaded by students, and, in particular, a young student and military leader by the name of Aung San—said by some to be the father of modern and independent Burma, and also the father of Aung San Suu Kyi. Tragically, he and six fellow government ministers were assassinated by political rivals on July 19, 1947, just months before Burma became an independent republic on January 4, 1948. Aung San was only thirty-two years old when he was assassinated, leaving behind a wife, two sons, and a two-year-old daughter, who forty years after his death would take up the cause that had cost him his life.

When her father was assassinated in 1947, Suu Kyi was barely two years old and therefore had little recollection or memory of her father. She would later write a biography of Aung San based on her own research and the recollections of family, friends, and political associates. As a teenager, Suu Kyi lived with her mother, who served as ambassador to India during a brief period of Burmese democracy.

Suu Kyi's formal university education was completed at Oxford University from which she graduated with a degree in philosophy, politics, and economics. Following her formal education, she spent three years in the United States in the late 1960s and early 1970s working at the United Nations. While in the United States, she was strongly influenced by the civil rights movement and social turmoil that was taking place in the country at that time, particularly the work of Mar-

tin Luther King Jr. and nonviolent protest movements. Commenting on that time, Suu Kyi said, "There was a feeling of tremendous vigor. I had been moved by Martin Luther King's 'I Have a Dream' speech and how he tried to better the lot of black people without fostering feelings of hate. It's hate that is the problem, not violence. Violence is simply the symptom of hate" (quoted in Wallechinsky 1997, 5). Philip Kreager, an Oxford University historian, writes that during her early studies at Delhi University, Suu Kyi also gained a lasting admiration for the principles of nonviolence embodied in the life and philosophy of Mahatma Gandhi. He states, "Her campaign of civil disobedience in Burma was directly inspired by that example. She cited both Gandhi and Martin Luther King as models" (quoted in Aris 1995, 325).

In 1972, following her years in the United States, Suu Kyi married Michael Aris, an Oxford University scholar who specialized in Tibetan studies. Prior to her marriage, she prophetically wrote to her husband, "I only ask one thing, that should my people need me, you would help me to do my duty by them" (quoted in Wallechinsky 1997, 5). Throughout the 1970s and until 1988, Suu Kyi lived quietly in England, raised her two sons, and pursued her own scholarly activities—including the biography of her father.

Circumstances were such that in the spring of 1988, Suu Kyi was called home to Burma to care for her seriously ill mother, who had suffered a stroke and would later die. Her return to Burma coincided with a particularly violent period of political unrest that culminated in a riot in which police shot to death two hundred mostly student demonstrators who were protesting government policies and repression. Demonstrations continued throughout the summer of 1988, as did the government's violence and repression. The government reportedly killed three thousand people during August 1988 (Wallechinsky 1997, 5). At the time of a general strike called for August 26, Suu Kyi, as the daughter of one of independent Burma's founding fathers, responded publicly to the protests and the violence for the first time in a speech delivered at the Shwedagon Pagoda in Rangoon (Aris 1995, 192). Reportedly, this speech was the first and only one of the estimated one thousand speeches Suu Kyi would deliver between August 1988 and July 1989 for which a prepared text exists. Circumstance and heritage had conspired to propel the daughter of the founder of modern Burma, who had lived quietly abroad for most of her life, to emerge as the leading spokesperson for Burmese freedom and democracy.

In September 1988, the military once again asserted its control of

the government, declared martial law, and continued its violence and repression against demonstrators. Along with other antigovernment leaders, Suu Kyi helped to form the National League for Democracy (NLD) and began traveling the country speaking out against the military and for multiparty democracy and freedom. Her growing popularity with the Burmese people and her increasing influence as a prodemocracy spokesperson led government and military leaders to place her under house arrest in July 1989. Perhaps prophetically, the caveat to her commitment to her husband and family—that she would return to Burma, if necessary—had to be invoked.

She would remain under detention for six years until her release in 1995. She was not allowed even to see her children for more than two and one-half years. Her country needed her, and she had responded. Rather than silencing this quiet voice of nonviolence and freedom, the government's detention of Suu Kyi's made her into a rallying point for the prodemocracy movement in Burma and later an international symbol for peace.

While Suu Kyi's six-year detention severely restricted her contact with her family, the outside world, and the people of Burma, it failed to silence her message of democracy and freedom for Burma. The continuing pressure from the prodemocracy movement, combined with the government's effort to attract foreign investment forced the State Law and Order Restoration Council (SLORC), Burma's military government, to hold elections in 1990. The results were astonishing. Suu Kyi's party, the NLD, won 80 percent of the vote and seats in government with the military securing only 10 percent. Even though Suu Kyi was not allowed to run for office, the election results made it clear that the Burmese people desired multiparty democracy and greater participation in their government. Not surprisingly, the SLORC quickly moved to dismiss the results of the elections and continued to hold Suu Kyi incommunicado for the next four years.

The work of Suu Kyi to bring peace and democracy to Burma earned her international recognition; while still under house arrest, she was awarded the Nobel Peace Prize in 1991. Even with such international attention focused on her and her work, the SLORC refused to release her to accept the Peace Prize, which her son accepted in her absence. (In fact, the government refused to guarantee that she would be allowed back into the country if she left Burma to accept the prize.)

Following her release in 1995, Suu Kyi continued to speak out against the government. Regular weekend gatherings outside her house served as one of the few forums for free expression in Burma.

These gatherings provided an opportunity for Suu Kyi to speak directly to the Burmese people and indirectly to the international community. The popularity of these gatherings lead the government to limit such meetings, arrest more than one thousand people, and once again restrict the activities of Suu Kyi in the fall of 1995. Since late 1996, while formally not under arrest, Suu Kyi has not been allowed to travel or speak freely.

THE LADY'S RHETORICAL CHALLENGE

While the Burmese government's six-year detention of Aung San Suu Kyi severely limited her movements and her voice, it failed to silence her as a force for freedom and democracy. The facts of her detention and that she was not able to speak freely became a powerful message not only to the people of Burma, but also to the entire world. The fundamental challenge faced by The Lady was the repressive military government that was in power in Burma. The will of the Burmese people, as demonstrated by the results of the elections held in 1990, was and continues to be the goal of establishment of a multiparty democratic government in Burma. The obstacles have been and remain formidable. Despite ongoing popular resistance and considerable international pressure, the SLORC remains intractable in allowing the will of the people to participate in their government to take place.

An examination of The Lady's messages, her talk, prior to her imprisonment and several examples following her release, demonstrate her skill as a woman who speaks for peace. Three specific instances of her rhetoric are examined, one preceding her detention, one immediately following her detention, and a recent interview with an American television newsmagazine. The audiences for each of these three occasions were different, but the essential message remained the same. In each instance, Suu Kyi speaks both eloquently and simply from the heart to her audience. The outcomes of these three instances were not revolutionary, but rather careful and calmly considered dialogue intended to further the cause of democracy in Burma. Patience and persistence are perhaps the two qualities or characteristics that have shaped the rhetorical efforts of The Lady.

The Speech at the Shwedagon Pagoda

In the year preceding her detention, Suu Kyi addressed approximately one thousand citizen gatherings throughout Burma. The speech at the

Shwedagon Pagoda, delivered in Rangoon on August 26, 1988, was
the first and the only one of these speeches for which she had a pre-
pared text (Aris 1995, 180). It took place following the government's
killing of several student demonstrators. The rhetorical challenge in
this case was to call for calm and to remind the Burmese people of
their ultimate goal. While it was delivered to the immediate audience,
this speech set the tone and themes that would characterize her work
throughout Burma prior to her detention. Delivered in Burmese to a
mass rally, Suu Kyi essentially called for discipline and unity among
the Burmese people as they worked nonviolently toward multiparty
democracy and freedom. She said, in part:

> This public rally is aimed at informing the whole world of the will of the
> people. Therefore at this mass rally the people should be disciplined and
> united to demonstrate the very fact that they are a people who can be disci-
> plined and united. Our purpose is to show that the entire people entertain
> the keenest desire for a multi-party democratic system of government.
> (quoted in Aris 1995, 180)

Acknowledging the occasion, she reminded the audience of the recent
government violence directed toward student protesters, many of
whom had sacrificed their lives in the struggle against the govern-
ment, and called for a moment of silence to honor their memory. Hav-
ing established the central themes and purpose of her speech and the
people's struggle, Suu Kyi established her credibility by reminding
those gathered of the work of her father in the first struggle for Bur-
mese independence years earlier. Recalling her heritage and his strug-
gle, she said, "I could not, as my father's daughter, remain indifferent
to all that was going on. This national crisis could in fact be called the
second struggle for national independence" (Aris 1995, 193). Suu Kyi
suggests that it was her duty—if not destiny—to become involved
with the fight for democracy and freedom. Duty to the Burmese peo-
ple and her country would become a recurrent theme in her rhetorical
struggle for democracy.

Throughout the speech, Suu Kyi remains focused on the end
sought, multiparty democracy, and the means to achieving the end,
nonviolent unity and discipline on the part of the Burmese people. She
said, "To achieve democracy the people should be united. That is very
clear. If there is no discipline, no system can succeed" (quoted in Aris
1995, 194). She reminds the Burmese people that it is the government
that must change, and that the people should not view the military—
which her father built—as the enemy. In fact, she calls upon the armed

forces to join the struggle for freedom and democracy, suggesting, "May the armed forces become one which will uphold the honor and dignity of our country" (quoted in Aris 1995, 195). She extends the call for unity to all politicians by encouraging them to work together rather than for partisan ends and calls on the "gulf" between the older and younger generations to be bridged.

In addressing the government directly, she calls upon then-president Dr. Maung to bring about a multiparty democracy through free and fair elections, as soon as possible because it is the will of the people. The continuing pressure from the prodemocracy movement, combined with the government's effort to attract foreign investment, forced the government to hold elections in 1990. While the elections were not the direct outcome of the rhetorical challenge to the government issued by Suu Kyi, certainly the movement she had begun and the pressure the people were able to place on the government, in concert with international pressure, helped to make the elections possible.

During the months following this speech, Suu Kyi traveled throughout Burma spreading essentially the same message. One incident that increased her visibility as a spokesperson for democracy occurred in the spring of 1989. In early April, Suu Kyi nearly lost her life when she and a group of prodemocracy demonstrators were ordered off a road by the military. By literally stepping in front of the demonstrators, Suu Kyi made herself the target for the military who would have opened fire had a major in the Burmese army not intervened. Reports of this courageous act helped to galvanize support among the Burmese people behind Suu Kyi, as well as to make The Lady the most visible opposition target for the government. Not surprisingly, to remove such a visible symbol of the opposition, the government soon placed Suu Kyi under house arrest where she would remain for nearly six years.

Keynote Address to the NGO Forum on Women

Suu Kyi was asked to deliver the keynote address to the Nongovernmental Organization Forum on Women sponsored by the United Nations that was held in Beijing, China, in August 1995. Her challenge or perhaps opportunity in this speech was to take her message of peace and democracy to a worldwide audience. Though the audience was an international gathering on women, the message was one that could resonate beyond the immediate gathering.

While her detention or house arrest formally ended in July 1995,

Suu Kyi was unable to deliver her address in person, fearing that if she left Burma, she would not be allowed to return. She explains: "The regaining of my freedom has in turn imposed a duty on me to work for the freedom of other women and men in my country who have suffered far more—and who continue to suffer far more—than I have."[1] She thanked those in the international community who made her video appearance at the forum possible, suggesting, "They made it possible for me to make a small contribution to this great celebration of the struggle of women to mould their own destiny and to influence the fate of our global village." Her message focused on four key issues: peace, security, human rights, and democracy in the context of the participation of women in politics and governance.

The following quote sets the context for Suu Kyi's remarks to the conference and more broadly declares the place of women in the process of peacemaking:

> For millennia women have dedicated themselves almost exclusively to the task of nurturing, protecting, and caring for the young and the old, striving for the conditions of peace that favor life as a whole. To this can be added the fact that, to the best of my knowledge, no war was ever started by women. But it is women and children who have always suffered most in situations of conflict. Now that we are gaining control of the primary historical role imposed on us of sustaining life in the context of the home and family, it is time to apply in the arena of the world the wisdom and experience thus gained in activities of peace over so many thousands of years. The education and empowerment of women throughout the world cannot fail to result in a more caring, tolerant, just and peaceful life for all.

While speaking to the forum in particular, these comments also recognize and speak to the rest of the world concerning the role women have historically played in peacemaking. Anticipating the new millennium, Suu Kyi notes that if "the growing emancipation of women" can be combined with a peace dividend resulting from the end of the Cold War, then "truly the next millennia will be an age the like to which has never been seen in human history."

Suu Kyi recognized that the obstacles of intolerance and insecurity must be overcome. The genuine tolerance she spoke of requires "an active effort to try to understand the point of view of others" rather than a mere live and let live attitude of a passive view of tolerance. Such a tolerance is possible only if women are valued and "their opinions are listened to with respect, they are given their rightful place in shaping the society in which we live." Dismissing an old Burmese

proverb that states: "The sun rises when the rooster crows"—suggesting a subservient role for women—Suu Kyi concludes that a more enlightened view of the role of women "with their capacity for compassion and self-sacrifice, their courage and perseverance, [suggests they] have done much to dissipate the darkness of intolerance and hate, suffering and despair." Challenging the traditional view of security through force, and recognizing the connection between tolerance and security (those who are insecure tend to be intolerant), Suu Kyi argues that "the people of my country want two freedoms that spell security: freedom from want and freedom from war." These, she argues, are only possible through a change in the government of her country.

Suu Kyi suggests that women have a unique and vital role to play in the search for tolerance and security, but this role can only come about if women are afforded full participation in the affairs of government that, she argues, is only possible through a democratic form of government. Ironically, the democratic movement in Burma that was spearheaded by a woman and did in fact produce elections in 1990 nevertheless failed to give women a representative place at the government table with only 14 of the 485 members of parliament elected being women. Acknowledging that none of those elected were in fact able to serve, Suu Kyi argues, "The very high performance of women in our educational system and in the management of commercial enterprises proves their enormous potential to contribute to the betterment of society in general. Meanwhile our women have yet to achieve those fundamental rights of free expression, association and security of life denied also to their men folk."

Recognizing that gender barriers need to be overcome, Suu Kyi suggests the relationship between men and women "should, and can be characterized not by patronizing behavior or exploitation, but by *metta* (that is to say loving kindness), partnership and trust." Suu Kyi addresses the stereotype, which is apparently worldwide, that women talk too much. Commenting on what she perceives as a unique characteristic of the female gender, Suu Kyi cites research than women are better at verbal skills while men tend toward physical action and further psychological research concluding that disinformation by men is more damaging than feminine gossip. In terms of resolving conflict, she concludes that female dialogue is superior to potential male violence. Addressing the forum directly, she states that collectively, women represent "the belief in the ability of intelligent beings to resolve conflicting interests through exchange and dialogue." Using

the spirit of the United Nations Human Development Paradigm, which suggests "people must participate fully in the decisions and processes that shape their lives," she rightly points out that "people" includes women, who make up half the world's population.

As she concludes her address, Suu Kyi tells the forum that her six years of solitude and reflection have brought her to the realization that the world is not divided into those who are good and bad but rather those who are capable of learning and those who are not. Recognizing the traditional role of women as teachers of children, she states: "It is time we were given the full opportunity to use our natural teaching skills to contribute towards building a modern world that can withstand the tremendous challenges of the technological revolution which has in turn brought revolutionary changes in social values."

She concludes that while modesty and pliancy are prized virtues of the female gender for the learning process, women "must be given the opportunity to turn these often merely passive virtues into positive assets for the society in which we live."

August 2000 *Dateline* NBC Interview

Since her freedom from house arrest, The Lady has been far from free. Her movements, activities, and contact with the Burmese people and certainly with the outside world are under the constant scrutiny of the government. In the fall of 2000, NBC *Dateline* correspondent Hoda Kotbe arranged to secretly interview Suu Kyi. Kotbe reported that the *Dateline* team went to Burma as tourists, but that reaching Suu Kyi "was like a scene from a secret agent movie: phone calls in code, decoy cars, hidden tapes—only this was all too real given that journalists are not officially allowed to interview her."[2]

While not a formal speech, some of the more recent comments by Suu Kyi seem important to understanding her past and present work. In discussing whether the price she has paid for her work has been worth the sacrifice, Suu Kyi states, "I don't look at it as a sacrifice. It's a choice. If you choose to do something then you shouldn't say it's a sacrifice. Because nobody forced you to do it." Whether a sacrifice or a choice, Suu Kyi's work has cost her almost a decade of freedom, the opportunity to see her sons (who were twelve and sixteen years old when she was detained) grow into men, and the pain of being separated from her husband even as he died from cancer in March 1999. Reflecting on her upbringing, she said, "I had been brought up by my mother with a very strong sense of duty towards my people and my

country, so I was always aware of that [the price or sacrifice]." In characterizing her existence under house arrest, she explained that her phone was literally cut off, no one was allowed in or out of the house, malnutrition caused her hair to fall out, and, with the exception of three brief visits, she was not allowed to see her sons.

Several times, including when she was awarded the Nobel Peace Prize, she was given the impossible choice of leaving the country she loved, knowing she would not be allowed to return, or being with her family in England. Each time, her choices were duty and country. From the government's perspective, according to U Tin Winn, ambassador to the United States from Myanmar (Burma), "She was under restriction in accordance with existing laws. She had an easy life. I think as compared to being in the prison or in the solitary confinement it is very easy, a very lenient, and even convenient for her." Upon her release, the government restricted her to the capital of Rangoon.

In defiance of the authorities, when supporters would gather at her house, she took the opportunity to speak to them and continue to press for the cause of democracy. Suu Kyi observed of her supporters, "Some of them came with little bags with a change of clothes in case they were taken away to prison." As the NBC *Dateline* interview concluded, Suu Kyi stated, "Democracy's not perfect. I think you have to keep working at it. Unless my lifetime is unexpectedly short, I certainly will see democracy come to Burma." Her belief in the cause of democracy seems unshakable. The government has a different characterization as expressed by Ambassador U Tin Winn: "She's just a housewife. Just a housewife. Nothing more than that." At the time of the interview in 2000, the state-run newspaper reported that Aung San Suu Kyi could face the death penalty or life in prison for high treason for her prodemocracy activities.

AUNG SAN SUU KYI AS A WOMAN WHO SPEAKS FOR PEACE

Like most women, Suu Kyi has played multiple roles in the course of her life from the traditional roles of student, wife, and mother to the nontraditional role of spokesperson for the prodemocracy movement in Burma. She has confronted the traditional challenges faced by women, as well as the extraordinary challenges resulting from her heritage and her deep sense of duty to her family, country, and people. Throughout her life, she has played these roles and faced these chal-

lenges with quiet determination, patience, and persistence. Perhaps it is because she was seemingly ordinary prior to her entry into the political struggles of Burma that she appears so extraordinary as a result of her work for peace and democracy in Burma.

Feminist standpoint theories provide one means of analyzing the rhetorical efforts of Suu Kyi. Hallstein (1999) suggests that feminist standpoint theories are grounded in the central idea that "knowledge is socially located and arises in social positions that are structured by power relations," arguing that women "occupy a distinctly subordinate position in patriarchal culture that is structured by power relations, and that this position is qualitatively different from men's" (35). Suu Kyi draws upon her considerable experience, background, and heritage within the context or circumstance in which she found herself in 1988. She was not the average Burmese woman—having had the advantage of education, international experience, and heritage—but she was nevertheless able to speak effectively to the military-controlled government and the rest of the world not only for women but for the majority of the Burmese people.

Hallstein (1999) points out that feminist standpoint theories argue that "women occupy a distinct position or standpoint in culture because, under the sexual division of labor ensconced in capitalist patriarchy, women have been systematically exploited, oppressed, excluded, devalued, and dominated" (35). While the comments of the Burmese ambassador—that Suu Kyi was just a housewife—and Suu Kyi's own use of the rooster proverb suggest a subordinate position for Burmese women, these cultural limitations failed to diminish the message and effectiveness of Suu Kyi as a spokesperson for peace and democracy in Burma. In the speech to the United Nations' Forum on Women, Suu Kyi acknowledges the traditional role of women as nurturers and teachers, but also advocates that such traditional roles have much to say and contribute to peace in Burma and elsewhere. So, while seemingly subordinate to and dominated by men, such social knowledge, drawn from traditional roles and experience, uniquely position Suu Kyi, and more broadly women, to speak for peace.

The challenge that Suu Kyi faced upon her return to Burma in 1988 was coping with the illness and subsequent death of her mother. By virtue of her heritage and the political circumstances in Burma at the time, her sense of duty and responsibility to that heritage necessitated her taking an active role in the unfolding political situation. While she was part of a much broader movement for political reform in Burma, the "accident" of her birth as the daughter of one of the founders of

modern Burma provided credibility that others could not claim. Rather than use her unique circumstance to claim political advantage for herself, Suu Kyi used her circumstance to speak for the wishes and desires of the Burmese people. She did so not because of potential personal political gain, but out of a sense of duty. How easy it would have been, and would be, for her to leave Burma and return to what remains of her family.

Her goal throughout her public life has been establishing peace and democracy for the people of Burma. It is important to remember that she was not calling for the overthrow of the government, but rather that the government yield to the will of the people by accepting the results of the elections it sponsored. In this sense, she is a reformer working within the system rather than a revolutionary working outside the system. As the most visible spokesperson for democracy in Burma, she speaks for her people. Prior to her detention, she spoke out throughout the country. During her detention, her silence became a symbol of the repressive government she sought to change. After her release, and perhaps because of her notoriety, she was able to carry her message to a much wider audience around the world.

The means advocated and followed by Suu Kyi have consistently been peaceful and nonviolent due to her early education and admiration of Martin Luther King Jr. and Gandhi. It is important to note that the rhetoric of The Lady is without hate or aggression. In the Shwedagon Pagoda speech, she does not call on the people of Burma to overthrow the government. Rather, she explicitly calls for discipline and the use of nonviolent means to exert pressure on the government. When she addressed the military in the same speech, she did not call on them to turn on the government; she called on them to join the prodemocracy movement.

Her message to the women gathered in Beijing, China, was not one of hostility, but one of careful reason and understanding. As a woman speaking to women, she stressed the themes and issues that were important and common to women and used those common experiences to address the broader issues of tolerance, peace, human rights, and democracy in Burma. Her essential message was that women have, can, and should continue to make contributions to a better and more peaceful world.

The broadcast interview on the popular NBC television show *Dateline* introduced the viewing public, at least in the United States, to a country that most would probably have difficulty locating on a map and to a woman many probably had never heard of or seen. While she was speaking as a Nobel Peace Prize Laureate, the struggle Suu Kyi

represents has failed to achieve the type of press coverage necessary to familiarize the public with the ongoing situation in Burma. Again, she spoke plainly and simply about her life and her work for democracy in Burma as her story was told during the interview. The interview was less about the political struggle for democracy than about the difficult choices Suu Kyi made and the consequences she was willing to accept for the choices she made. At the conclusion of the *Dateline* interview, a Burmese supporter commented, "We have a hope. We have the future. She will be the leader. She will be our leader." Interestingly, while others see Suu Kyi as having a political leadership role in a democratic Burma, Suu Kyi consistently speaks of democracy for the people of Burma with little or no mention of her assuming any type of leadership role.

Peace is not a men's concern or a women's concern. By virtue of traditional cultural norms, stereotypes, and roles, perhaps women are uniquely positioned or qualified to speak for peace. In the case of Aung San Suu Kyi, it is her keen sense of duty and fateful heritage, in addition to gender, that make her such an effective spokesperson for peace.

NOTES

The military government changed the name of the country from Burma to Myanmar. The traditional name (used by the prodemocracy movement) is Burma.

1. The text of the speech is available online at <danenet.wicip.org/fbe/beijing.html>.

2. The transcript of the interview is available at <www.msnbc.com/news/438322>.

REFERENCES

Aris, M., ed. 1995. *Freedom from Fear and Other Writings: A Collection of the Writings and Speeches of Aung San Suu Kyi*. New York: Penguin.

Aung San Suu Kyi. 1995. My Country and People. In *Freedom from Fear and Other Writings: A Collection of the Writings and Speeches of Aung San Suu Kyi*, edited by M. Aris, 39–81. New York: Penguin.

Hallstein, D. L. O. 1999. A Post-modern Caring: Feminist Standpoint Theories, Revisioned Caring, and Communication Ethics. *Western Journal of Communication* 63, no. 1: 32–56.

Kreager, Philip. 1995. Peaceful Struggle for Human Rights in Burma. In *Freedom from Fear and Other Writings*, edited by M. Aris, 318–59. New York: Penguin.

Victor, Barbara. 1998. *The Lady: Aung San Suu Kyi, Nobel Laureate and Burma's Prisoner*. Boston: Faber and Faber.

Wallechinsky, D. 1997. How One Woman Became the Voice of Her People. *Parade Magazine* (supplement to *Erie Times News*), January 19, 4–6.

Conclusion

Anna L. Eblen and Colleen E. Kelley

These twentieth century activists represent a cross section of women's peace efforts and impacts upon our world. Authors of this collection examined women peacemakers of our century, using feminist rhetorical theories. The descriptions and analyses indicated that each peacemaker addressed social problems in highly individual ways, yet they shared some commonalities as nonviolence advocates. The first purpose of the book was to document the voices of the women peacemakers, and this conclusion begins by reviewing the major thrusts of their rhetorical efforts and gender images that they put forward. Second, the book has sought to evaluate the effectiveness of the peacemakers' efforts. Here we comment on the appraisals and attempt to assess the value of these analyses within feminist rhetorical and peace theory.

This book is primarily grounded in feminist standpoint and ecofeminist rhetorical theory. Increasingly, peace theorists have acknowledged the place of women's experiences in their approaches to peacemaking. Rather than the essentialist argument that women inherently differ from men, current expression has stressed that women's understanding of gender grows from their lived experiences, and, in the case of peacemaking, their experiences with violence and nonviolence. The ecofeminist extension of this theory emphasizes that women's experiences have often provided a sense of interconnectedness to others and to nature. The variability of this group of authors and peacemakers represents a range of viewpoints about gender and nonviolent solutions. We seek to draw out commonalities as well.

193

REVISITING PEACEMAKERS
AND GENDER IMAGES

Without exception, the peacemakers in this collection presented implicit or explicit messages about gender in their public speaking and writing. Let us briefly review their communication about peace, including the gender images our authors detected. We also revisit public activism as symbolic behavior portraying gender, which is perhaps as important as the peacemakers' language about gender.

Peacemakers' portrayals of womanhood and manhood addressed both popular culture's gender images and their own, sometimes contradictory, images of gender. In the introduction, we remarked that, even though some of these peacemakers might not see themselves as feminists, feminist thought provides insights about their discourse. Gender perception is one of the symbolic elements that the feminist lens sharpens most clearly. Feminist rhetorical analysis also encourages examination of interconnected images that depict the intricate relationships among gender and race, age, or social class.

In Kennedy's chapter, Ida B. Wells struggled with the complicated interaction of race, gender, and sexuality in her antilynching campaign. Kennedy detects Wells's images of human as property, and she notes roots of organized violence among distorted African American/white and female/male power relationships. Wells sought to counter property and sexual mythologies that were not only inherently destructive to African American lives but also to African Americans' self-definition of manhood and womanhood. Her journalistic and public speaking campaign against lynching drew national and international attention to racial violence. She exemplified an individual woman's ability to campaign for political justice that protects her community and family.

LeFebvre documents topics in Jane Addams's Carnegie Hall address about her international peace efforts. In addition, LeFebvre describes the subsequent apologia, in which Jane Addams, bemused by virulent negative reactions, justified her speech. The speech contains themes coalesced around manliness and the experience of the warrior, as well as recognition of the plight of ordinary citizens, women and men, during times of war. She directly confronted patriarchal values in her portrayal of "old men" held responsible for the war. Her ongoing activism served as a model for activist women. Addams's Nobel Peace Prize, awarded for her work trying to mitigate World War I, gave recognition to a woman who publicized social justice and war

issues that powerful political and economic groups preferred to avoid. LeFebvre notes Addams's return to the speech issues in her later work. She held the troubling war images in the public domain, establishing a pattern that would prove useful to subsequent women activists accused of similar unbecoming behavior.

Rankin, according to Christie, concerned herself with social justice and equity issues in both her suffrage and peace work. For Rankin, gender issues provided a touchstone for tests of fairness and reasonableness. She refused to vote for war in Congress for World Wars I and II based upon reasons grounded in gender equity and social justice. She expressed the principles involved in her dissenting vote, the only one in Congress against U.S. entry into World War II, "As a woman I cannot go to war, and I refuse to send anybody else." Rankin advocated for gender equity in the vote, in labor standards, and in access to political power. Christie shows that Rankin's rhetorical approach stood as a hallmark for women and peace activists from the early twentieth century through the Vietnam War and beyond.

Maria Pearson, Running Moccasin, reworked two primary cultural gender images in her reconciliation efforts concerning Native American ancestral remains. Dowlin identifies the image of the ancestors as advisor as well as a revisioning of the warrior. In these new reflections, the "grandmother" appeared as mystical advisor and the "warrior" spirit delivered strength to resolve old grievances. Although her portrayals of the images were uniquely hers, Running Moccasin's depictions resonated with similar popular culture images. Her work furthered the cause of racial reconciliation and exemplified Native American women's activism. Her implicit message, couched in traditional native symbols, revealed a woman with a strong capacity for difficult, public work for racial justice.

Mary Lou Kownacki, a Benedictine, worked within the Catholic patriarchal structure in peace and social justice leadership positions. According to Mester and McMullen-Pastrick, Kownacki relied upon support of the Benedictine sisterhood, as well as her own creative gifts, in Pax Christi and her work with community social justice. Her faith-based writing and speaking shows a high degree of innovation regarding adaptation to her contextual needs and rhetorical constraints. Her words reflected obedience to church structure and gender normative behavior, yet her rhetorical actions revealed dedication to change. In addition, Kownacki utilized civil disobedience and other nonviolent strategies to further peace and social justice.

Yet another important activist of the antinuclear peace movement, Australian Helen Caldicott created metaphors that, at least on the sur-

face, contravened gender stereotypes. Cavin identifies three power-related metaphors in Caldicott's speeches—physician, mother, and deity. Caldicott co-opted the metaphors from their standard usage within the power structure. Although most of the other peacemakers used the mother trope to some extent, Caldicott's appropriation of physician and deity, images typically associated with maleness, innovated around powerful metaphors. Cavin argues that Caldicott's use of the metaphors, however, perpetuated oppressive authority structure by using (and sometimes misusing) patriarchal forms while simultaneously calling for a nonpatriarchal paradigm shift.

Eblen and Wisdom-Whitley analyze myth and metaphor in Betty Bumpers's speeches. Bumpers, whose ethos as Senator Dale Bumpers's socially active spouse gave her "assured elite" status (Lofland 1993, 121), enhanced awareness of nuclear issues. She directed her appeals to middle-class, politically uninvolved women by invoking the responsibilities of "mother" and citizen. She also used a series of metaphors that suggested the mythology of the frontier. The authors conclude that Bumpers rhetorically modified the "nuclear frontier" myth to include symbolic space for frontier women and peacemaking. Although the metaphors created a fairly traditional "good woman" image, the messages also revealed a frontier woman capable of strong positive action to "civilize" and give "a new direction" for nuclear policy.

Next, Cavin studied Sis Levin, who acted for peace when her spouse became a hostage in Lebanon. Cavin's analysis of Levin's metaphors uncovers the image of the Middle East conflict as a quarreling dysfunctional family. Levin used both religious and psychotherapeutic images to portray the aggression. Levin's own experience of gender and fighting in her dysfunctional family of origin informed her descriptions and proposed solutions. Her linguistic strategies concentrated upon solutions to fighting among the "children of Abraham," a characterization of Moslems, Jews, and Christians. Levin's prescriptions for peace include steps for multiple voices, rather than patriarchal intimidation, to "break the silence" around their dysfunction.

Ruth Perry, according to Kelley's study, enacted a literal as well as rhetorical maternal leadership of war-torn Liberia so that political factions that had been engaged in a decade-long, bloody, intertribal civil war might have time to form a strategy for peaceful governing. Kelley found that Perry discursively framed herself as a stern but loving mother, who scolded and coerced her misbehaving children, not out of a desire to discipline them but in order to protect them. This mother

trope expands upon the current knowledge in that it demonstrates the application in an international setting. This chapter details the rhetorical power of the "fierce and protective mother" persona in building, if not a sustainable peace, then a discursive space within which peace might be approached.

Troester examines Nobel Peace Prize winner Aung San Suu Kyi's autobiography and speeches in Burma and her videotaped keynote address at the Nongovernmental Organization Forum on Women in Beijing. While under house arrest, Suu Kyi spoke about democracy in Burma and discussed women's roles in the international peace movement. She eloquently argued that much of the work that needed to be done required women's dedication and participation. Troester describes her courageous example of nonviolent protest as a political method to move Burma toward democracy through citizen action.

EFFECTIVENESS: RHETORICAL CHALLENGES AND SOLUTIONS

One way of looking at effectiveness is to examine the rhetorical challenges that the peacemakers faced and to consider their adaptations to these challenges. This examination includes an effort to trace evolution of cultural "meanings" presented in the gender images as the challenges and solutions developed. Rhetorical and communication theory has highlighted systems of meaning because of the discipline's study of symbolic behavior, both language and action.

All of these peacemakers responded to at least two rhetorical and possibly pancultural challenges: speaking out as women in patriarchal societies and speaking for peace in societies prone to violence. As the introduction to this book suggests, some feminist theorists have categorized these challenges as related, if not the same. Theorists link the patriarchal structures that deny women access to power with violence inherent in power imbalances. The authors in this book have demonstrated that understanding reasoning about gender in talk and public activism furthers understanding of militarism, violence, and peace. Thus, the most effective solutions typically served to justify women's public talk in general and to give them particular authority to speak about peace. We can examine effectiveness by tracing a few cultural images centered in rhetorical challenges and solutions. These images represent cultural meanings exemplified in language and behavior.

The first rhetorical challenge, concerning how women negotiate a

symbolic space for themselves as public change agents, appears around the issue of "separate spheres." Women peace activists struggled with the issues of public and private spheres, and these chapters delineated women's answers to the rhetorical problems posed by public involvement. Social demands on women at the turn of the twentieth century mandated minimal engagement with the public sphere, wherein political and social action generally evolved or at least took seed. Because theirs was primarily and traditionally the domestic sphere, simply engaging in public persuasion drew vehement criticism of women activists, no matter what the message. As Kennedy's 1999 book about the World War I era argues, women on the public stage, especially debating controversial issues, found themselves portrayed as "unnatural women" for daring to step out of their proper discursive space. All chapters documenting early-century activists— Wells, Addams, and Rankin—demonstrate "separate sphere" challenges about the legitimacy of women's public participation. Wells's participation evoked additional challenges based upon her race. By the 1980s, peace activists Kownacki, Bumpers, and Caldicott still encountered such criticism, including questions about their legitimacy and competence to discuss nuclear issues.

The solutions to these challenges appears primarily in the form of "standpoint" arguments. From early activist discourse, for example, in the Women's International League for Peace and Freedom (WILPF) preamble, women sought to preempt such complaints about their behavior by claiming that their knowledge and experience as women provided distinctive solutions that needed to be voiced. In other words, they asserted that their experiences and knowledge gleaned from inhabiting the private sphere provided insights so important that the need to share them with the world surpassed the laws that would have kept these women silent. Thus, "the mother half of humanity" tropes began to pervade women's peace discourses, as well as other social welfare reform talk. Arguments about special insights as an experience of womanhood tended to persist, first, because the logic effectively appealed to the audience of potential women converts. Second, the reasoning was difficult for men to dispute, because they could claim neither knowledge provided through motherhood nor the same access to private sphere information.

Issues of separate spheres also impacted the rhetorical challenge of speaking for peace in violent societies. Early in the century, women rhetorically manipulated the concept of their private domestic sphere to evidence their moral authority. When militarism or violence ran

rampant in a society, women could, and often did, emphasize their "outsider" status in efforts to move their programs forward. In the cases of Wells and Pearson, their race as well as gender separated and gave a different voice to their peacemaking efforts. They spoke as women of their races, with insights based upon knowledge from outside the dominant white group. By sharing their perspectives, they educated the public and moved the social issue into a more general cultural knowledge. Such strategic communication continued throughout the century, as evidenced by Perry's purposeful lack of involvement in the violent Liberian political turmoil and reliance on her "mother" persona, both of which credentialed her for interim presidency. Aung San Suu Kyi was literally imprisoned in her own home (the center of the private sphere) to try to keep her outside the political process in Burma, but she influenced the public dialogue through her sustained nonviolent appeals.

Another persuasive challenge for peacemakers, whether male or female, involved the perceived need to speak out about the militarist systems while eschewing violent and adversarial tactics. As this book demonstrates, most of these women tried to adapt to this exigency. Wells, even though her antilynching campaign maintained strict ethical standards for evidence, perhaps experienced extra antagonism because she spoke about race and sexuality, a controversial taboo topic. She managed, however, to turn the controversy into a means of educating the public about lynching as racial violence. A nonviolent approach usually emphasizes innovative thinking, education, and information as change strategies. Chatfield (1993) states, "Virtually every existing instrument of avoiding war or moderating its effects was envisioned by peace advocates well before it became feasible or necessary for political leaders" (180). In this book, Cavin identifies Caldicott as one who adopted relatively abusive argumentation methods, including exaggeration and misrepresentation. These methods evoked particular criticism, because most peace activists hold themselves to the highest ethical standards regarding means of persuasion. Most of the peacemakers profiled here found themselves faced with choices about responding to highly adversarial media or verbal attacks, but they maintained their positions and responded peacefully.

In another response to the rhetorical challenges, women formed separatist peace organizations. These organizations redefined the meaning of women's democratic participation and bettered the lives of women, another measure of effectiveness according to Foss (1989).

Women created innovative organizational structures and campaign methods in efforts to change violent social institutions. These organizations and skills set the stage for two kinds of changes: more women in political power and more institutionalized peacemaking processes. Separatist organizations, an early adaptation to the rhetorical challenge of public involvement, allowed women to hone their governance and public communication skills. They argued the terms of womanhood (and, by extension, manhood) within patriarchal establishments, such as judicial or legislative systems, media, and military institutions. The effectiveness of their cumulative efforts is apparent in the gradual transformation of these institutions. While no single struggle—except suffrage—marked women's greater inclusion within the power structure, their ongoing work and mentoring of other women suggests that the peace and social justice advocates influenced substantive institutional changes over the twentieth century.

THEORETICAL CONTRIBUTIONS

The analyses in this book expanded the usual focus of peace studies, including feminist peace studies. The traditional approach has been to explore peace movement organizations and leaders. Although the majority of our subjects (Addams, Rankin, Kownacki, Caldicott, Bumpers, Levin, Aung San Suu Kyi) were women who participated in or led peace movement organizations, several authors documented those (Wells, Pearson, Perry) whose work went beyond what is generally considered a "peace movement" study. As Kennedy states, "It is not clear that [maternalist] . . . peace theory is relevant to or accounts for the conditions of women of color." Kennedy makes the point that even in white, middle-class peace movement organizations, women of color may have worked toward different goals, for example, attempting to incorporate antilynching into nonviolent platforms (Blackwell-Johnson 1998). The analysis of women of color provides the opportunity to examine the impacts of race and sexuality, as well as gender, upon peace and violence. At least in the cases reported here, the women of color focused on nonviolence issues in their racial/ethnic/national communities. Their agendas concentrated upon illuminating the connections between race, gender, and violence.

Second, we have also paralleled some of the evolutionary steps in feminist and peace history noted in Frances Early's (2000) work. She notes that "first generation" scholarship involved interdisciplinary

documentation of lost history and gradually moved to acknowledge the extensive social change activism of separatist women's organizations. The analyses here have brought together original information about peacemakers, whose work has been relatively unknown, and new rhetorical analyses of historically well-known peacemakers. Like Early's "second generation" theorists, these examinations reflected how women peacemakers utilized cultural images in new ways, strongly differentiating their perceived female experience as moral protector/nurturer from male violence. Early cites interdisciplinary theorists who suggest that women invented novel approaches to peacemaking through revisioning cultural images, including the "mother," the "beautiful soul," and the "warrior." Redefining these images may reconfigure symbolic forms from the popular usage, as well as create new forms and models. Like the "third generation" theorists, who expected study to lead to practice, the authors in this book propose that uncovering and publicizing the symbolic behaviors behind oppression and proposing alternatives can influence not only academic theorizing but also public action.

At least among the women associated with peace movement organizations, each peacemaker and each campaign built upon the rhetorical methods and symbols of previous campaigns, yet each responded to unique social conditions. This does not imply linear progression but that some groups maintained their efforts over a long period, with recognition of prior successes. Because the contexts varied, sometimes a change method had to be abandoned. Certainly, the cultural forms change over time, and the chapters reveal how peacemakers around the world create or modify the symbols to appeal to the needs of the situations they confront.

The analyses here also detail alternatives to traditional or patriarchal "methods of persuasion" that are commonly studied in rhetoric. Communication and rhetorical theorists, most notably feminists, have made the point that persuasion often assumes coercive forms. Peace activists, in contrast, often hold themselves to the highest ideals of nonviolent language and action. While a few rhetorical theorists have called for new nonviolent theories of rhetoric (Gorsevski 1999), we may look to feminist peace studies to make additional needed links, often through interdisciplinary efforts.

We have attempted to illuminate some of these efforts by examining the words and actions of women peacemakers who rhetorically created new ways of acting independently and acting together for peace. This sometimes required the women to work as outsiders within their

own cultures, on occasion circumventing patriarchy, at other times being co-opted, and at still other times using a culture's own symbol systems to change it from within. We examined how effectively they controlled the symbols, when the peacemakers rhetorically challenged violence without committing violent acts themselves. Certainly, many, if not all, of the "peace talkers" benefited from the discursive efforts of their predecessors. In turn, it is likely that their stories and words will continue to inspire twenty-first century women who speak for peace.

REFERENCES

Blackwell-Johnson, Joyce. 1998. African-American Activists in the Women's International League for Peace and Freedom, 1920s–1950s. *Peace & Change* 23, no. 4 (October): 466–82.

Chatfield, Charles. 1993. *The American Peace Movement: Ideals and Activism*. New York: Twayne Publishers.

Early, Frances. 2000. Feminism's Influence on Peace History. *Atlantis* 25, no. 1 (fall/winter): 3–10.

Foss, Sonja. 1989. *Rhetorical Criticism: Exploration & Practice*. Prospect Heights, Ill.: Waveland.

Gorsevski, E. W. 1999. Nonviolent Theory on Communication: The Implications for Theorizing a Nonviolent Rhetoric. *Peace & Change* 24, no. 4 (October): 445–75.

Kennedy, Kathleen. 1999. *Disloyal Mothers and Scurrilous Citizens: Women and Subversion during World War I*. Bloomington: Indiana University Press.

Lofland, John. 1993. *Polite Protesters: The American Peace Movement of the 1980s*. Syracuse, N.Y.: Syracuse University Press.

Index

About the Contributors

Margaret Cavin is an associate professor at Biola University in Southern California. Her research focus is social protest rhetoric, and, in addition to her work on Helen Caldicott and Sis Levin, she has published articles and written conference papers on rhetors such as Reverend William Sloane Coffin, who championed efforts against the Vietnam War; Glenn Smiley, who was Martin Luther King Jr.'s teacher of nonviolence; Dr. Elise Boulding, a researcher, educator, and spokesperson for peace; and Reverend Greg Dell, a Chicago preacher who conducted holy unions for homosexuals in his church and was put on trial and suspended from preaching by the United Methodist Church. Currently, she is working on a project about Al Feldstein, who has been the editor in chief of *MAD Magazine* for over thirty years, in an effort to show how humor is a form of social protest.

Victoria Christie is a native Montanan with a keen interest in Jeanette Rankin's life. She earned her bachelor's degree at the University of Montana, her master's at University of New Mexico, and her doctorate at the University of Kansas. She has taught in Japan and in Alaska, has served as a teaching fellow at Harvard University, and is presently an associate professor of communication studies at Rocky Mountain College in Billings, Montana.

Sheryl L. Dowlin, Ph.D., is a professor in the Speech Communication Department at Minnesota State University in Mankato. Her research has focused on cross-cultural peace communication education issues. She serves on local, state, and national reconciliation committees as program planner and liaison and, since 1987, has co-coordinated a

unique cross-cultural third-grade field trip in Mankato involving Dakota (Sioux) area teachers and parents.

Anna L. Eblen (B.A., Duke; M.A., West Florida; Ph.D., Oregon) serves as professor and chair of the Department of Communication at Western Washington University. She teaches interpersonal, small group, and organizational communication. She worked in the Navy Hospital Corps during the Vietnam conflict, and her experiences were formative in her commitment to intercultural and peace communication. Her mother and sister Jennie inspired the work on Peace Links.

Colleen E. Kelley is an assistant professor of speech communication at Penn State Erie, The Behrend College. She received her Ph.D. in rhetoric and communication from the University of Oregon. Professor Kelley is the author of *The Rhetoric of First Lady Hillary Rodham Clinton: Crisis Management Discourse* (Praeger, 2000) and has written various articles for learned journals.

Kathleen Kennedy is an associate professor of history at Western Washington University. Her most recent publication is *Disloyal Mothers and Scurrilous Citizens: Women and Disloyalty during World War I* (Indiana University Press, 1999). She is currently working on a number of projects that examine the relationships between constructions of womanhood and racialized violence in the United States.

Edith E. LeFebvre, Ph.D., is a professor at California State University Sacramento in the Department of Communication Studies. She teaches and consults in the areas of conflict management, mediation, persuasion, and interpersonal and political communication. She has particular interest in the study of peace and nonviolent conflict resolution strategies. The chapter on Jane Addams stems from her research in the Peace Collection Archives at Swarthmore College in Pennsylvania.

Miriam McMullen-Pastrick, OSB, Ph.D., is a lecturer in speech communication at Penn State Erie, The Behrend College, where she has taught in the areas of public speaking, small group process, and organizational communication for the last eleven years. She has been a Benedictine sister at Mount St. Benedict Monastery for over forty years and is a member of Benedictines for Peace and Pax Christi USA. Her research and national convention presentations have covered such